THE · SECRET · LIFE
OF PAINTINGS

By arrangement with the British Broadcasting Corporation

THE · SECRET · LIFE
OF PAINTINGS

RICHARD FOSTER & PAMELA TUDOR-CRAIG

THE BOYDELL PRESS

(c) Copyright Richard Foster, Pamela Tudor−Craig
and the British Broadcasting Corporation 1986

First published 1986 by
The Boydell Press
an imprint of Boydell & Brewer Ltd
PO Box 9, Woodbridge, Suffolk IP12 3DF

Reprinted in 1986

British Library Cataloguing in Publication Data
Foster, Richard
 The secret life of paintings.
 1. Painting, European 2. Painting, Renaissance
 I. Title II. Tudor-Craig, Pamela
 759.03 ND450

ISBN 0 85115 439 5

Designed by Gillian Crossley-Holland
Printed in Great Britain by
St Edmundsbury Press Ltd, Bury St Edmunds, Suffolk

Contents

Acknowledgements

We had not previously done any work on the pictures we chose. Richard Foster and I spent an amazing year doing that research, a lot of it in the Library of the Warburg Institute, that great resource for those who wish to find keys to the understanding of the Renaissance. We are profoundly indebted to the staff of that Institution and to all our colleagues for their generous help in our endeavours. We should mention in particular that we consulted John Glenn about the mathematics of the Holbein, that Amanda Lillie was a brilliant research assistant in our studies of the Botticelli, that in working on the Uccello we are particularly indebted to Carmen Blacker and Michael Loewe. For the van Eyck we are specially grateful to the curator and staff of the Musée Rolin in Autun, and to the staff of the archives of the Louvre in Paris. For 'La Primavera' we are indebted to the staff of the Uffizi Gallery and of the Palazzo Davanzati in Florence, and to our friend Eve Borsook. In our enquiries about the Rolin Madonna we are grateful to Monique de Ruette and Catherine Lewis Puccio generously gave us access to her researches on the Holbein. We owe a very special debt to Marie Slocombe for her prodigious help in many areas and in particular with the folklore aspect of Uccello. But for

the most part the arguments here offered were worked out by our two selves. Conclusions are entirely our own and very much open to debate. We are working on the fringes of knowledge, and may very well have got some of it wrong: in research there are no guarantees. Anyone who has acquired a taste for it, finds it an irresistible occupation. The only basic requirement is an insatiable curiosity. It was not an art historian, but a quantum physicist, Max Planck, who said 'when the pioneer in science sends forth the groping fingers of his thoughts, he must have a vivid, intuitive imagination, for new ideas are not generated by deduction, but by an artistically creative imagination.'

We are grateful to Dr Graddon Rowlands and the University of Evansville for allowing Pamela Tudor-Craig to have a sabbatical term to work on this book.

We are indebted to the BBC research assistants, Valerie Green and Jill Butler, To Robert Smith for assistance with diagrams within the text, to the tireless industry and encouragement of Marilyn Jenner, Pamela's secretary, and to the sympathetic understanding of our publishers, Richard and Helen Barber of Boydell and Brewer.

Chapter 1

Introduction

Art galleries are a very necessary expedient. Without them we could not be confident that the most precious pictures from the past would be maintained in perfect condition, or as near to it as we can manage. But for those who wish to discover the delights of painting, they are a very mixed blessing. Paintings, like people, make friends one at a time. Like people, they are complex, they don't wear their hearts always on their sleeves, they are eloquent not only in what they do say, but what they don't say. The mere fact that there is another masterpiece hanging a foot away prevents us from attending very closely to any one of them. After an hour of visiting a gallery, like an hour at a cocktail party, we are more aware of our aching backs and feet than we are of what is around us. Works of art were meant to be enjoyed in a very different context from this. They were intended to be part of daily life, hanging in the intimacy of a home, or to be a focus of worship in a church, or part of the panoply of circumstance in a palace.

There are really only two kinds of works of art: those which were commissioned by a patron and those which were created in the hopes of a sale. Architecture always falls into the first category. The other arts, including music, may be from either. Most of the pictures that we are discussing in this book come into the first category. They are pictures with programmes that were worked out in collaboration between the artist and the person who wanted them. Commissioned pictures are the products of more than one mind, and in the days when a commission was the normal way of setting about a picture, artists did not expect to be doing their own thing, but to be fulfilling specific requirements. Some of those requirements would be standardised; others would be special to the occasion. If we can decipher what went on between artist and patron, we will be much nearer to understanding what the picture was intended to convey.

Furthermore, no patron can command (and no writer can define) beauty, but it can be discovered. Some kinds of beauty are recognised in an instant, but others have a way of growing on you. The recognition of beauty is frequently the reward of specific effort. A very considerable effort is made in struggling around dozens of

rooms in a gallery, but there are two other ways in which the revelation of beauty can be helped. One of them is by actual physical pilgrimage. If you go to a great gallery intending to spend half an hour before one specific picture there, you will gain a very great deal more from that picture and from the experience than if you go in the hopes of seeing everything in one day. In the same way, if you go all the way to a specific museum or house which only contains one work of importance, you will see that work with much clearer eyes than if you are going to share that day with many other works. There is another way in which you can make a pilgrimage, and that is by preparing for the encounter with a specific work of art by studying it carefully first.

The intention of this book is to explore an encounter with five specific paintings, and to initiate a process which anyone can continue for themselves in studying the works of their choice. Research is not the prerogative of universities. Anyone with a decent spirit of enquiry and a little time can find out more about a work of art if they wish to. There is a direct ratio between knowledge and enjoyment. We may start to develop knowledge from the point of having initially enjoyed, but in the process we shall come to enjoy a very great deal more. Paintings, like ballet, have a choreography. You can spend a delightful evening watching the ballet *Sleeping Beauty*, but if you know the specific meaning of the movements of the dancers, or study the score, you will gain a great deal more. The pictures that we have chosen belong to the century between 1430 and 1530, when there was a fairly well developed sign language, generally inherited from the classical world, which is by no means foreign to us. We also expect the figures in paintings to take up the stance which we regard as dignified. We may also know that the hand dangling idly from the wrist indicates a man of leisure and culture. We may be familiar with the paraphernalia of haloes and armour and martial array. This is only the first level of recognition. The five paintings which were chosen are not instantly comprehensible, and our object was to try and see whether we could further their understanding. In all societies there is an in-language, which is immediately available to the accepted group

1

and not intended to be too obvious to 'outsiders'. All our pictures partake of this social elitism. In some cases the hidden meanings were deliberately concealed, in the sense that it wouldn't have been too wise to share them with everybody. The century of our paintings was one of considerable unrest and disquiet, of deep criticism of the church, and thus of the basic groundwork of all aspects of society in western Europe. By the seventeenth century it was possible to buy a little bronze statuette of the reigning monarch on horseback provided with several screw-in heads, so that you could change your allegiance according to who was coming to tea. A touch of the same caution applies to the Bosch, to the Holbein and perhaps the Uccello.

The pictures we chose were not ones where we thought we knew the answers already. They were selected for completely different reasons. They had to be of considerable fame and attraction. We hoped that most people would be basically familiar with them or happy to become so. They had to include puzzles which have not been totally resolved so far. What we did not expect was that the result of this relatively random choice would so remarkably complement itself. The five pictures work out very much like the five movements of a symphony. Where they do differ greatly is in scale: the Uccello is a very little picture, the Holbein is nearly life-size.

The principle of collecting pictures by great artists, as opposed to commissioning works of art for a special place, began at the end of our period. The first correspondence about such an approach came from the patron Isabella D'Este. She wrote to her agent saying that she would accept anything providing it was by Leonardo da Vinci. That represents the great breakthrough for artists. At the same time in Venice we get the first references to pictures as *poesie*, that is, mysterious paintings with no declared subject. The great exponent of this new art form, which was intended for intimate surroundings in the cabinet of the collector, was Giovanni Bellini, whose pupil, Giorgione, followed him in this matter. Their *poesie* still elude us. None of our pictures are as hard to decipher as theirs. However, they all contain mysteries, which we have attempted to resolve. It was a great mathematician who said that the right resolution of a problem can be recognised by its 'elegance'. We hope that our interpretations will carry something of that instinctive rightness.

The choice of the Rolin Madonna was partly made in the hope that it would provide the groundwork of what lay ahead. Here the relationship between patron and artist is very evident, in as much as the actual image of the patron takes up about a third of the picture space. We chose the picture partly because it was a very clear representation of the imagery associated with the Virgin Mary, and the Virgin, as the ideal of all that was most admired in womanhood, is one of the keys to understanding the fifteenth century. We did expect, and find,

the imagery associated with the Seat of Wisdom in connection with the Virgin. We did expect, and find, the new realism of the fifteenth century in the image of Nicholas Rolin. We knew of his prosperity and political importance. What came fresh to us was the possibility of identifying the picture with a very significant political occasion, a turning point in the history of Burgundy and in the personal career of Rolin himself. The picture has been otherwise interpreted; the background has been discussed as an image of the City of God. While this remains a viable alternative, we find a specific topic more in tune with the mood of the 1430s. Van Eyck was appreciated for just that: his capacity to make evident the actual rather than the generalised. This does not mean that he did not handle symbolic material, as his painting of 'The Virgin as the Church', clearly reveals. There is plenty of symbolism in our picture: observe the floating angel carrying the crown. But symbolism plus the illusion of total reality is what Jan van Eyck offered. He lived in a fantasy world where the chief aesthetic pleasure of the Duke of Burgundy, his main patron, was to achieve by every means available a Garden of Paradise in which to live himself. Like the Maginot Line in 1939, the borderline between fairytale and reality ran down the centre of fifteenth-century Burgundy.

Uccello's 'St George and the Dragon' which we thought we would find a relatively obvious picture, proved to contain a great deal which is not straightforward at all. Maybe our associations were all coincidence. Never mind, the journey is worth it even if the destination doesn't exist.

We are convinced ourselves that our interpretation of 'La Primavera' is correct. If a reading is completely in tune with everything that is known about the people concerned and their major pre-occupations, it ought to be the right one. We have tried to describe the philosophic background clearly but the extraordinary fact that this association has not been made before is surely due to the elusive mind of Marsilio Ficino. He has to be read and re-read before it is clear what he is getting at, and even then he may shift his images in the next chapter. Nevertheless, he is a profoundly worthwhile philosopher.

Something similar besets our interpretation of the Bosch painting. It has remarkable parallel with the *Enchiridion*, an early book by Desiderius Erasmus. The format of the *Enchiridion* returns again and again to the Mocking of Christ; each time the images shift slightly, so that the exact identification is difficult to pin down. It is my belief that Erasmus was personally engaged with this picture, either that he possessed it or that he knew of it. The alternative would be that Hieronymus Bosch had read the *Enchiridion* and that his painting was based in part upon it. Alone among Bosch's paintings, his Mocking of Christ relates to Italian imagery, specifically in the manner of Leonardo. The immediate effect of Italian influence on Northern artists and their painting is a change of scale. Pictures move into close-up from the

more distant viewpoint, as indeed this one does. The anecdotal is reduced, the human element is explored much more deeply, the personal is enlarged at the expense of the narrative.

One of my students, under my encouragement some years ago, had found the significant date of the Holbein. The Holbein was the picture where we thought every detail had been deciphered. We knew almost too much about it. We had all the words, but no message with any but a nihilistic sense which was quite out of keeping with the early sixteenth century. Again, it was a philosopher, this time Cornelius Agrippa, who, as far as we are concerned, decoded the picture.

So out of our five paintings, three are intimately associated with the writings of contemporary philosophers, one enticed us into the mazes of folklore, and one involved both theology and historical chronicles. The days of the art historian who stuck to style criticism alone appear to be over: understanding pictures is a Jack of all Trades profession.

Some have been known to speak of the Triumph of the West. Our exploration bears more resemblance to the Requiem for the West. There is a profound undertow of pessimism in nearly all our pictures, all of them perhaps excepting the van Eyck. The period in which they were painted, when decadence and disease of the spirit were everywhere present, resembled our own. It differed in one very important respect. It had a hope beyond the horizon: one which for most people nowadays has been virtually blotted out: a hope of another world beyond our world. Without that hope, the requiem is unendurable. Were we wise to jettison that hope? The knowledge that the world was not made in seven days or that there are an almost infinite number of planets and stars, does not make any difference to the need of the human heart, which is exactly the same as if it was in 1500, the need to make a larger sense of our individual lives. These pictures speak to that need. They can become companions as alive and as relevant as the greatest literature and music of their time.

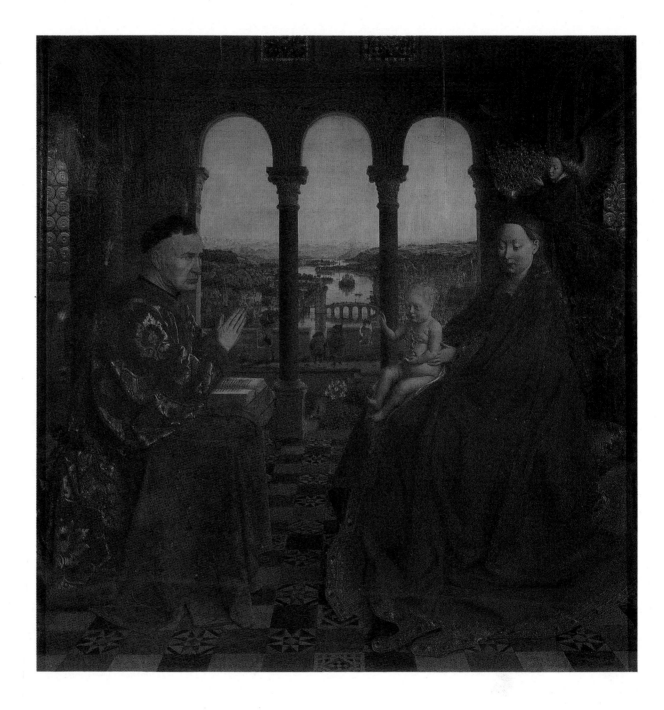

Chapter 2

The Madonna and the Chancellor Rolin by Jan van Eyck

Nothing trivial came from the brush of that exquisite painter Jan van Eyck, pre-eminent artist of the Flemish school of the fifteenth century.[1] His art sprang from that of the illuminator,[2] which expected to be examined with as much attention and as close a scrutiny as the densely crowded Gothic script it accompanied. The illuminations of the early fifteenth century had to pass the test of daily examination by a patron whose flesh would have preferred to rest while the spirit demanded the performance of repetitive spiritual exercises. The duty of the miniaturist was not to while away an evening in the armchair of the collector, but to accompany, encourage, focus, even inspire, the attention of the owner on every day of his life, perhaps from marriage to death. While the marginalia around the borders of the text beguiled the weary heart as tales shorten the miles of the traveller, the set pieces of the religious subjects were altarpieces in little where the worshipper might gaze repeatedly to their advantage. Even the pictures hanging over our mantelpieces today are not studied with such a lifetime's concentration. The secret of holding the attention through such an exhaustive test lay not in novelty, which soon palls, but in meeting the anticipated exposure to examination by a concentration equal in intensity. Jan van Eyck's paintings contain, and even deliberately conceal, further secrets, like little boxes within boxes, of which each holds the key to the next. The observer is tempted to continue to explore until he eventually penetrates to the centre of the mystery. And that . . .

But we have to start with the outermost layer. Some of these layers are more difficult for us to unpack than they were for van Eyck's contemporaries. Allusions obvious to them we may easily miss. Some may remain unreachable, but on the whole we are unlikely to go far astray in the case of the Rolin Madonna, where the main characters are identified and the allusions, if they are not to universals, are to known historic events. It is

probably more intelligible than a joke in a *Punch* or *New Yorker* of the last generation. The obvious questions that we are entitled to ask of this picture are as follows:

a Who are the people?
b Where are they?
c What's going on outside?
d What is actually happening?

We can answer the first two questions with reasonable certainty. It is only when we get to the third and thence the fourth that people disagree, but by the time we reach these the reader will be in a position to take sides in the debate.

Who are the people?

It is perhaps eccentric to suggest that the seated lady in red with her naked babe on her lap is a convincing portrait of the Madonna and Child. However, a conclusion that can be drawn from a careful examination of the body of van Eyck's work is that his considerable output was achieved by dint of never doing his homework twice. He certainly painted at least two very minutely finished pictures every year.[3] We have at least eight images of the Virgin and Child besides this one from his brush,[4] and all of them could have been painted from the same model. For that matter, the list could be extended to works in which Jan's assistant and successor, Petrus Christus was involved.[5] For that matter, the same type of beauty served for St Catherine in van Eyck's Dresden triptych, and for St Barbara in the tinted drawing.[6] On the other hand, the two images of the Virgin in the Ghent Altar, and the Virgin of the Annunciation in the Metropolitan Museum, New

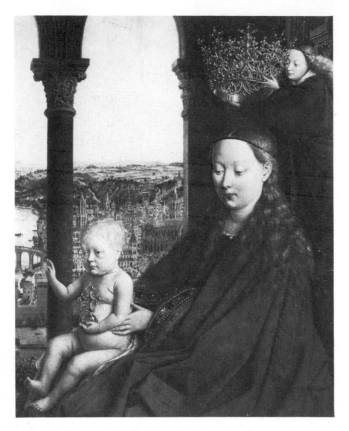

'The Madonna and Chancellor Rolin': the Virgin and Child.

York, do not conform to the same ideal. It could well be that the choice of feminine ideal is a useful criterion for distinguishing the work of the two van Eyck brothers, Jan and Hubert. It is not only the particular cast of the Virgin's features and hair which runs true to form throughout this whole group of Jan's paintings. In all but three of them,[7] the Virgin is similarly dressed in a great red cloak with a blue dress beneath it. In all of them save the Dahlem Virgin, which is crowned, she wears a bandeau round her hair; but only in the Thyssen Annunciate Virgin is it plain, as in our picture. In the other versions it is studded with jewels. The reason for its plainness here is not far to seek: an angel hovers over her, about to put the crown upon her head. A jewelled bandeau would have been a grave and painful mistake under a crown.

Moreover, the same chubby and curly headed infant could have sat for all these paintings, though he looks a trifle younger in the Dahlem Museum group. The pictures in question were certainly painted over at least seven years. A beautiful young woman could have kept her looks over that time, but the years do not stand still for babies. This observation proves something which has important implications for other aspects of van Eyck's work. His totally convincing realism was founded on careful studies from the life. But having established his stock of such studies, van Eyck used them again and again without further reference to the originals.

If this applies to the child, it applies with equal force to the crown, whereby the seated Virgin is celebrated as the Queen of Heaven. There are four gold crowns in the work of van Eyck,[8] all carefully differentiated, but with a great deal in common. The foundation of all of them is a band edged with pearls and studded with rubies alternating with sapphires. From this there springs a foliate design of leaves, tipped by cruciform branches, and with the side stems curling back towards the band. It would be possible to construct any one of these crowns from the data van Eyck gives us. Indeed, one of his paintings was 'realised' in 1458, when Philip the Good made his ceremonial entry into Ghent. The central procession to the altar of the Lamb from the Ghent Altarpiece was acted out on his behalf.[9] When it came to equipping the band of clergy with their crosiers and processional crosses, there was probably no difficulty. They were still in the Treasury where van Eyck had studied them. His crosiers are immediately recognisable as being of very different dates, some going back at least to the thirteenth century. There can be no doubt about Jan van Eyck's vivid interest in the appurtenances of glory. There were twenty six goldsmiths working in Bruges in Jan van Eyck's day, and in 1436 he painted one of them.[10] If the tableau designed for Philip the Good in 1456 represented the crossing of the line between reality and fantasy, which was so evident a characteristic of the Burgundian court, Jan van Eyck anticipated this threshold in our picture. The idea of an angel hovering over the Virgin in order to crown her is of great antiquity, but as interpreted by Jan van Eyck, it is only a step from late medieval dramatic effects. When Isabella of Bavaria entered Paris in 1389, she crossed to the Ile de France by the bridge slightly to the west of Notre Dame cathedral. An angel descended 'by means of well constructed engines' from one of the Western towers of the cathedral to put a crown on her head, and was drawn up again 'as if he had returned to Heaven of his own accord'.[11] Whether the 'well constructed engines' were kept in trim or reconstructed, Philip the Good, patron of Jan van Eyck, was to be similarly greeted on his entry into Paris. It is even possible therefore, that van Eyck had witnessed the trick of the flying angel bearing the crown. The idea of course, originates from a classical formula of the winged victory bearing a laurel wreath, and as such is carved on the triumphal arches of antiquity. Jan van Eyck was very sparing in his introduction of the miraculous. Angels there are of necessity in his pictures – protagonists in the Annunciation, reading the Gospel in the choir behind the Virgin in the cathedral[12] (which is therefore, the Gospel of the Feast of the Annunciation). Doves hover, rays of light descend from Heaven, where strictly necessary; but whenever he can, Jan van Eyck introduces the supernatural in as 'ordinary' a way as possible. Thus the Ghent altar musical angels are without wings,

haloes are generally eschewed, Catherine leaves her wheel quietly on the floor,[13] while Barbara, rather than balancing her tower on her hand, allows it to stand on *terra firma* behind her.[14] The hovering angel in the Rolin Madonna, therefore, is very much an exception, though one so close to the spirit of the Paris entry of Isabella, that we find ourselves looking for the trapeze wires.

The babe carries a crystal orb surmounted by a jewelled cross to indicate his victory over the world. For all that he is a cherubic infant of perhaps 9 months old, the relationship of Mother and Child is more hieratic than in any other of van Eyck's renderings of the scene. His studies of the Virgin and Child run the gamut of variations on this idyllic theme. The babe explores the neck of his mother's dress,[15] turns the pages of her Book of Hours,[16] waves an inscribed scroll,[17] plays with a parakeet,[18] steals her rosary and snuggles into her neck,[19] and reaches her breast.[20] Where a donor is present, both mother and child incline graciously

towards him. But in our painting the encounter is directly in line with their formal seated pose. For all van Eyck's thoughtful provision of the nappy, this blessing Christ Child is placed upon his mother's knee with the geometric symmetry of a twelfth century Throne of Wisdom group. It is as if the artist has performed what would have been a very popular and much sought-after miracle: he has brought an ancient statue of the Virgin and Child to life. Among the most widely circulated compilations of the later Middle Ages, were the various collections of the miracles of the Virgin. The mutilated remains of fourteenth century reliefs illustrating these miracles encircle the Lady Chapel at Ely cathedral.[21] The grisaille painted cycle in the chapel of Eton College of the 1470s and 80s derives from the similar texts of Vincent of Beauvais and the *Speculum Historiale*, testifying to the continued unabated popularity of this material into the later Middle Ages.[22] Nor was England unusual in favouring this type of literature. In fourteenth

Jan van Eyck, 'The Madonna with Canon van der Paele' (Stedelijke Musea, Brugge).

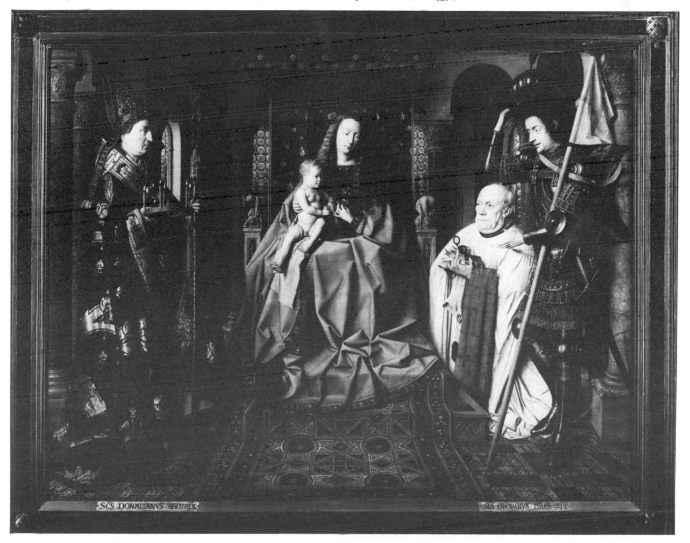

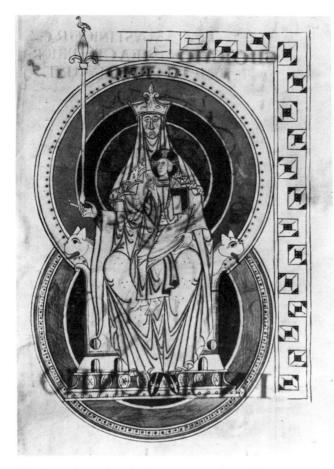

*The Seat of Wisdom (*Sedes Sapientiae*) (Bodleian Library, Oxford, MS Bodley 269, f. 3).*

century Paris, a choice from forty dramatised Miracles of Our Lady was presented annually by the Guild of Goldsmiths.[23] The tradition was particularly popular in the Burgundian court of Philip the Good, that 'great lover of recitals of tales'.[24] By 1467 the inventory of the special section of books reserved for his chapel, itemised alongside the Golden Legend, a copy of the Miracles of the Virgin. This particular compilation was made by Jean Mielot, his personal secretary. The first volume is now in the Bodleian Library in Oxford (Douce 374). The second volume is now Paris Bibl. Nat. Fr.9192.[25] There are variations within the numerous miracles recorded in these compilations, but the standard formula of the Miracles of the Virgin is of a hero or heroine praying before the statue of Our Lady, which comes to life in response to their plight. One facet of Jan van Eyck's skill which would have been vividly appreciated in Burgundy was his ability to effect the almost miraculous in paint: a vitalisation of the archaic pose of the Throne of Wisdom.[26] This aspect of Marian iconography is usually represented by a rigidly frontal seated Virgin presenting her child between her hands.

The Throne of Wisdom is literally an armchair for the Word or Wisdom, Christ himself.

The informal poses adopted by Jan van Eyck in most of his pictures of the Virgin and Child are not devoid of symbolic reference: his audience were accustomed to reading poses as a sign language, at the same time as enjoying the impression of spontaneity generated by his realistic approach. In this picture the unusual formality would not have been missed. It refers to the most ancient type of sculpted image, superseded during the previous two hundred years by less intimidating renderings of motherhood. The reason for chosing the older type was its venerability. Churches and chapels might be altered or rebuilt, but statues of Our Lady, once they had acquired a reputation for miracle-working, were reclothed and recrowned, but, like Byzantine icons, grew in veneration as they aged. One such statue, focus of devotion in van Eyck's time and certainly known to the kneeling donor, is still encircled by candles and devotees today: the miraculous Virgin, Notre Dame de Bon Espoir in the church dedicated to her, immediately beside the ducal palace in Dijon.[27] Her drapery proclaims her early twelfth century origin. The Child has been stolen from her knee, and her hands are missing, but her power is undimmed. She performed a miracle for the city of Dijon in 1513, and saved it again during the last war. In Liège a famous statue of Our Lady was venerated in the Old Choir: it was repaired and regilded in 1540 and appears to have been destroyed during the French Revolution. Another, from the church of St John the Baptist in the same city, is now in the Diocesan Museum. The French Revolution was responsible for the dispersal of these cult images, most of which are now in museums. The one from the cathedral at Autun, home of our patron, is now in The Cloisters in New York.[28] A feature of many of these twelfth century figures is the provision for a metal crown, usually now lost. Among his many endowments to his special church of Notre Dame de Chastel in Autun, a crown, surely for the statue of Our Lady, was given by Nicholas Rolin. We could, therefore, interpret van Eyck's picture as the record of the Virgin's response to the gift of a crown by rewarding the donor with a momentary replacement of her substitute which he is embellishing by her Real Presence and that of Her Son. It could be a special Miracle of the Virgin devised by his artist for Nicholas Rolin.

If the illusion of reality which van Eyck was the first to fully exploit in painting, invested a wooden statue of the Virgin with a moment of miraculous vitality, the same capacity to suggest actuality has extended towards infinity the fleeting presence of the middle aged and unattractive Nicholas Rolin. Jan van Eyck and his followers were the first since antiquity to capture in paint the speaking presence of a sitter. Even in antiquity, and even in the contemporary Italian Renaissance, the urge to idealise blurred the edge of truth in portraiture. Only in Flanders, and then in

Germany, do we find the dreary truth captured with such devastating accuracy that its very ordinariness persuades. This has to be the shaven nape (the hair style which we rightly associate with King Henry V), the scowl, the petulant jowl, the thick neck, of the man who paid for the picture. There could be no possible motive for inventing so daunting a face. By daring to mirror this uncompromising visage, Jan van Eyck has captured the presence of his sitter. If his regard when his hands are meekly joined in prayer is so fierce, how does he look in the company of a defaulting tenant? But first we must discover how it is that we know this is Nicholas Rolin, Chancellor to Philip the Good, Duke of Burgundy, for the phenomenal span from 1422 to 1461.[29] None of the reasons for identifying this eminent citizen risen from the 'little people' of Autun is conclusive in itself, but taken together the case is sound. The first key lies in the pedigree of this picture itself. The earliest document of its whereabouts is of 1705.[30] It occurs in a description made in that year of the church of Notre Dame du Chastel in Autun. This little Romanesque building stood in what is now an open space between the Rolin family house, the *Palatium Rolinorum*, as it was known at the time, now the Musée Rolin, and

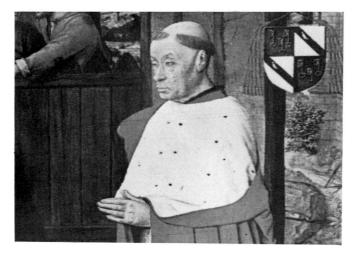

Maître des Moulins, 'The Nativity with Chancellor Rolin': detail of Chancellor Rolin (Musée Rolin, Autun).

'The Madonna and Chancellor Rolin': detail of Chancellor Rolin.

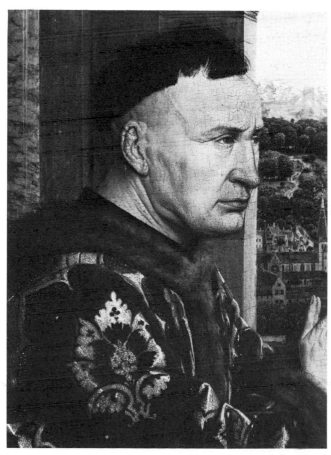

the Cathedral of Autun. The Rolin family had a much closer relationship with Notre Dame du Chastel than they had with the Cathedral. Nicholas Rolin's father was buried in the choir; Nicholas had been baptised there. In 1426 he founded a chaplaincy at Notre Dame du Chastel for daily masses on his behalf and that of his ancestors. By 1429–30 he had established funds to rebuild the family chapel there, funds which became in 1436 an endowment notable for the time, of £650 a year. By 1450 he had coaxed the Pope to make his church collegiate. By then he had rebuilt not only a family chapel, a chapter hall and a library, and given vestments, a font and a crown, but rebuilt the choir. Already six masses a day and a daily office were being offered on his behalf. He had his own balcony overlooking the choir, that choir where he was to be buried upon his death in 1462. Colleges of secular canons were much more popular than the older monastic establishments by the mid fifteenth century. Compare, for example, the similar foundation by the Duke of York at Fotheringhay in Northamptonshire. Nevertheless, one of the Chancellor's sons, Jean Rolin, redressed the balance when he became Cardinal Bishop of Autun by taking a considerable interest in the cathedral, where he was responsible for the beautiful fenestration of the nave chapels. Cardinal Rolin, who had closed his father's eyes in 1462, was painted by the Maitre de Moulins as he knelt with his dog upon the threshold of the stable of the Nativity. He has hung the red hat of his office upon a nail on the stable wall. The picture is still in his house at Autun. Cardinal Rolin, according to the Maitre des Moulins, was a flabbier, paler, fatter, version of his redoubtable father (and so, it is tempting to add, was his dog). But the Rolin features are unmistakeable. Genetics have an unfortunate way of repeating features which are more striking than handsome. If we had no further evidence of the identity of the gentleman kneeling before the Virgin in our picture, the features of

9

Cardinal Bishop Jean Rolin would suggest the paternal connection. The placing of our picture in the church of Notre Dame du Chastel and not in the Rolin house is also of special interest. The portrait of Canon Georges van der Paele kneeling with his patron saints before the Virgin and Child, painted by Jan van Eyck in 1436, is known to have been destined for the Canon's monument.[31] Van der Paele had been ailing since at least 1433, though he was to live till 1443. Our sitter, however, was clearly a long way from the 82 years he was to reach when he was painted by Jan van Eyck. His memorial was probably still far from his mind in commissioning this portrait. Nevertheless, the picture may have formed part of the remembrance of him in the church of his special patronage – his perennial participation in the prayer he had endowed and shared whenever possible.

There are two other representations of Nicholas Rolin, in both of which he is identified by the context. They represent Rolin at a more advanced age than he is in our picture. Both were painted after van Eyck's death. He appears standing obsequiously immediately behind his master, Philip Duke of Burgundy, in the presentation page of 1448–50 from the French version by Jacques de Guise of the *Annales Hannoniae* by Jean Wauquelin, attributed to Roger van der Weyden.[32] The features of the Chancellor are unmistakeably the same. He appears in the miniature wearing a hat, a long fur-lined velvet coat, with a purse hanging from his waist. While this inevitably reminds us of his vast riches, the purse could have contained the Great Seal which it was his duty to guard, and which he returned to the duke from his death bed. An X-ray has shown that the under-drawing of the kneeling figure in the Rolin Madonna showed a similar bag hanging from his

'The Madonna and Chancellor Rolin': X-ray detail showing underpainting of purse hanging at Rolin's belt.

fashionably low waistline.[33] Van Eyck painted it over with the rich cloth of gold brocade. Assuming that van Eyck's portrait is indeed of Nicholas Rolin, the sombre elegance of his dress was of a piece with his Chancellorship. Philip the Good had knighted Rolin in 1424, when he gave him a special belt, for which the account survives among his general finances at Lille:[34] 'A Michel Ravary, demeurant à Lille, vingt livres quinze sols, pour une sainture d'un tissu de soye noire garnie de bouches, mordant et cloux de fin or, pesant ensemble XI onces, que mon dit seigneur a faict prendre et acheter et donner de lui et celle donnée et faict présenter de lui par lui à mon seigneur d'Authume son chancelier le jour qu'il l'a creé et sacré chevalier!'

In addition to his special belt which is surely portrayed by van Eyck, the Chancellor received annually a furred robe. The miniature of 1448–50 suggests that one of these furred robes was of figured velvet. The Rolin Madonna portrays the grandest of them, of cloth of gold brocade. A third, entirely of black, emulates the austerity and simplicity adopted in later life by his master, Philip the Good, who, at any rate after 1454, always wore black. This third portrait of Nicholas Rolin appears on the exterior of the great altarpiece of the Last Judgement that he commissioned between 1443 and 1450 for the hospital he endowed at Beaune. This third painting is undoubtedly by Roger van der Weyden, who held the field unchallenged after van Eyck's death. Rolin would have been at least 63 years old and perhaps more when the Beaune Last Judgement was painted, but, like President Reagan, the cares of office do not appear to have brought to him grey hairs. Roger van der Weyden as a portraitist has a way of creating a formula out of the truth, of distancing himself from the reality, and making a pattern out of it. But here are the same general features and the same quirks of individuality. Characteristics van Eyck only hinted at are confirmed by van der Weyden. Yes, the chin was cleft. Yes, the crease of the frown between the eyebrows was particularly protruberant and jutted in as it met the nose. Surely Rolin must have worn glasses for reading, though he would not have wanted the Virgin to know.

The Beaune altarpiece, the Wauquelin miniatures, the Maitre de Moulins portrait of his son, and the provenance from the church of Notre Dame du Chastel, which he had made virtually his own, all testify to the identity of the sitter. Nicholas Rolin becomes the first fully and frequently portrayed commoner in Northern Europe. He emerged alongside Jacques Coeur of Bourges, financier to the kings of France, and such lesser fry as Edward Grimston, merchant,[35] as one of the pioneers of the bourgeois middle class, who took over by force of their wits what they could grasp of the strings of power. Nicholas Rolin amassed considerable wealth by means which were not admired at the time; 'He always harvested upon earth,' said the chronicler Chastellain, 'as though the earth were to be his abode for ever.'[36]

Roger van der Weyden, 'The Last Judgement'. 'Chancellor Rolin', portrait from exterior panel of altarpiece (Hôtel-Dieu, Beaune).

Where are they?

The architectural history of Christianity could be divided into two sweeping categories: provision for communal worship, and provision for private prayer. The centuries which have dedicated their main endeavours to the first have left a conspicuous testimony in the monasteries, the cathedrals, and even parish churches. Private worship on the other hand, is of its nature secluded, and the provision of special sacred places is modest in scale, and frequently temporary in character, whether it be the beehive huts of the Celtic church, the caves of the Desert Fathers, or the wooden screens which compartmentalised churches and cathedrals to provide privacy. Among the religious the Carthusians living a life of what might be called 'collective isolation', alone retained their popularity to the end of the Middle Ages. This need for privacy, both at home and at prayer, is an important characteristic of the later fourteenth and fifteenth centuries over the whole of Europe. It is an expression of the same sense of personal individuality which gives rise to the art of portraiture of which our pictures provides so striking an example. The tendency that encouraged van Eyck to capture the unique, in the real sense, in the appearance of Nicholas Rolin, also allowed this man to be placed in isolation, without even the intermediary of a patron saint, before the Divine Child and his Mother: more, he appears before them in the same space. Such an exalted privacy was frequently Rolin's privilege within the court of Burgundy. He held private audience with Philip the Good, his duke, on a virtually daily basis. The Burgundian court, with two centres, still distinct in Rolin's time, in the Netherlands and in Burgundy proper, centred on Brussels and Dijon respectively, but with numerous subsidiary rendevous, such as Lille, Ghent, Beaune, Dol, was unusually mobile in a time of frequent aristocratic travel. Rolin and his duke had a more or less regular engagement to meet daily after High Mass in the Ducal Chapel of whichever palace the duke was frequenting. That private audience was probably usually held in the state bedchamber. The panoply of official government invested in a grand council of nine people, met after 2 February, 1433, before or after dinner every day wherever the court might be. But the reality behind the closed doors of the ducal bedchamber was well understood. What we have here is the spiritual equivalent of a private audience. Rolin was accustomed to dispensing with intermediaries in the political arena. But in the spiritual arena he was perhaps the first to dispense with the need of an introduction from an accredited go-between. He has even dispensed with the usual gestures of humility – being painted on a smaller scale, appearing in the wings, or on the outside of a panel, or below the border. He occupies the same space, and nearly as much of it, as the Queen of Heaven. There is not so much as a step between them. This is perhaps the first meeting 'on the

According to another contemporary Jacques du Clercq, 'the aforesaid Chancellor was reputed one of the wise men of the kingdom, to speak temporarily, for as to spiritual matters, I shall be silent.' But we must be fair: Rolin may have used graft to reach a position of remarkable importance in European politics of his time; but having got there, and even on the way there, he used his undoubted eloquence in the cause of peace. One of the two major portraits of him, by Roger van der Weyden, shows him at prayer before a portrayal of the Last Judgement in the hospital he had founded with his own and his second wife's money. This is the image of Rolin the almsgiver as he would wish to be remembered. The other by van Eyck is again Rolin, the man of prayer, but this time in a context which, if our interpretation is acceptable, represents Rolin as the Peacemaker. The financiers of the fifteenth century may have been brothers under the skin of their twentieth century counterparts, but they had one thing you cannot count on today: they had consciences. But what is this context?

level' between the divine and the human in Christian art.

The hidden agenda in our general attitude to the fifteenth century is that the term Renaissance described not only a rebirth of Classical knowledge, but the awakening to individualism won by throwing over the subservience to a Judgemental God. This is not a position Nicholas Rolin, who was to commission a major painting of the Last Judgement for Beaune, would have held. Nor was it held by that great pioneer of Italian Renaissance studies, Jacob Burckhardt.[37] The rich individualism of the fifteenth century was not so much due to the throwing aside of religion as to a new and more immediate approach to it. During the twelfth and thirteenth centuries the heights of spirituality were reserved for the professional religious, and the laity placed their best hope of gaining a foothold in the other world as well as this one in their practical generosity to the specialists in religion. Relaxation within the monastic orders and even the friaries as they slid over the crest of their first fervour reduced confidence in their saving power for others. In the later fourteenth century and earlier fifteenth centuries a galaxy of mystics, led by the great Meister Eckhart, and including at least four English saints who are still household names,[38] opened up the realm of immediate spiritual experience to the enquirer, no matter what his or her status in life. 'Do it yourself' religion included attendance at the eucharist and the recital of liturgical prayer not as an end in itself, but as a means of preparing the soul for the mystical private audience which van Eyck has portrayed. We have already observed that in rebuilding the choir of Notre Dame du Chastel, Rolin provided for himself a western gallery, from which he could see and hear without being observed. Such an arrangement, which was very common in the fifteenth century,[39] precluded all but the rarest participation of the sacrament of the altar.[40] So, when in the nineteenth century frequent participation of the sacraments became the norm in Protestant countries, this disposition was discontinued. A 'box' contrived within the ancient triforium with access from outside, or a western gallery, were not the only alternatives for achieving privacy for prayer. It was sometimes contrived by curtaining off a special space within a church or chapel.[41] This was the logical extension of the same principle that offered domestic privacy for married couples only within the curtains of their four-poster beds. Inevitably, these curtained enclosures within churches did not survive, but the very small devotional panels which do survive in some number from the fifteenth century, may well have come from such enclaves. The Rolin Madonna itself could

Autun cathedral: tympanum of Last Judgement by Gislebertus.

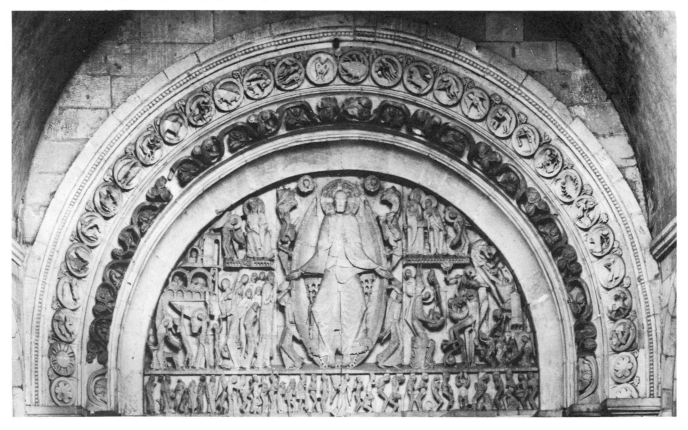

12

have been so placed in its first years.

These provisions for privacy at prayer during life were the prerogative of the privileged, as were the chantry chapels where that prayer was continued on their behalf after their death. In their defence it must be added that they were the group whose devotions would have been disturbed, as was every gesture of their public life, by the minute observation of the generality. If there is one thing which makes prayer – and indeed many worthwhile occupations – impossible, it is the knowledge that you are being stared at.

The possible refuges from observation are not exhausted. There was the private oratory within the household, in particular within the castle. A striking aspect of literature in the later middle ages is the eloquence of the symbol of the castle. We have the Castle of Perseverance,[42] the Castle of Love,[43] the Castle of Roses,[44] the Castle of Care,[45] and above all the Castle of the Soul.[46] The cathedral was scarcely used in this way at all. In fact cathedrals were deliberately furnished with the appurtenances of castles, in order to take on the attributes of buildings physically defended against evil. From the mid thirteenth century[47] west fronts, and then gradually the whole encirclement of cathedrals and parish churches came to be crenellated – armed against the foes of the spirit. The analogy was developed with special thoroughness at Exeter cathedral, where the creation of a battlemented walk-way over the nave aisles has bequeathed to the cathedral the drainage problems of a valley gutter. This is to go further than a preference for a crenellated edging to a wall.

The essence of castle thinking in the classic sense, is that the safest and most secret place is at the top of the highest tower. Here, at least, the besieged may hope to have climbed above the slings and arrows of fortune. Here, at the top of an interminable spiral staircase, he may defend himself from a host of attackers, who can only reach him one by one, be they outraged peasants, angry invaders, or our own sly sins. Hence the original similarity between the silhouettes of major churches and castle towers. Castles were not imitating cathedrals: cathedrals were imitating castles. Both offered to the skyline clusters of mighty towers with pointed caps. In the fifteenth century both modified the treatment of those extravagantly pointed roofs, known in the context where they survive, the church, as spires. In the mid fourteenth century the spire began to be replaced on occasion by a fantastic building, occasionally called in castle terms a gloriette. The earliest example in England is the octagon of Ely cathedral. This building preceded by half a century the famous lantern tower of Utrecht, which appears in our painting. Between them they influenced such landmarks as the towers of Boston and Fotheringhay and the western tower of Ely cathedral in this country, and in the Low Countries the octagonal terminations of St Jean de Maastricht and Notre Dame d'Amersfoort.[48] Both the octagonal turret and the filigree spire, another option of the later middle ages[49]

create the impression of habitable spaces, if only habitable by birds and angels. Precisely the same structural features crowned the most sumptuous castles of the years of the very earliest fifteenth century.[50] The joy of a fantastic lantern structure on the top of a great tower is that, being over the shooting height of missiles, it could afford to be lit by great windows. It was in fact a lantern tower riding like the topmost chamber of a lighthouse, above the dangers. Its security depends entirely upon the solidity beneath it.

In the same way that in the thirteenth century spires could be built on the ground – witness the Eleanor Crosses, – so in the later fourteenth and fifteenth centuries, lantern towers were built at look-out places, summer houses, in protected gardens, and these were called gloriettes.[51] The gloriette is architecture for joy, for dalliance, perhaps, when placed above a tower of dizzying height[52] intended to be a convenient stopping place for those who may defy the laws of gravity. Since it may forget the rules of caution and stability, it can also be the architecture of innovation. If we may believe the details of the two copies of a lost painting of falconry at the court of Philip the Good,[53] he had such a gloriette built on piers into the lake, which presented a very precocious essay in Renaissance type architecture. There are no rounded arches in the *Palatium Rolinorium*, and no pointed ones in Jan van Eyck's painting of the Chancellor. The issue of the architecture in Jan van Eyck's pictures has never been resolved. It would appear that he adopted rounded windows and arches, and marble columns with appropriate entasis, before there is any reason to suppose they they were being built around him. His sources, however, were certainly eclectic, as were those of the Ospedale degli Innocenti in Florence built by Brunelleschi in 1419. Both Brunelleschi and Jan van Eyck in the triple opening behind our figures adopted the procedure of arches coming down onto columns, which is more properly Romanesque than Roman. Perhaps fantasy architecture in the Burgundian court – and there was plenty of it – explored these quotations from miscellaneous layers of antiquity before they were adopted by the architectural profession as such.

The Chancellor Rolin, therefore, has climbed to what would be later termed the prospect room at the top of a great tower. The popularity of such great keeps revived all over Europe in the fifteenth century, from Tattershall, Ashby de la Zouch and Raglan,[54] to Brussels, where the great castle of Coudenberg stood on the present site of the Palais Royale,[55] to the vertiginous tower added to the ducal palace at Dijon by Philip the Good. These high towers dominated the landscape of Burgundy, as they dominated the pictures of Roger van der Weyden. Symbols of the ultimate stronghold, they have haunted dreams from Ezekiel[56] to Keri Hulme.[57]

An eloquent small object demonstrating the part dream-world of Rolin's high tower is the table fountain now in Cleveland. Each castellated stage is stepped back

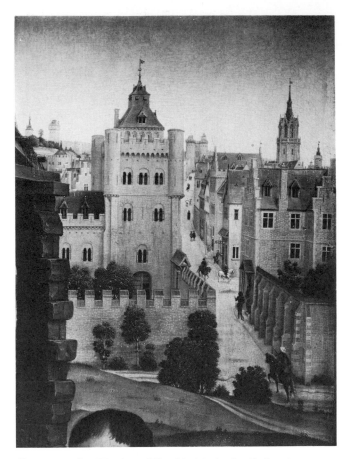

Roger van der Weyden, 'The Nativity': detail showing town street with high towers (Staatliche Museen, Berlin).

*'The Madonna and Chancellor Rolin': detail of the roof garden (*hortus conclusus*).*

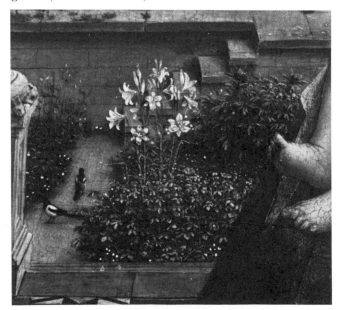

from that below it, and the uppermost deserves the name of gloriette.[58]

The gloriette, *mirador*, prospect room[59] – call it what you will, if placed on *terra firma* within a walled garden looked out upon pleasaunce or pleasure garden. The gloriette in the garden afforded a view of an idyllic immediate setting. The gloriette transposed to the top of a mighty tower afforded a view of a panoramic landscape. But there is evidence that it was on occasion provided with an immediate foreground of plants as well: that in the castle context, the elevated gloriette could be the equivalent of a penthouse flat, with a garden terrace between it and the battlements. The flats of the great keep at Tattershall were originally planted,[60] and on occasion castles in the backgrounds of fifteenth-century paintings show planting on high terraces.[61]

What's going on outside?

This roof garden, planted high above the city, is a particularly secure form of the *Hortus Conclusus*, the enclosed garden, itself an emblem of Mary's virginity.[62] There is no way into this garden except through the tower itself, unless, like Gabriel you are winged. Here flourish flowers which were regarded as specially sacred to Our Lady – the inevitable Madonna Lily, emblem of her purity, which is usually found in a vase in representations of the Annunciation; the purple iris, symbols of her Immaculate Conception, and a low growing red shrub rose. The rose, in its exquisite medieval form, the most symmetrically perfect of all flowers, was first associated with Christ, but from the mid thirteenth century it was absorbed into the iconography of the Virgin. Rather less obvious is the bank of red peonies.[63] Mary was known as 'the rose without a thorn', and medieval roses had thorns. Perhaps van Eyck introduced the nearest equivalent to a thornless rose in his red peony. The blue flower on the other side of the path may be a cornflower or perhaps a columbine. Froissart's *Paradis d'amour* of 1375[64] lists the rose, fleurs de lys, lily, lily of the valley, marigold, peony, violet, columbine (there called angelique), cornflower and daisy. This catalogue probably accounts for everything van Eyck has planted in this paradise. The range of relatively showy garden flowers was not much greater than this in the fifteenth century. Most of them were associated by some ingenious train of thought with the Virgin. Our later flowering garden species were unknown. Under the sun of eternity it was always May or early June in van Eyck's time. If the flowers were restricted, compared with the exotica available today, the visual joys of cultivation included flowering orchards, and were complemented by the cultivation of birds and animals. The rabbits, herons, deer and occasionally bears which inhabit the floriated tapestries

of the fifteenth century did in fact find a protected paradise in the gardens and parks of the courts of Northern Europe. The grounds of Philip the Good's palace in Brussels[65] became a game reserve in 1432. Stags, hares, wild swans and bears were caught and released within it, though we may take it the bears had collars and leads. By 1450 there were two hundred creatures there including lions, and the care of the birds was a duty of the duke's surgeon. In those terms the pair of magpies for joy[66] and the trio of peacocks for immortality, resurrection and sanctification[67] are a minimal enrichment of our patio.

We descended three steps to enter this concealed paradise garden: we climb six to reach the battlements which ensure its seclusion. Something has gone a trifle awry with the scale here, for the two gentlemen on the battlements would have found the steps a formidable obstacle. For that matter the Chancellor's hands are a trifle small for him. These slight discrepancies in a work of such overwhelming conviction remind us that no one had reached such a level of realism before Jan van Eyck, and none of his countrymen were to surpass him in this respect for a couple of centuries.

If van Eyck has hesitated a little with his two figures on the battlements, so must we, for they have yet to be convincingly identified. Their visual purpose, to establish a middle distance, and to draw our attention to the dizzying drop below them, and to what lies beyond that, is fulfilled. But we do not know who they are, or whether they were meant to be anyone in particular at all. There is virtually nothing vague in this picture. It has been suggested that the gentleman in profile is Philip the Good, Duke of Burgundy. We have no certain

portrait of Philip before he adopted the garb of a short black tunic and distinctive hat with liripipe, shown in the Wauquelin miniature and in the official portrait of him by Rogier van der Weyden.[68] It would seem he never sat to his official painter, Jan van Eyck, or if he did, the picture is lost. The essential identification mark, the collar of his own Order of the Golden Fleece, which Philip had founded in 1430, is not clearly indicated, though it is just possible to imagine it is represented here. If his companion, leaning over the parapet is the king of France, Charles VII, as has been suggested, we have no means of telling.

The central problem of this picture is the interpretation of the landscape background, which stretches beyond and beneath this couple.

As they are arranged nowadays in galleries of the same period and school, it is possible to weary of paintings of the Virgin and Child. Whenever the main topic of a Flemish painting of the fifteenth century begins to pall, the appetite can be revived by looking into the background. However repetitive the central scene may seem, Flemish backgrounds are all immediately observed. Each window or doorway opens onto a world before the French Revolution, when cities were small, sparkling and prosperous; when no means of assaulting the eye or ear had yet been invented, when nobody was expected to live in highrise slums, when the air was unpolluted, and the relationship between man and his environment was in balance. Defenders of the concept of progress will think of modern hygiene and modern medicine, but if Chancellor Rolin were to revisit Dijon or Brussels today it is doubtful whether he would admire the changes. Of course there is no disease

'The Madonna and Chancellor Rolin': detail of two figures by the battlements.

'The Madonna and Chancellor Rolin': detail of island and cross on bridge.

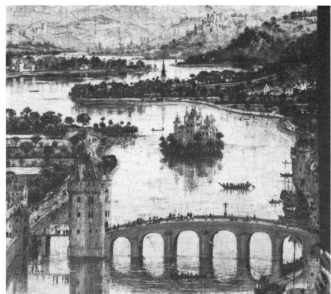

and/or decay in the world as van Eyck painted it, but we are threatened by terrors of our own devising besides which the wars and plagues of the fourteenth and fifteenth centuries were no more than epidemics of the common cold.

Of all the glimpses into the past beauties of a Europe we have done so much to destroy, our painting is one of the most important: and most mysterious. Only in the background of the Adoration of the Lamb in the Ghent Altar, and in the panel of the Three Maries at the Sepulchre[69] do the van Eycks offer comparably important landscapes. These earlier works have a direct bearing upon the problem of what is represented here. The Ghent Altar background must, of its nature, represent the Heavenly Jerusalem. Identification of the actual buildings, prominent among them the Great Tower at Utrecht, is a fascinating exercise. But the enormous octagons springing from the ground on the left hand side must be a reference to a celestial equivalent of the Temple in the earthly Jerusalem. Despite the declaration in the Apocalypse[70] that the Heavenly Jerusalem had no need of a Temple, at least eleven of the buildings in the background of the Ghent Altarpiece Adoration are clearly churches, the two on the right hand side bearing considerable resemblance to the Ottonian Westwerks of Maria Laach and Mainz cathedrals. The background of

the Three Maries at the Sepulchre represents of necessity the earthly Jerusalem. This obligation is honoured by another octagonal building with a dome, the most important structure within this walled city. This representation bears a reasonable relationship with what was then thought in northern Europe to be Solomon's Temple. The omission of a major octagonal building from the background of our painting means that it is very unlikely to have been intended to represent Jerusalem, Earthly or Celestial.

The next question is whether we are intended to be looking at a specific place at all, or just a general idea of a city set in a landscape. If this were an Italian painting of the same date, that would be a valid question. Topographical exactitude was not a feature of the painting of Fra Angelico, for instance, Jan van Eyck's contemporary. But in Flanders a realistic approach to landscape marched hand in hand with portraiture. If Jan van Eyck has presented us with enough information to recreate the crown and orb, to tile the floor or plant the garden, he has also given us enough to draw up the plan of his city with an elevation of its principal buildings. From the orientation of the churches, for instance, we know our high tower is looking to the south west. A careful examination of the north west bank of the city, for instance, as in most European cities the more important

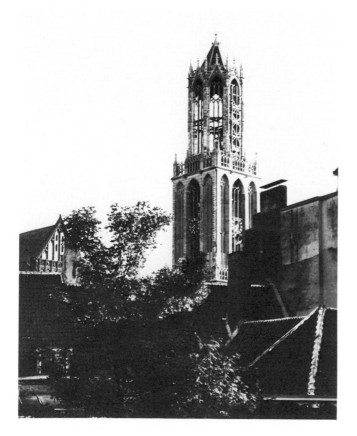

The tower of Utrecht.

'The Madonna and Chancellor Rolin': the tower of Utrecht and Brussels cathedral.

16

of the two banks, shows us that the walls of the city appear to have been over-generously planned. There is room for expansion beyond the cathedral within the walls. Such room for expansion was a deliberate part of city planning in a growth economy. The city walls of Florence, for example, five miles in circumference, as laid out between 1285 and 1340, were not completely filled and overpassed until the nineteenth century.[71]

The roll call of cities, which, by prodigious feats of scholarship, historians have identified with what van Eyck has painted here, is very impressive.[72] Bruges, Brussels, Geneva, La Rede, London, Lyons, Maestricht, Marmande, Namur, Prague, Tarbes, have all had their protagonists.[73] The most favoured of these identifications is Liège, supported by Jean Lejeune, and Joseph Philippe.[74] While applauding the keenness of inquiry which has gone so far to establish the parallels with Liège, we are left, not only with the visual discrepancy of the absence of an important castle on what in Liège is known as the Îlot des Hochets, but with a nagging question: why Liège? The artist is not known to have spent much time there; the sitter had no especially strong connection with the town. Nothing of overwhelming importance happened there in the 1430s. Why Liège? Why not Bruges, if van Eyck was painting the view from his own windows? Why not Brussels or Dijon, the twinned capitals of Burgundy? Why not London, to show how far van Eyck had travelled? In fact, the Cathedral on the north bank bears some considerable resemblance to the Cathedral of St Goudule in Brussels as it is portrayed in the illumination of the *Acts of Margaret of Burgundy*.[75] For that matter the disposition of north bank with a major cathedral and south bank with a subsidiary one, is very true of London and most north European cities.

The immediate setting in which the city is placed is unmistakeably Burgundian. Here are the vine terraces, each with its watch tower, set into the slope of the hills towards the valley, with relatively flat plateau above them, on the south bank wooded, on the north apparently open heathland. The valley bottom on either bank of the river, where not occupied by the city itself, is cultivated in narrow fields. In the neighbourhood of Lyons the sky line is of snow-crested peaks of the Alps, but it is doubtful whether at any one place vine country and an Alpen backdrop can be seen at once. If we remember Jan van Eyck's method of assembling and reassembling studies originally made from the life, it becomes possible that he brought this background together in the manner of a capriccio.[76] The features, individually, were taken from actual buildings, and their relationship was reasonable, as it would be in a capriccio, but they were drawn from a variety of sources. Could there be any reason for such an approach to the background? Van Eyck could have been asked to portray an assembly of the attractions of Burgundy: or he could have been asked to suggest a city he had never actually visited.

This is where we part company with the main stream of Eyckian research, and support the conclusions of Zdislaw Kepinski.[77]

Nicholas Rolin had established his reputation as a peacemaker as early as the spring of 1419, when John the Fearless, father of Philip the Good, was in parley at Meulan with Joan of Arc's Dauphin of France, and Henry V of England. Rolin is recorded to have said that 'the King could well alienate some of his domain and give away part of his kingdom in exchange for so great a benefit as peace',[78] a point equally applicable to the kings of England or France. The Tripartite negotiations broke down on 30 June, but on 13 July a preliminary treaty between Burgundy and the sixteen year old Dauphin was signed at Corbeil. Throughout Rolin's career and beyond, Burgundy was to hold the balance of power between the three nations. If Burgundy sided with France, England could be evicted from the Continent. If Burgundy threw in her lot with the English, France was outmanoeuvred. Burgundy had acquired this position of eminence through the strategic marriage in 1384 of Philip the Bold, grandfather of Rolin's master, Philip the Good, to Margaret, heiress of Flanders. Margaret and Philip the Bold united the rich wine country, approximately the Burgundy of today, with the Netherlands. The French kings had an overmighty brother and cousin: for Burgundy to consider alliance with France's sore enemy, England, was treachery within the family. A conference was arranged for Sunday 10 September, on the bridge at Montereau, then, as now, a relatively unimportant place, but between the two capitals of Paris and Dijon. So small was the trust between the two principals that Jean sans Peur was housed the night before in the fortress on the island in the Yonne, in a position so key to the power-struggle that it was to be besieged in 1420 and 1437. From the isolation of this island a pontoon bridge, intended to be temporary, but in fact surviving for a century, was constructed to the stone bridge spanning the Yonne, and dominated by a Tour du Pont. The bridge at Montereau has now been replaced, but its appearance with the church of Notre Dame on its north bank, is recorded in early nineteenth century views. It seems to have been of great antiquity, probably twelfth century, with rounded arches.[79] The wary precaution of meeting on a bridge was to be used again in 1475 when Louis XI of France and Edward IV of England agreed to a treaty upon the bridge at Picquigny. The device might protect the protagonists from ambush, but it formed at Montereau the perfect situation for treachery from within. With the connivance of the sixteen year old Dauphin, Jean sans Peur was murdered upon the bridge of Montereau upon Sunday, 10 September, 1419.[80] The victim was no stranger to betrayal and murder himself, having inflicted the treatment on the Orleans family. But the outrage of Montereau drove a gulf between France and Burgundy, that was not to be healed for sixteen years. In 1521 a monk of the Chartreuse at

Illumination from Les Grandes Chroniques de France *showing murder of Jean sans Peur, Duke of Burgundy, on the bridge at Montereau (Bibliothèque Nationale, Paris, MS Arsenal 5084, f. 1).*

Champmol, where Jean sans Peur eventually received honourable memorial, showed his damaged skull to Francois I – 'Sire, this is the hole through which the English entered France' – an arguable point, but it was certainly the hole through which they stayed there after the early death of Henry V of England in 1422, throughout the long and disastrous minority of Henry VI. The government of France fell to Henry V's uncle, John, Duke of Bedford. In 1423 Philip the Good, son of John the Fearless, gave to the Duke of Bedford the hand of his sister Anne in marriage. The murder at Montereau had sealed an allegiance between Burgundy and England. The miniature describing this momentous crime in the *Grandes Chroniques*[81] shows the deed taking place on just such a bridge, through just such a Tour du Pont, as van Eyck described in our picture.

In 1435, however, the rift between France and Burgundy was healed for the time being by a stroke of diplomacy that was the crowning achievement of Nicholas Rolin's career. The authorities are agreed that the massive conference – the most fully attended, prolonged, and lavishly entertained of the middle ages – which culminated after a summer of delicate negotiations in the Treaty of Arras, signed on 21 September 1435, was the brain child of Chancellor Rolin. The Duke of Burgundy presided at the banquets, but refused to chair the conference. Nicholas Rolin was host at Arras from 15 July, with a personal bodyguard of thirty-four archers, to eighteen princes, dukes and counts, three cardinals, three archbishops, ten bishops, eighteen abbots, twenty-two knights, the president of the Parliament of Paris, two secretaries of state, eminent members of the University of Paris, and doctors of law. The emperor Sigismund, the kings of Poland, Sicily, Aragon, Navarre and Denmark and the dukes of

Brittany and Milan were represented. Chroniclers suggest that Arras saw a gathering of ten thousand people. The English delegation, which arrived on 25 July, was led by the archbishop of York, the bishops of Norwich and St Davids, the earl of Suffolk and Lord Hungerford, John Popham and a suite of two hundred men. It was fatally weakened by the absence of the duke of Bedford. Philip the Good's brother-in-law was lying sick in Paris. Things might have gone otherwise for the English if it had not been so. As it was the English delegates left in disgust on 6 September, and news of the Duke of Bedford's death reached Arras on the 16th of that month. The marital link was broken. The final treaty was drawn up between France and Burgundy, and sealed by a ceremony in the cathedral of St Vaast in Arras on 21 September. It ran to over thirty clauses, most of them territorial concessions from France to Burgundy, in reparation for the murder of Jean sans Peur. 'The King could well alienate some of his domain and give away part of his kingdom, in exchange for so great a benefit as peace,' as Rolin had said in 1419. Ritualistic requirements for a display of the French king's repentance for the murder at Montereau found expression in several clauses of the treaty. Charles VII was to found a daily requiem mass for the soul of Jean sans Peur in the major church of Notre Dame by the bridge at Montereau; he was to pay for a fitting memorial to Jean sans Peur to lie beside his father in the Carthusian monastery at Champmol,[82] and he was to endow a monastery of Carthusians on the south west bank of the river at Montereau, as near as possible to the bridge. Finally, he was to erect a gold cross upon the bridge at Montereau itself, marking the site of the murder. The arrangement of this cross was to be supervised by the most important papal legate, Cardinal Albergati. Nicholas Albergati is a very sympathetic figure in this story. A Carthusian himself, he had taken the church of the Holy Cross in Jerusalem as his titular church when he became a cardinal in 1426. He had already visited the powers of France, England and Burgundy on a peace mission in 1431. On that occasion he had stayed in the Carthusian house in Bruges between 8 and 11 December. There survives a drawing with colour notes of him by Jan van Eyck[83] and the oil painting worked up from that drawing.[84] Some authorities associate Albergati's sitting to van Eyck with those three days in Bruges. He was fifty-six years old in 1431, and he looks all of that or rather more in van Eyck's portrait of him ('the lips very whitish . . . and the nose rather red . . .' as van Eyck noted on the drawing. He could have added – crowsfeet well developed, neck very creased). It is not impossible that Jan van Eyck took Albergati's likeness during those three crowded days in 1431, but surely much more likely that the sitting took place during the two month conference at Arras. In all that array of attendants Philip the Good brought to Arras – the lords of Brabant, Artois, Flanders, Hainault, the Duke of Guelders and his Nephew of Cleves, not to

mention the ladies, and three hundred archers – Philip must have brought his court painter. There is no record that the requiem mass, or the Carthusian monastery, were actually founded, or the cross erected on the bridge at Montereau. But it is irresistible to conclude that the pledges were recorded in the background of the Rolin Madonna. On the south bank stands the monastery. It has been suggested[85] that the people flocking over the bridge are going to the midday requiem mass in the church of Notre Dame on the north bank. On the crest of the bridge above the almost parallel fingertips of the Blessing Christ and the praying Rolin, is the golden cross to be organised by Cardinal Albergati.

There is no reason to suppose that Jan van Eyck ever visited Montereau, though the larger church in this picture is as like Notre Dame de Montereau as it is like any other possible models. Montereau itself is a relatively flat area with no Burgundian vineyards and no glimpses of the Alps. If this is a fictional Montereau it explains the presence of the tower of Utrecht next to the cathedral of Brussels. However topographically convincing the little city may be, it stands as a landscape of good intentions rather than of realities. It would follow that the picture was commissioned by Chancellor Rolin in the days of euphoria, immediately after the Treaty of Arras. At that concluding ceremony the chronicler

'*The Madonna and Chancellor Rolin*': detail of priory behind Rolin.

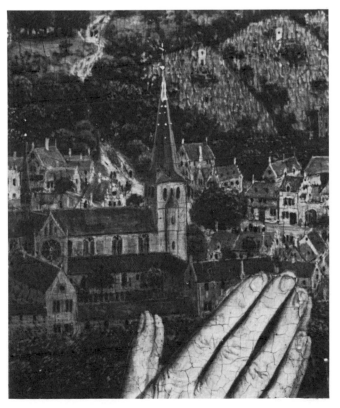

reported that the congregation shouted 'Noel' so loudly that even God could not have made himself heard. This picture can be interpreted as Chancellor Rolin's Noel.

The setting of the Rolin Madonna received the rarest compliment. Like his setting of the Arnolfini family portrait[86] it was copied in this case by two of his contemporaries. Both these adaptations shed light on the original. The more prominent is Roger van der Weyden's panel of 'St Luke Painting the Virgin' now in the Boston Museum of Fine Arts.[87] Rogier became city painter to Brussels in 1436, and probably painted the St Luke for the chapel of the painters guild in Brussels at about that time. He has taken from van Eyck the idea of the secluded room, though it is not set so high above the town and its triple opening onto the *hortus conclusus* is under a flat entablature. The two figures on his battlements are both looking over the view, and one is a woman. They could be Roger van der Weyden and his wife. The prospect at which they gaze, however, has nothing except a river in common with van Eyck's landscape. It appears to be an idyllic view, composed no doubt from a random selection of studies, with the unconvincing cliffs of an untravelled lowlander in the background. There is no island, and no bridge. Roger must have seen van Eyck's painting, but has taken from it only that which was not specific to the agenda of the Rolin Madonna.

The other copy, on the other hand, has repeated with great exactitude just those features which do belong to the Montereau connection, and certainly with intent. The copy of the background from the ramparts into the distance is in the Book of Hours of Jean Dunois, Bastard of Orleans,[88] of 1450, a gentleman for whom the event on the bridge of Montereau wore the colour of Nemesis. This manuscript carries an unusual series of illuminations beside the seven Penitential Psalms. Each is illustrated by one of the Deadly Sins mounted on a beast. The psalm 'which David wrote when he was in despair because he had killed Uriah for the sake of Bathsheba',[89] is illustrated by a man with his head in his hand and his sword under his other arm, riding upon an ass, with the Montereau panorama by van Eyck behind him.[90] This image of despair, regarded as the gravest of medieval sins, could scarcely have a more pointed allusion to Montereau.

What is actually happening?

It would seem that van Eyck has woven a further reference to murder and sin redeemed into the decoration of the chamber in which the Chancellor kneels before the Virgin and Child. The group of historiated capitals over the Chancellor's head shows a sequence of Old Testament subjects. Starting with the expulsion of Adam and Eve from paradise, there follow the sacrifices

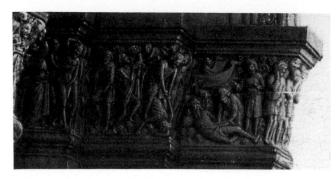

'The Madonna and Chancellor Rolin': detail of capitals above Rolin's head.

of Cain and Abel, and Cain's murder of Abel; followed by Noah's Ark and the drunkenness of Noah. The prominence given to this last subject never ceases to astonish, and we mustn't forget its place on the Sistine Ceiling. The answer lies in the somewhat humourless commentaries, stemming from the Great St Augustine,[91] which saw in the drunken Noah a 'type' or foreshadow of Christ crucified: '. . . he took our flesh and blood of of the vineyard, that is the house of Israel, and was drunk and uncovered, that is, suffered the passion . . . He was uncovered in the midst of his own house[92] . . . an excellent demonstration that he was to suffer death by the hands of his own countrymen, fellows and kinsmen in the flesh . . .' Augustine goes on to praise Shem and Japheth, the sons who covered their father's nakedness, and speaks of this covering as a sacrament. We have, therefore, in these three capitals, the sin of Eve, which was to be redeemed by Mary, the 'second Eve', followed by the fratricide of Cain, and the healing of Noah by his good sons. The cycle is almost a shorthand of the medieval theological method of discovering in the Old Testament parallels, some of them very tortuous, for the events of the New Testament. One more capital, that above the head of the Virgin, is also historiated. The subject here is extremely hard to decipher, but van Eyck used the same design for a capital in his 'Madonna with the Canon van der Paele'. There it is the only historiated capital behind the canon's patron, the Bishop St Donatian. Behind St George on the other side of the Virgin's throne is a historiated capital of a knight on horseback in battle, suitable to the 'Knight of Christ'. In the context of the Canon van der Paele, it is likely that the capital behind Donatian refers to the reference, also favoured by St Augustine, 'you are a priest for ever, after the order of Melchizedek', quoted in Hebrews 7, 1–17. Melchizedek, king and priest, brought bread and wine to Abraham returning in triumph and blessed him: 'Blessed be Abraham by God most High maker of heaven and earth; and Blessed be God Most High, who has delivered your enemies into your hand.' An appropriate gloss for the Christ Child, as he blesses the architect of the Peace of Arras.[93]

The remaining capitals are essays in the foliate forms of Romanesque decoration in the Low Countries, as are most capitals in Jan van Eyck's paintings. Among those surviving, the several cycles in the twelfth century churches in Maastricht are closest to van Eyck's work. These deliberate quotations from local antiquities find their most striking example in the actual book lying on the blue figured velvet of the Chancellor's *prie dieu*. With the book we come to the last question posed by the picture.

In the blessing of Abraham by Melchizedek we may be overhearing the intent of the Christ Child's blessing of Nicholas Rolin. The Chancellor himself is frozen in a perpetual prayer which thanks to the open book, we can even read. The mould in which the prayer life of the literate laity was cast in the later middle ages, was usually held within the fairly diminutive covers of the Book of Hours.[94] The great missals, bibles and psalters of the earlier Gothic period, like the cathedrals, already existed. The more intimate devotion that required a small oratory such as this exalted room, in which the Chancellor has received his private vision, called also for the production of liturgical books of prayer, each one made for a single person's prayer life. As we have seen, the art of the van Eycks springs from the production of such exquisite books. However, and this is really strange, nowhere in all his surviving oeuvre, does either van Eyck show, in a painting, a manuscript of the type they had themselves illuminated. On the contrary, of the at least eleven manuscripts held in the hands or placed on the shelves of pictures associated with the van Eycks, none look as if they were contemporary. Some are arranged in double columns, which are relatively rare, except for the litany, in the smaller format of books of his time. None are illuminated with more than the occasional embellished letter, which itself tends to be of Lombardic form. Indeed, this sparing ornamentation recalls the same visual ambience as the capitals – the initials could be from the twelfth century. The life-time of Jan van Eyck was the first period since late classical antiquity that identified and cherished 'antiques'. When Henry V of England wished to give a precious

'The Madonna and Chancellor Rolin': detail of Rolin's prayer book.

cope to his Bridgettine Convent at Syon, which he founded in 1414–15, he did not get one made: he gave them the famous Syon Cope, then already a century old.[95] While van Eyck was studying Romanesque capitals, Brunelleschi was sketching classical antiquities in Rome.

Comparison suggests that Jan van Eyck used relatively few models for his manuscripts. The pattern on the gilt fore-edges of Nicholas Rolin's Book of Hours is similar to that on the book lying on the shelf behind the Virgin of the Annunciation in the Ghent Altarpiece, and the book held by the Baptist within the same picture. If the manuscripts shown in van Eyck's paintings are restricted in variety, he only offers one design of bookmarker.[96] The system was to insert an ornamental metal rod called a *pippe*, into the binding of the manuscript, from which the bookmarkers or *signaux* were themselves suspended. There are at least four *pippes* in other paintings associated with van Eyck, all exactly the same pearl-studded articles as this one. Not all *pippes* can have been identical. Perhaps van Eyck had one, and used it as a model every time. Rolin's Book of Hours was protected by a red silk chemisette, opened out upon the blue cushion of his *prie dieu*. From his *pippe* four bookmarks indicate different places, suggesting an ambitious programme of prayer. Although his book is open half-way through, he is at the beginning of the day's prayer, the Office of Matins. The front of the book was occupied by the Calendar of Feast Days, a series of four short excerpts from the four evangelists, and two formal prayers to Our Lady. To recite the whole cycle of the Offices, even in the abbreviated form of the lay book of Hours, would have taken between one and two hours. Rolin probably preferred to start the day with Matins, and then he might dip into the Penitential Psalms and perhaps use one or two of the special prayers to favourite saints which he would have found towards the back of his Book of Hours. Rolin has opened his manuscript at the first office of the day, which begins as does Matins to this day, with the phrase – 'Domine Labia Mea Aperies . . . Lord open thou my lips'. We can just make out the D for Domine in Rolin's book. Van Eyck might say that he had dispensed with a miniature of the donor kneeling before Our Lady at this point in the book, because that is the all enveloping theme of the whole picture. We know not only that Chancellor Rolin is reciting his Little Office of the Blessed Virgin, we even know that his praises have reached her. Specific passages, derived from the Office of Matins have been quoted as embroideries around the hem of her robe.[97] 'Thou whose glory above the heavens is chanted by the mouths of babes and infants' (Psalm 8). 'And so I was established in Sion and in the beloved city likewise he gave me a resting place, and in Jerusalem was my dominion. So I took root in an honoured people, in the portion of the Lord, who is their inheritance. . . . Like a cedar I am exalted in Lebanon, and like a cyprus on the heights of Herman. I

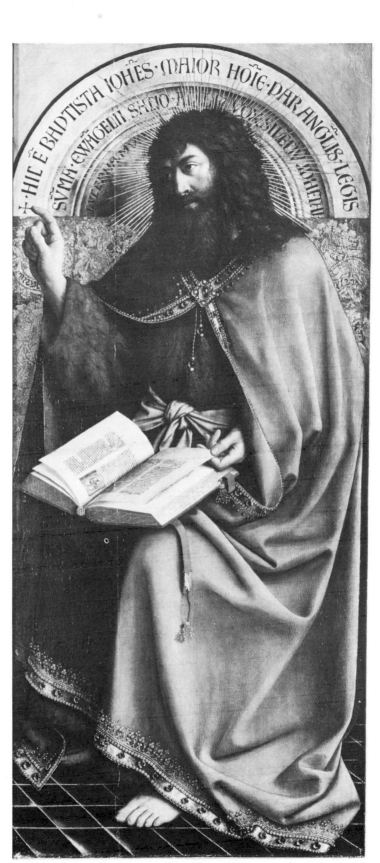

Hubert and Jan van Eyck, 'The Ghent Altarpiece': detail showing book in hand of John the Baptist.

21

grew tall like a palm tree in Engedi and like rose plants in Jericho; like a beautiful olive tree in the field, and like a plane tree I grew tall. . . .' Ecclesiasticus 24, vv.11–19.

To which the responsory replies: 'Happy art thou, Holy Virgin Mary, and worthy of all praise, for out of thee is sprung the sun of justice, Christ our God.'

The road whereby the beautiful and feminine figure of Wisdom in the Book of Proverbs and in the Book of Ecclesiasticus, becomes identified with the Virgin Mary is a complex and ancient one. In as much as Christ was deeply versed in the Jewish Holy Books, it might be reasonable to assume he alluded to Wisdom under the term Pneuma, which is feminine, or Paraclesis, which is neutral, the only words which have come down to us as purporting to be from his lips and describing the Holy Spirit. However, in those pre-Trinitarian days the opening of the Gospel of St John annexed the concept of Wisdom, of the Word, and applied it to Christ himself, and not the Holy Spirit. Passage after passage of the Book of Proverbs yearns to be identified with Christ's image of the Holy Spirit:

> For wisdom is more mobile than any motion;
> Because of her pureness she pervades all things
> For she is a breath of the power of God
> And a pure emanation of the glory of the Almighty. . . .
> Though she is but one, she can do all things,
> And while remaining in herself she renews all things;
> In every generation she passes into holy souls,
> And makes them friends of God and prophets. . . .
> (Proverbs 7, vv.24–27)

> The wind blows where it wills, and you hear the sound of it, but you do not know whence it comes or whither it goes; so it is with everyone who is born of the Spirit. . . .
> (John 3, v.8)

But the identification cannot be made, for the feminine principle is debarred from the Trinity. So, from the early Fathers, passages of the Wisdom literature were apportioned out between Christ and His Mother, Theotokos, Mother of God, as she was already defined by the Council of Ephesus in 431 AD. She could not be Wisdom – that was her Son; but she could be, as we have already seen, the seat of wisdom, or the mediatrix of wisdom. In that role she presided over the council chamber of the Religious – the chapter house – the council chambers of the citizenry – the Palazzo Pubblico in Siena – and the councils of heads of state.

So it is inevitable that Chancellor Rolin should come to the Virgin to render his gratitude to her for having allowed him, on 21 September 1435, to heal the breach between France and Burgundy. Through the Cross of her Son, the bridge of treason was transformed into the

The Breviary of Philip the Good: *miniature showing the duke kneeling before St Andrew (Bibliothèque Royale Albert Ier, Brussels, MS 9511, f. 398).*

bridge of reconciliation and the sun of justice shines once more over the united countries. The Little Office of the Virgin was usually illuminated with a series of miniatures of the birth of Christ. The treaty of Arras was Nicholas Rolin's Christmas. The full monastic offices, through which the religious of the middle ages recited or sang the cycle of psalms and the whole of the Bible over a stated period are the most rich and complex prayer-wheel; the *Opus Dei* of the Dominicans. Even the abbreviated form used by Nicholas Rolin and others 'in the world', was the mould of their spiritual experience. Among the writers on the spiritual life who most eloquently praised the faithful adherence to the offices, and in particular to the offices of Matins and Lauds, that should be recited during the night was Honorius of Autun, whose works must have been familiar to Rolin's spiritual supporters, the canons of Notre Dame du Chastel, in Autun.[98] Honorius compares the night office with labour in the vineyard, and the night watch with 'the watches, kept in supernal Cities, namely in the Heavenly Jerusalem . . . the watchtower in Sion represents the Church in the World

. . .' And again he used the familiar association of the Virgin with the imagery of a tower, in which she is raised above the city. As the office says of her, she was 'established in Sion and in the beloved city.'

The high tower in which van Eyck has placed the Chancellor is therefore of itself proper to the Virgin. And in Honorius' analogy between the office of matins and the vineyard, an analogy, for all its Biblical sources, particularly vivid for Burgundians, we have perhaps the reason why Montereau, in disregard for topographical accuracy, is set among the vineyards, each with its watchtower. Rolin, in the watchtower of Our Lady, is keeping guard over his world, good steward of vines both earthly and heavenly.

Pie-crust politics soon took Nicholas Rolin down again into the streets of negotiation. But it was this moment of gratitude above a high tower in the mirador or gloriette of Mount Sion, not quite of earth nor yet quite of heaven, when it seemed the Virgin and her Son had blessed his endeavours with the gift of peace, that Nicholas Rolin asked van Eyck to record for him, and for all time.

Chapter 3

St George and the Dragon
by Paolo Uccello

In 1959, by the courageous decision of the Director, Sir Philip Hendy, the National Gallery in London, acquired a small picture with a relatively short pedigree,[1] no earlier documentation and painted upon canvas, a support rarely used before 1500. All the credentials of Uccello's St George are worn upon its sleeve: its passport is its appearance, and on that passport it has found an enthusiastic and affectionate welcome among the British public. Even the attribution to Paolo Uccello (1397–1475) has seldom been challenged.[2] By any other name, you might say, the picture would smell as sweet. But Uccello's version of 'St George and the Dragon' is a very odd painting of profound originality which could only have been executed by someone who was not content to supply the standard article. It is for his originality that Uccello is most highly praised today. It was in those commissions where he had a chance, or made one, to do his own thing that Uccello was most happy. Indeed his tendency to use his official undertakings to convey what interested him rather than what his patrons cared about, probably accounts for the striking fact that he is more valued now than he was in fifteenth-century Florence.[3] For Uccello's problems with his contemporaries there is not only the evidence of the breaking of the contract for the altar-piece of the Blessed Sacrament for the Church of Corpus Domini at Urbino,[4] but also the story of Donatello's criticism of Uccello's lost fresco of St Thomas.[5]

The legend of St George, of course, hardly needs retelling. A dragon lived in a great lake outside a city which he threatened to destroy with his foul breath, unless he received a daily supply of two sheep. After a while the sheep ran out, and the dragon demanded two children a day instead. Eventually just one child remained: the king's only offspring, his beloved daughter. So the young princess was left outside the city, alone and palely loitering, to await her fate. But before the dragon could consume her, St George arrived to slay the beast and save both princess and city.

The difference between Uccello's treatment of the story of St George and the standard formula can be measured, almost as with a ruler, by comparing our picture with the panel of St George in the Jacquemart-André Collection in Paris,[6] attributed variously to the school of Uccello or to the artist himself. The existence of two renderings of the same subject, both associated with Uccello, both painted to roughly the same size[7] and with similarly short histories,[8] provides the art historical equivalent of a control in a scientific experiment. The basic ingredients of St George on a white horse, dragon, cave and princess to be rescued, are found in both paintings. But, by its very pedestrianism, the Paris version throws into relief the remarkable features of the London painting. The Paris panel, be it understood, is quite up to the required standard for a piece of Florentine furniture painting of the mid-fifteeenth century, as it is sometimes suggested to be. But the London one is something more. All the ingredients of the Paris version can be found in other pictures by Uccello and his predecessors.[9] It presents, in the clearest and most straightforward way, the central incident in the encounter of St George with the Dragon.[10] When the features common to both versions have been accounted for, the additions – and omissions – in the London version are the measure of its strangeness. Our painting *omits* any identifying emblems of St George; the conventional landscape; the king and queen who should be observing events from, or near, the threatened city, which itself is set so far in the distance as to be virtually invisible. The painting *adds* an earlier incident in the story in which the princess sets her girdle, like a lead, around the dragon's neck; a strikingly disposed foreground; a wood behind St George; a spiral cloud; a pool of water at the back of the cave; and the slaying of the dragon in an unusual manner, through the eye, not the mouth and throat.

None of these departures from the norm typified by the Paris St George, can be explained by examination of

25

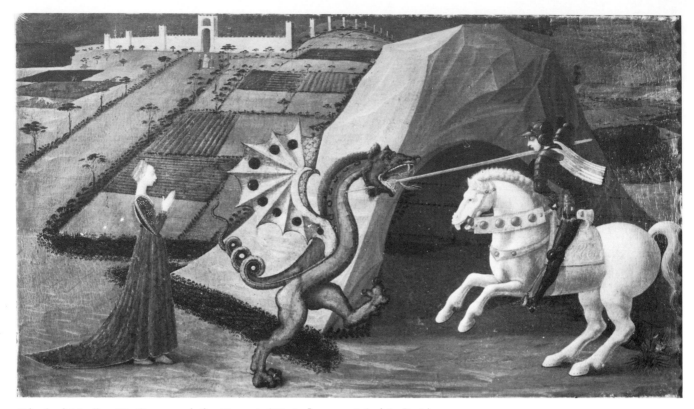

School of Uccello, 'St George and the Dragon' (Musée Jacquemart-André, Paris).

the then popular text of the *Golden Legend*, with the exception of the girdle incident which is reported there.[11] In one of the two variations on the theme of St George's defeat of the dragon which is given in that work, St George, having stunned the dragon, persuaded the princess to slip her girdle round the dragon's neck and lead the subdued beast to the city where he was formally slain before the admiring company. The dragon in Uccello's London picture cannot be expected to survive the blow which it is receiving from St George's lance, so by including the slaying and the girdle incident within one scene, Uccello has telescoped the narrative. The same motif, an obvious reference to the powers of purity or virginity, reappears in the legend of the French St Romain, who took two companions with him to the forest in search of a dragon, which was captured with the help of St Romain's girdle. It was led in procession to the market place at Rouen and there burned.[12] The girdle incident is also included in the cycle of images illustrating the legends of St George in the major altar-piece, ascribed to Marzial de Sas (active 1393–1410), in the Victoria and Albert Museum. There it is properly presented with a stunned, but not mortally injured, dragon submitting to the girdle while the townsfolk watch from the walls of the city. There are a few other representations where the girdle features, but most of them appear to have been painted after 1500. It is possible that the actual garter of

the English Order of that name refers in reality not to the hose of the lady of the court of Edward III, but to her girdle.[13] Relatively little is known about medieval underwear, but it is well established (there having been no elastic) that garments were joined to one another by tie-strings and not by belts with buckles. It is unlikely that a lady would have held up her stocking with a belt – it would have impaired her circulation. It follows that the belt the Countess of Salisbury dropped, and Edward III gallantly strapped on his leg, fell from her waist and not her thigh. 'Honi soit qui mal y pense' is even more appropriate in this context since the loosening of the girdle was an eloquent symbol of lost virginity.

Apart from its unconventional iconography, Uccello's painting of 'St George and the Dragon' is also unusual in its use of canvas as the support at such an early date. This problem was addressssed by Norman Bromelle when the National Gallery bought the picture.[14] He quoted Cennino Cenini, whose treatise on painting, *Il Libro dell Arte*, was written about 1390, as advocating painting banners on cloth in a technique that he claimed would withstand the rain. A roughly contemporary banner of comparable size in the Society of Antiquaries carries the figures of St Martin and the Beggar on both sides, that on the reverse being painted in mirror image. All surviving medieval banners are painted on both sides. Our painting, however, is not, and so cannot have been a banner. Bromelle further quoted the record

in the 1492 inventory of the Palazzo Medici in Florence which describes two paintings on canvas of lions and dragons fighting. They hung in the great chamber on the ground floor with the surviving paintings of 'The Rout of San Romano', all by Uccello. Other canvasses were also mentioned in the inventory. Bromelle also cited the mid-fifteenth Flemish painting in the National Gallery of 'The Entombment' by Dieric Bouts.[15] The Bellinis and Mantegna, as well as Botticelli and the Pollaioulo brothers, also used canvas. However, the rarity of canvas before the 1480s is an argument in favour of dating this picture towards the end of Uccello's life. All surviving paintings recognised as being part of *cassone* – marriage chests – are on wood, so it is unlikely that our painting came from the side of a *cassone*. Nevertheless, a phrase of Vasari's in his life of Uccello[16] reminds us that there were alternative contexts: 'In many Florentine houses can be found a number of pictures by Uccello, all of them small, painted in perspective to decorate the sides of couches, beds and so forth . . .' But before we conclude that either this or the Paris St George were indeed set into furnishings, we should remember that furniture was usually adorned with mythological or allegorical subjects. Religious paintings were commissioned as objects of devotion and accorded more respect.

St George was one of the most popular of the saints. Uccello would have been surrounded, both in Florence and Venice, by representations of his encounter with the dragon. A relic of the arm of St George, still in the treasury of San Marco in Venice, is richly encased in enamels and crowned with a gold miniature of St George and the dragon. St George has been replaced, but the dragon, which is very similar to ours, is the one Uccello would have known. In Florence, Donatello had begun work in 1415 on his great sculpture of St George for the Guild of Armourers and Swordsmiths – the armoured soldier of Christ was their patron. Beneath the figure of St George, a relief of his battle with the dragon, executed about 1417, is the first definite landmark in the use of single vanishing point perspective. Uccello, fascinated by perspective, must have not only known, but studied, this relief. It may well have been a member of the same Guild of Armourers that later commissioned Uccello's own version of St George and the dragon. The mystery lies not in its commission, but in its interpretation. And the key to this lies, in its turn, in the uncanny popularity of St George in the middle ages – a popularity which was out of all proportion to what we know of his life.

We have sound evidence that George was among the company of third – and fourth-century martyrs 'whose memories will always remain green' within the church, but of whom we know little more than the fact of their martyrdom. The striking difference is that George's memory is much greener than that of any other.[17] What is now remembered of St Polycarp, or St Ignatius of Antioch, both of them earlier martyrs than George? The records of these early heroes of Christianity were preserved in books of the *Acts of the Martyrs* of which the first examples are from the fourth century. Canonisation did not become a legal formula until the twelfth century: earlier saints were just accepted as such. In the year 495, Pope Gelasius mentions George in a list of those whose names are 'justly reverenced among men, but whose acts are known only to God.'[18] George's martyrdom is thought to have taken place at Lydda in Palestine, but it is claimed that he was born in Cappadocia where many of the strange rock-cave churches are painted with his image. In Cappadocia they say he was a bishop who was torn to pieces by the mob. On balance, however, it is more likely that he was a soldier who, to cite the hymn of Prudentius, was one of those who had abandoned 'the banners of war to die under Christ's banner of the Cross'. Prudentius compared the wind-sock dragon banners carried by the Roman Army with the dragon of the Crucifixion, a parallel based on comparing the Cross with the brazen dragon held aloft by Moses to heal his people in the wilderness.[19] Fifth-century bishops referred allegorically to the acceptance of martyrdom as the slaying of the dragon. By such a roundabout way, George came to be associated with his dragon. St George was known to Bede,[20] but his entanglement with the dragon was already at least two hundred years old by then.

It is generally assumed that George's involvement with the dragon is due to the fusion of Christian and Greek imagery, in that he seems to have taken on the role of Perseus who rescued Andromeda from the sea monster.[21] The myth of Perseus is associated with Joppa, which is not very far from Lydda, where George was martyred. For that matter, George's story may have been modelled on Gushtasp, the legendary Persian king who slew a dragon and was recorded to have done so in a poem of 1010.[22] Christianity is not the only religion to have borrowed imagery from other cultures. The Islamic forces whom the Crusaders encountered in the late eleventh century in the Holy Land, had themselves absorbed the ancient Persian Empire.

The Crusades mark George's arrival as a major Christian saint in the west. Returning Crusaders reported that he had appeared to them at the siege of Antioch and spurred them on to victory: thereby ratifying not only the Crusades in particular, but the concept of war as a Christian activity in general – a matter in which the principles of Mahomet have over-ridden those of Christ from that day to this. The possibility of divine intervention in battle had always been present in the Jewish faith.[23] Naturally George, so valuable an ally in war, came to be the patron saint of several European cities, including Venice, and of England since 1222. He presided over the Order of the Garter, established in 1348, but only became a major saint in England after he had again appeared to English soldiers at the battle of Agincourt in 1415. His most recently recorded appearance was during the German invasion of Greece in the

Second World War. No wonder he is the patron saint not only of England, but of Portugal, Greece and Aragon.

But his association with the dragon cannot be the whole reason for George's popularity. Other Christian saints have their dragons too: St John of Reims, St Cyriacus, Longinus and Servatius, St Theodore and St Germanicus of Auxerre, as well as St Romain and St Margaret of Antioch. Of that company, only St Margaret became as popular in the middle ages, on account of her efficiency in helping women in childbirth – Margaret was swallowed by a dragon and escaped by splitting open the beast's belly. All these saints and their dragons had been foreshadowed by the Archangel Michael, whose primeval victory over the Devil in the form of a dragon is celebrated in the Book of Revelations.[24] The connection between the Devil and the dragon was well recognised by medieval bestiaries.[25] St Michael, vicegerent of God, never completely lost his association with the dragon during the middle ages, but he did take on another role as the bearer of the scales at the Last Judgement, and tended to delegate dragon responsibilities to St George.

Every ancient mythology has its dragon. In most of them, the dragon personifies the principle of evil, darkness or chaos. (The exception is the Chinese dragon which is the beneficent bringer of rain.) The dragon is the most powerful of the mythological beasts. As Herodotus said, on the threshold of history: 'myths are things that never happen but always are'.[26] The roots of the struggle between the hero and his dragon lie deeper

Babylonian seal showing Marduk defeating Tiamat (British Museum).

than the stories of Perseus or Jason, Apollo or Gushtasp. They begin in the creation myths of every civilisation. The fundamental difference between mythologies of creation and the modern approach to the origin of the universe, is not how long it took, or in what order events occurred, but whether we consider the act of creation to be the arrival of the raw materials or the bringing of order out of chaos.[27] Hesiod said 'chaos first came into being, and thereafter earth, and love'.[28] The classic view was expressed within the ancient formula of the Four Elements by Thomas Hayward in his *Troia Britanica* of 1609:[29]

> (canto 1)
> This universe with all therein conteined,
> Was not at first of Water fashioned,
> Nor of the Fire, as others oft have feyned,
> Nor of the Ayre, as some have vainly spread,
> Nor the foure Elements in order trained,
> Nor of Vacuity and Atom's bred,
> Nor has it been Eternall (as is thought
> By naturall men that hath no further thought,)
> But this most glorious Universe was made
> Of nothing by the great Creator's will,
> The ocean bounded in, not to invade
> Or swallow up the land, so resteth still,
> The azure Firmament, to over shade
> Both Continent and Waters which fulfil
> The maker's word. . . .

'The ocean bounded in, not to invade or swallow up the land'. This is the hub of the matter. A diagram of the Cosmos, based on Hebraic and Hebraic-derived Christian sources,[30] provides a key to understanding the 38th chapter of Job, for example, verse 8: 'who shut up the sea with doors, when it brake forth, as if it had issued out of the womb'. The close links between the imagery

Schematic representation of the ancient world picture (derived from N. M. Sarna, Understanding Genesis, New York 1966).

28

of the Old Testament and even more ancient Mesopotamian material has long been recognised.[31] The element of Jewish creation mythology presenting a primeval water chaos goes back to Sumerian and Babylonian sources. The most famous of these is the 'Enuma Elish', in which the Babylonian storm-god, Marduk, defeats the monster, Tiamat. He creates the universe by splitting the corpse of Tiamat in two, setting up one part as the firmament to hold back the waters above, and the other part as the earth to hold in place the waters beneath. This account of creation is reflected in Psalm 74, verses 12–15: 'for God is my king of old, working salvation in the midst of the earth. Thou didst divide the sea by thy strength, thou brakest in pieces the heads of the dragons in the waters. Thou brakest the heads of Leviathan in pieces . . . Thou didst cleave the fountain and flood . . .' In the earliest Egyptian myth, the sun-god, Atum-Re, rises out of Nun, the original ocean and, having risen, controls it.[32]

It is the responsibility for this controlling of the primeval waters by the slaying of the Dragon of Chaos which is handed down from the Creator through a host of mythological gods and heroes to our St George. The dragon of chaos must still be kept at bay lest the waters above and beneath should overwhelm us again. In mythological terms, then, there is a clear connection between dragon-slaying heroes and the cataclysm of the Deluge. The Deluge was, in fact, the subject of a fresco by Uccello in the Chiostro Verde of Santa Maria Novella. Here, as in our painting of 'St George and the Dragon', Uccello telescopes more than one episode into a single scene, conjuring up a strange, enigmatic atmosphere and setting riddles for the art historian.[33]

There are several features of Uccello's 'St George and the Dragon' which suggest that either the artist or his patron were not unaware of the archetypal nature of the story with which he was dealing. There is the introduction, albeit very discreetly, of the element of water, the natural habitat of the Dragon of Chaos. It appears at the back of the cave, which becomes an opening to the watery underworld. Such an introduction is virtually unknown in fifteenth-century Italian interpretations of the, by then, totally westernised imagery of St George.

Then there is the striking omission of St George's usual insignia: his famous red cross on a white ground. It does not appear as a pennon on his lance, on a surcoat, on the horse trappings, or in any of the several other ways in which Uccello could have introduced it. This omission seems to evoke, quite deliberately, overtones of the wider identification of the dragon-slayer already discussed.

A prominent feature of the painting, but one which is usually ignored because of its inconvenient peculiarity, is the spiral cloud in the sky behind St George. This cloud formation is not at all incongruous, however, if interpreted once again in the light of the legacy of creation myths. In the Old Testament, we hear that God 'rideth upon the heavens' (Psalm 84, verse 4) – an image which is taken up in Deuteronomy (chapter 33, verse 26) and in Isaiah, chapter 19: 'Behold the Lord rideth upon a swift cloud'. Like his Mesopotamian predecessors,[34] Yahweh was a storm-god, 'who maketh the clouds his chariot' (Psalm 104, verse 3). The Babylonian god, Marduk, also rode upon the wind. 'When Tiamat opened up her mouth to consume him, he drove in the

Paolo Uccello, 'Noah and the Flood', fresco from S. Maria Novella, Florence.

29

'St George and the Dragon': detail of St George, including spiral cloud.

evil wind and then she closed not her lips'. The imagery of the spiral cloud, therefore, is quite proper to George as a descendant of the storm-gods. The study of meteorological phenomena was something quite new and fascinating to artists of Uccello's day. We know that Gentile da Fabriano, who was working in the Ducal Palace in Venice from 1408 until 1421 or 1422, painted a whirlwind. It was praised by Barthomaeus Facius in his *De Viris Illustribus*, published in 1456.[35] Visually, Uccello's whirlwind may be a tribute to his memory of Gentile da Fabriano's lost fresco: iconographically, it sets the tone for a 'cosmic' reading of the story of St George and the Dragon.

Even the method of slaying the dragon persuades us that Uccello is drawing on sources, even if second-hand, that go beyond the orthodox interpretation of the legend. The dragon is usually slain by a lance through the mouth and neck: here he is pierced gruesomely through the eye. This means of killing the dragon is found in a modern Coptic Arabic poem, but one based on extremely ancient sources.[36] The Copts still celebrate the rising of the Nile by trailing a mummified hand of a female virgin saint in the water. This ritual is thought to be the last vestige of a pre-Christian custom of drowning a virgin to encourage the Nile to rise[37] and make the land fertile, which brings us to our princess and her role in the story.

For one who has narrowly escaped being torn apart and devoured by a hungry dragon, the princess appears remarkably calm. Her role in initially subduing the dragon has already been mentioned and now, with the dragon as her captive, she has the air of officiating over its ritual execution. In Egypt, there is a nature myth explaining the daily cycle of the sun in which the sun-god must defeat a serpent that tries to prevent the

dawn each morning. The goddess Isis holds the serpent, Apopi, on a chain, just as our princess holds the dragon on her girdle, while the sun-god, Osiris, delivers the fatal thrust that defeats the serpent and allows the sun to rise again.[38] There is more to be found in the connection between these two couples: George with his princess, and Isis with her brother and husband, Osiris. Osiris was a vegetation-god. In his mythology he was killed by his brother, Seth, shut up in a chest and thrown into the Nile. His wife, Isis, recovered the chest but Seth took it from her, took out the corpse, cut it to pieces and scattered them throughout Egypt. Isis gathered together all the pieces of Osiris' body and restored him to life, after which he became the king of the place of departed spirits. This story has a striking parallel in the Coptic legend of St George. While in prison for refusing to sacrifice to Apollo, George was told by God that he would suffer for seven years and be killed three times over. George's first martyrdom is of special interest in our context: his body was cut to pieces and scattered across the land. The pieces were reassembled by the Archangel Michael, and the Saint brought back to life by God himself.[39] This dismembering and resurrection seems to be a standard motif in the mythology of vegetation-gods. The Arab writer Ibn Wahshiya Al Kasdani, who translated *The Book of Nabatean Agriculture* around 900 AD, identified 'the legend of St George which is current among Christians' with Tammuz.[40] Moslems further identified George with the great prophet, Khidr, whose feast day falls on 23 April – St George's day.[41] Khidr is a green man who leaves a green footprint wherever he treads. In Greek, George's name actually means earth-worker, or farmer. Uccello's painting shows St George emerging not only from the spiral cloud, but also through the greenwood. The famous *Golden Bough* by J. G. Fraser gives several circumstantial accounts[42] of rituals associated with the green man or vegetation spirit. Ceremonies performed by the Slavs of Corinthia included a song:

> Green George we bring,
> Green George we accompany,
> May he feed our herds well,
> If not, to the water with him.

Folklore material has an unnerving knack of transcending both time and culture.[43] We find just the same fate awaiting the Padstow Hobby Horse in Cornwall today. In this annual ritual, the Padstow 'day' song makes a similar identification with St George:

Awake St George our English Knight O,
For summer is acome O and winter is ago,
And every day God give us his grace,
By day and by night O.

Where is St George, where is he O?
He is out in his long boat all on the salt sea O,
And in every land O, the land that ere we go.

It is our view, with deference to Violet Alford,[44] that such hobby horses as that at Padstow are misunderstood relics of what once represented St George upon his horse. The survival throughout Europe, from the middle ages and beyond, of hobby horses is remarkably extensive. The persistent popularity of mock tournaments and processions including men caparisoned as if on horseback, is fully attested by Violet Alford, but she might have been very interested in a painting of a tournament at Nuremberg in 1561,[45] showing a number of mounted horsemen which are obviously hobby horses, each led by a jester or wiffler, sometimes by two. Hobby horses have always carried implications of fertility, which is not surprising when we remember that the Green George was a fertility figure. St George in his 'green aspect' represents the return of the sun, of light, of the wind – and of life. The Mummers' Play is the *pièce de résistance* of this thread of Georgian material, and the boast of George from a well-attested version belongs here:[46]

I am King George from old England I spring,
My famous name throughout the world doth ring,
And many deed and wonders have I made known.
 . . .

'Twas I that fought the fiery Dragon and brought
 it to the slaughter,
And by those means I won the King of Egypt's
 daughter.

This text comes from Syresham in Northamptonshire and was recorded in 1881. In other versions, the 'King of Egypt's daughter' is known as Sabra. Curiously enough, the central dramatic action of virtually all the Mummers' Plays is not that of the slaying of the dragon, which has already taken place, but of George's resurrection at the hands of the mysterious Doctor. This seems to refer closely to the multiple martydoms of St George in Cappadocia,[47] the Doctor appearing as an updated St Michael. The association of this magical St George with

Joost Amman, 'The Joust of the sons of the City Patricians at Nuremburg, March 3, 1560' (Nationalmuseum, Munich).

Egypt seems never to have been lost. It occurs again in Richard Johnson's *Famous History of the Seven Champions of Christendom*,[48] in which St George goes to Egypt to kill his dragon and win the hand of Sabra.

Uccello could not have learnt anything of these associations from official Christian sources. Then as now, they were the province of carnival characters whose play-acting, be it Padstow Hobby Horse or Mummers' Play, relives the primitive rituals of death and rebirth. In the Norwich Castle Museum there hangs 'Snap', the last surviving windsock dragon banner of the type referred to as early as the fifth century in the hymn of Prudentius. Snap himself was only made in 1795, but he was the last in a long procession of such dragons going back to the foundation of the Guild of St George in 1389.[49] In 1408 it was resolved that 'the George should go in procession and make conflict with the dragon'. The combat must have been rough, for not only did Snap need frequent repairs, but George's cloak was often replaced too. The bill for a new cloak in 1492 specifies that it was to be made of no less than twelve yards of satin at the great cost of four pounds. And the colour was to be – green.

At the entrance to a dragon's lair you might expect to find the ground scorched and littered with bones. But not in Uccello's painting of the scene. Instead of burnt earth we have a mysterious parterre garden, low-growing plants set out between a geometrical arrangement of narrow paths. A close comparison is to be found in the foreground of the Crucifixion panel, by one of Uccello's followers, in the Thyssen-Bornemisza Collection at Lugano.[50] Both paintings are scenes of death, and in both the pattern of the ground gives the impression of being part of a larger design of which we could make sense if only we could see more. The layout of the parterre in our picture resembles nothing so much as the heart of a labyrinth. Despite the stress of the moment, everyone in the picture keeps carefully to the

Coin from Knossos showing labyrinth (British Museum).

path.[51] But were such patterns known in fifteenth-century Florence? Cretan mazes are frequently found on ancient coins and gemstones, which were avidly collected by such connoisseurs as Uccello's patron, Cosimo de'Medici.[52] Uccello had worked from 1425 till 1430 in Venice, always the gateway to Greece, and beyond to the Levant. There was an established Greek colony in Venice before the fifteenth century, and Uccello had worked, in part at least, as a mosaicist. Mosaic technique was dependent, at that date, upon Greek craftsmen. In 1539, they were to contribute to their special church of San Giorgio dei Greci, George being as much patron saint of Greece as he is of England. The collapse of the Greek Empire and the arrival of the Greek emperor in Florence, in 1451, must have caused a major influx of Greek influence, bringing with it, perhaps, many of the pagan resonances we have discovered in Uccello's painting. There had also been earlier individual contacts. The French Seigneur de Caumont visited the palace at Knossos in Crete on a pilgrimage to Jerusalem in 1418. His travel diary noted the 'marvellous and horrible beast which was called the Minotaur (kept in) this intricate house made by Daedalus which was called the labyrinth and nowadays is commonly called by many the city of Troy'.[53] Calling a labyrinth a 'Troy' is of great antiquity. Pliny said that Daedalus brought the idea of the labyrinth to Crete, in about 2000 BC, from its origin in the approaches to the tomb chambers within the pyramids of the Egyptian monarchs. The shape of the labyrinth was used on Cretan coins for at least 1400 years, long after the destruction of the great palace at Knossos.[54] The idea was carried to the Greek mainland, where the theatre at Athens was laid out with a labyrinth in mosaic. At Epidaurus there survives a partly underground maze-like structure leading to a pit associated with snakes. In the *Aeneid*, written 30–19 BC, Virgil compares the processional dance called the *Lusus Trojae*[55] with the labyrinth:

> As when in lofty Crete (so fame reports),
> The Labyrinth of old, in winding walls
> A mazy way enclosed, a thousand paths
> Ambiguous and perplex'd, by which the steps
> Should by an error intricate, untraced
> Be still deluded. . . .[56]

The magic of a maze or labyrinth is that it appears to unite the opposites of Order and Chaos, the two forces we have seen at work already in the mythologies of creation. The uninitiated see nothing but a confusing tangle of paths – apparent chaos – but those to whom the secret pattern has been revealed can see its order and may tread its trail with ease.

All over the more lonely highlands of northern Europe there survive the structural supports of Stone Age burial mounds, many of them later associated with dragons who, it was believed, usurped the rich posses-

sions placed there as luggage for the dead on their journey to the underworld:

The age-old scourge that haunts the half-light,
Found what delights him, a hoard unguarded.
It is he who, blazing, seeks burial mounds,
He, the smooth, spiteful dragon that flies through
the night.[57]

So says the epic Anglo-Saxon poem of Beowulf the dragon-slayer. The prehistoric stones of burial mounds, and objects associated with them, were sometimes marked with a magic sign of re-birth: the spiral, a maze in its simplest form. The purpose of a maze is to guard or ensnare the secret at its centre, be it from dragons, malicious spirits or common grave robbers. The one who enters the maze must so tread that 'an error intricate' is avoided. The ritual of the maze dance, the *Lusus Trojae*, traced the path to the centre of the labyrinth. Once you knew the dance, you could tread the labyrinth in the dark. Thus a ground plan maze, like the mosaic floor in the theatre in Athens, enabled the dancer to make the magic of the maze without wall, tunnel or passages. Such ground plan mazes were observed by Dr E. von Baer at Vier in the gulf of Finland in 1838.[58] Others were subsequently found in Finland itself and Sweden.[59] They were formed of pebbles and larger stones, and had already fallen out of use. The one in perfect condition, and its repair in the seventeenth century is recorded, is upon the village green at Saffron Walden. Such mazes were for treading, as Shakespeare knew:

The Nine men's morris is filled up with mud,
And the quaint mazes in the village green
For lack of tread are indistinguishable.
(*Midsummer Night's Dream*, c.1594)

(Note that the Nine Men's Morris was not only a dance, but the special pitch laid out for it.) There was no clear break in the lore of mazes. They were laid out on the nave floors of Gothic churches, as at Chartres, so that the faithful, by painfully following them on their knees, might make vicarious pilgrimage to the cave tomb of Christ in the Church of the Holy Sepulchre at Jerusalem. It has been suggested that 'Rosamund's Bower' in the grounds of the royal palace at Woodstock in the twelfth century was a maze.[60] In his gardens at the Hotel St Pol in Paris, the French King Charles V (1364–80) had trellised pavilions, tunnel arbours and a labyrinth.[61] By 1494 a 'knot called a maze'[62] was apparently a commonplace. A knot garden, it must be admitted, is a very degenerate maze – you could not dance it without spoiling the flowers!

Uccello's St George has arrived like a storm-god from a spiral cloud and like Green George from the greenwood, to the heart of an earthly spiral, a labyrinth. There is one extraordinary coincidence, if coincidence it be, that brings Daedalus' labyrinth, so to speak, to Uccello's front door. Leonardo appears to have drawn a labyrinthine pattern with, at its centre, the double axe head of Knossos.[63]

This feature raises the question of whether there could have been any association between the old Uccello and the young Leonardo. Leonardo da Vinci (1452–1519) remained in the house of his master Verrocchio until 1476. Uccello (1396/7–1475) returned to Florence for his last years in 1469. In that year he filled in a tax return with the statement: 'I am old, infirm and unemployed, and my wife is ill'[64] Things need not have been quite so bad as the tax return was intended to suggest, though in 1469 Uccello was certainly 72 or 73. There are no documented commissions to Uccello later than that year, though it has been recently suggested that our painting was executed after 1470[65] and that the document for a panel of St George of 1465 should be associated with the Jacquemart-André Collection version in Paris. Verrocchio's studio had taken on something of the character of Ghiberti's in the first half of the century. Commisssions were undertaken in sculpture and metalwork as well as painting. It was the most successful artistic centre in Florence in the early 1470s. What more likely than that the old Uccello should have spent some hours there chatting to the brilliant young assistant with whom he shared so many interests? The tally of those shared interests is too long and too special to have had no circumstantial basis. The other artists flourishing in Florence at the time cannot be claimed to have shared any one of those interests. Old Florence is a small place. Uccello and Leonardo must have found one another, as the young Samuel Palmer found William Blake.

What are these shared interests?

1 *Perspective, and its attendant discipline, Mathematics.* Vasari records the famous story that Uccello was so absorbed in his work that his wife complained he would not come to bed, to which he replied 'How fair a thing is this perspective' which was hardly calculated to console her.[66] His paintings testify to the elaboration of his perspective calculations, and so do his academic exercises.[67] Leonardo designed a polyhedron for Fra Luca Pacioli[68] which was not only illustrated in his book, *On Divine Proportion*, but painted in the background of Jacopo de Barbari's portrait of Pacioli. 'There is no certainty in science where mathematics cannot be applied,' said Leonardo, and of the three kinds of perspective: 'The first has to do with the causes of the diminuation or as it is called the diminishing perspective of objects as they recede from the eye . . .'[69] In their determination to extend the powers of painting to explore visual depth, both Uccello and Leonardo went beyond the acknowledged text book of their time, Alberti's *Della Pittura*[70] of 1435–36.

2 *A shared interest in, and real affection for, living creatures especially birds.* Both artists struggled with the problems of showing horses in fierce movement, especially from a diagonal viewpoint. The fresh interest

33

in the naturalistic rendering of animals which characterised the International Gothic movement in northern Italy in Uccello's youth, offered no more variety, in the presentation of a horse, than a rigidly frontal or back view, both of a relatively stationary animal, or a profile in motion.[71] Growing demand for battle scenes from the ancient world as well as contemporary events like 'The Rout of San Romano' put pressure on the profession to offer more variety in the presentation of horses. A note of desperation was perhaps struck by Uccello in one experiment in the Uffizi panel of 'The Rout of San Romano' series.[72] One of the horses on the right hand side of the picture is shown diagonally from the back, kicking up its heels, with absurd results. A drawing by Leonardo in the Uffizi[73] for the background of his first surviving commission, 'The Adoration of the Magi', begun in 1481, shows, among a plethora of eloquent ideas for men and animals in swift movement, a repetition of Uccello's unfortunate experiment.

A drawing by Uccello of a knight on a rearing horse[74] has been associated with our St George, though not very convincingly, as it is pricked for transfer to a panel on a larger scale. It is either an attempt to suggest a horse twisting as it rears, or it is an intermediate stage in the mastery of the diagonal rearing or galloping horse.[75] The hind quarters of the animal are drawn in profile, but its chest and forelegs are seen diagonally, in three-quarter view. There is an early drawing by Leonardo in which the same thing happens.[76]

3 *An involvement with dragons.* There is a family resemblance between Leonardo's dragon sketches[77] and our dragon: bat wings, two legs, prehensile tail. There is something of a family likeness between most dragons, being, as they were, all members of the same species! Although Leonardo was never officially engaged on a commission to paint a St George and the Dragon,[78] as far as we know, the subject creeps into five out of thirteen studies on one page which may again be associated with his first Florentine period.[79] Popham suggests that he might have been working on a St George and the Dragon in his earliest years.[80] But we can link their interest in dragons closer than that, by a detail, as far as we know unprecedented. Leonardo has left his formula for the face of a dragon, and it approximates not only to his own drawings but very well to our painting.[81] 'If you wish to make your imaginary animals appear natural – let us suppose it to be a dragon – take for its head that of a mastiff or setter, *for its eyes those of a cat,* for its ears those of a porcupine, for its nose that of a greyhound, with the eyebrows of a lion, the temples of an old cock and the neck or a water-tortoise . . .' (italics mine). There are many fascinating matters of zoology in Leonardo's assembly of the dragon, and its relationship to his own dragon studies. But it is the eye which connects Leonardo's description with the dragon of Uccello's St George, for this dragon has the upright slit pupil of a cat. This was not the standard way of depicting dragons' eyes. The

Leonardo da Vinci, sketch of St George and the Dragon (Royal Library, Windsor Castle).

Jacquemart-André dragon has the round pupil of most species. Leonardo, and Uccello before him, were of course, anatomically 'correct', for dragons are reptiles, like crocodiles, and reptiles have the ability to contract the pupil of the eye to a slit.

We have already seen that Uccello's action departs from the norm in slaying the dragon through the eye instead of through the mouth and throat. This departure should be understood in terms of the Egyptian version of the slaying of the dragon, where St George attacks the dragon through the eye, the vulnerable member of the crocodile. In conjunction with the recipe for cats' eyes the evidence suggests some knowledge of Egyptian sources, shared by Uccello and Leonardo.

4 *The spiral cloud.* We have seen that Uccello probably inherited the idea of representing a spiral cloud from Gentile da Fabriano, and that he could have found literary material to support his imagery of the arrival of a storm-god from the Old Testament. We know that he had been obliged to study cataclysm by flood for his fresco in the Chiostro Verde in Florence[82] where there are so many elements of profound originality. The Arno in Uccello's time was subject to autumn floods: chroniclers record occasional serious toll of life in Florence.[83] The flood of 1966 had its medieval counterparts, of which the disaster of 1333 had swept away the Ponte Vecchio. Floods were, as they remain, an ever-present reality in Venice. As the year 1500 was reached, belief in an impending universal Doom was reflected in public and private works by the two greatest

artists alive: Michelangelo and Leonardo. The great sequence of Leonardo's deluges – arguably the most beautiful drawings the world has ever seen – probably began in studies of c1507 towards a book on water on which he was working in 1509–10.[84] If our association of St George with a storm-god seems extravagant, what of Leonardo's drawing in which the storm-god appears, riding upon the whirlwind? For all the glory of Leonardo's cataclysm drawings, no one of them represents a single spiral of clouds with the simple symmetry of Uccello's painting. Yet we have from Leonardo an analysis of the spiral: 'The spiral or rotary movement of every liquid is so much swifter in proportion as it is nearer to the centre of its revolution . . . since movement in the circular wheel is so much slower as it is nearer to the centre of the revolving object. . . . but the curve of the lesser circle is as much less than that of the greater as the greater circle is more curved than the lesser . . .'[85] As with the dragon's eye, the image is by Uccello, the description is by Leonardo.

5 *The Cave.* Caves as we have seen, are the habitat of dragons, and any fifteenth-century representation of St George killing the dragon is likely to have one. What is striking is that our roof appears to be upheld by a sequence of transverse ribs.[86] Again it was Leonardo who was to be the first to explore the actual mountains and caves of the Apennines. The 'ribbed vault' of our cave leads directly to Leonardo's description of his examination of the entrance to a cave, where he peered into the darkness until he thought he discerned that it was in fact supported by the skeleton of a vast fish: '. . . now destroyed by Time, patiently it lies within this narrow space and, with its bones despoiled and bare, it has become an armour and support of the mountain which lies above it . . .'[87] Withdrawal to sacred caves in

Leonardo da Vinci, drawing of vortices (Royal Library, Windsor Castle).

search of wisdom appears to have been associated by the Greeks with their Cretan forbears. Epimenides, the Cretan seer who was invited by Solon in 596 BC to purify the city of Athens, was claimed to have slept for fifty-seven years in the cave of the Cretan Mystery God.[88]

What, if not a labyrinth, is Socrates describing in Plato's *Phaedra*? 'He (Telephus) says that the path to Hades is straightforward, but it seems clear to me that it is neither straightforward nor single. If it were, there would be no need for a guide, because surely nobody could lose their way anywhere if there was only one road. In fact it seems likely that it contains many forkings and cross roads . . .'[89]

6 *The mountainous background.* Behind our clipped parterre there stretches a green middle distance, and behind that again rise the hills. The nearer range is brown, and upon its lower slopes are the slight indications of the city whose daughters the dragon has been consuming. Beyond that again rise the higher mountains, blue, their flanks touched with snow. We have to look hard to find so poetic, and yet so well-observed, a representation of a mountainous background in Florentine art. Most paintings of Uccello's day offer either the last of the Byzantine symbolic rocks – almost symbolist rocks – or a glimpse of the parched summer hills of Umbria, or the boulders and rivulets of Filippo Lippi. But one panel by Fra Angelico, dated to about 1451, has something of Uccello's horizon.[90] Uccello may well have known Fra Angelico's study of distant hills. But Fra Angelico does not add the snow along the upper slopes. Uccello, living in Venice for five years, must have seen the Alps: not only seen them, but looked at them. Leonardo was to be the first artist, so far as we know, to climb among mountains in order to study them. Verrocchio's 'Baptism of Christ' in the Uffizi Gallery was painted in 1472, when Leonardo was working for him and Uccello was still alive in Florence. Critics accept Vasari's story that one of the angels was by Leonardo, and many agree that the background must be Leonardo's also. As a landscape it does not quite hold together. The mountains behind Christ's left shoulder do not match well with those behind his right shoulder. But either side in isolation would be greeted as the overture to the symphony of mountainous scenery that we have from Leonardo's hand. If Uccello saw this picture – and surely he must have seen it – we hope that he was large enough of heart to rejoice in how far the twenty-year-old Leonardo had surpassed him.

The date of Uccello's St George.

There being no circumstantial evidence, the date can only be decided by the considerations we have been airing, with reference to the internal evidence of fashion in the appearance of ladies and in style of armour.

It must be understood that Italian armourers led the world in the fifteenth century,[91] challenged only by Germany, where the 'bat-wing' pointed shapes of the Gothic north were in contrast to the rounded forms of the Renaissance. If you wanted to convey the aesthetic distinction between Italy and the north in the mid-fifteenth century, you could not do it more clearly than by comparing the two types of armour. Armour is a science that purports to have no truck with fancy but to be all of function. Its shapes are literally matters of life and death – and yet, as with the safety devices of a new car, fashion exerts a compulsion. So it is possible for a student of fifteenth-century armour to date a suit, or part of a suit, to within approximately five years.[92] St George's suit has been dated to c1435–40. It is not dissimilar to the suit worn by Sir John Hawkwood in Uccello's fresco of 1436.[93] Nor does it differ very much from the armour worn by St George in the Jacquemart-André panel. The same features reappear in the cycle of the 'Rout of San Romano'. In consequence, some authorities have dated all these works to the 1430s.[94] It would appear on this evidence that Uccello never painted armour after 1440. The problem here lies in the circumstances of the cycle commemorating the Rout of San Romano. The event took place in 1432. However, the Palace whose 'chamera grande terrena' (large chamber on the ground floor) his pictures decorated in the fifteenth century was not completed before 1451.[95] The three panels were not separate rectangles that could

be hung in three different museums as they are now. At a more recent date they have lost their arched tops (and gained upper angles). They originally fitted into lunettes under the curves of the vaulted chamber. It cannot be claimed that they represent a complete decorative scheme for the room, as they were listed in the 1492 Inventory alongside a battle of lions and dragons and a scene from the legend of Paris, all by Uccello, and a chase of lions by Pesellino. So by 1492 it is likely there had been some rearrangements. The possibility the the 'Rout of San Romano' series was commisssioned for another house, and adapted for the Palazzo Medici-Riccardi cannot be discounted. But it is more likely that these ambitious panels were part of the general embellishment of this palace, which saw the Benozzo Gozzoli chapel paintings, still in situ, and dated to 1459; the activity of Pesellino, interrupted by his death in 1457; and Antonio Pollaioulo's commission for the Sala Grande, of 1460. Most people prefer to date the San Romano cycle to the 1450s.

A close comparison between the armour of our St George and the many suits displayed in the San Romano scenes suggests that Uccello did not in fact use a wide range of armour, but created an impresssion of variety by several different types of helmets, a number of fantastic crests upon those helmets, and by the introduction of the occasional Germanic wing to the cuisses and polyns (leg and arm pieces). His norm was a double circle for these wings which protect, of course, the

Paolo Uccello, 'The Rout of San Romano' (National Gallery, London).

elbow and knee joints. Suits like the one worn by our St George occur throughout the San Romano battles. The figure of a knight lying upon the ground (in perspective) in the London panel could be read as a back view of the suit worn by our St George. Uccello's predominant interest in armour, like his interest in horses, lay in the problems of rendering their predictable volumes in perspective. He seems to have been disinterested in decorative details for their own sakes. The trappings of our horse are treated in almost exactly the same way as the trappings of the horse ridden by Nicholas da Tolentino in the same panel. For that matter, they also occur on the horse ridden by Sir John Hawkwood, and in the drawing of a galloping horse with rider. It must be a matter of either using the same sketchbook material, or, in the case of armour, working from the same suit or miniature suit. This solution would explain why it was possible for him to display a suit of armour from so many alternative angles, as he does in the National Gallery panel of San Romano.

The fashion of the Princess.

'Uccello,' said Vasari, 'had a dry style, full of profiles!' If by dry he meant wooden, Vasari had a point. And of the profiles there is no scarcity. Profiles were high fashion: Domenico Veneziano used them, and probably through him they were a strong element in Piero della Francesca's work. The root was probably again in Venice, with Gentile da Fabriano and his pupil, Pisanello, who was to revive the ancient art of the profile coin with the most elegant medals the world has ever seen. Pisanello's profiles had already appeared while Uccello was in the north: the angel of the Annunciation in San Fermo, Verona, of 1423–24 is not only in profile, its mouth is open in speech. A characteristic of Uccello's profiles is that they often have their mouths open. When they do not, they are still distinguished by a certain piquancy of type, well illustrated by our princess.

It was suggested to Martin Davies at the time this picture entered the National Gallery that the princess' hair style could not be earlier than that of one of the women in the cycle of famous men and women from Villa Carducci, now in the Uffizi.[96] This great fresco cycle was painted by Andrea del Castagno in c1450–55. However, the portrait medal by Pisanello of Cecilia Gonzaga, dated 1447, shows a very comparable hair style swept back into a bun, and a drawing from the joint workshop of Gentile da Fabriano and Pisanello showing a vast bun and an even more obviously shaven forehead is thought to date to not later than 1437.[97] The whole fashion of shaven brow and swept back hair, no doubt supported by a frame, is present in Pisanello's princess in the Verona St George of 1437–8. The fashion of the shaven brow for ladies was to remain in vogue

'St George and the Dragon': detail showing head and shoulders of princess.

across Europe until the early seventeenth century. It is possible to define headdresses within much closer time limits, but the Princess is wearing a crown.

We are reluctantly bound to admit, therefore, that neither the armour nor the princess' hair affords evidence to fix the date of the painting more exactly than the other elements we have brought to bear. No one would want to date it before 1432. We would prefer to suppose it was a work at the end of Uccello's life, while emphasising that the validity of none of our inferences is disturbed by considerations of date.

There remains one cardinal mystery: the omission of the red cross of St George.

We cannot evade this problem by suggesting that Uccello was really painting Perseus and Andromeda all along. The girdle episode has no place in that legend. The omission cannot be an oversight on Uccello's part. The 'control' in the Jacquemart-André Museum displays his red cross on a white ground with due prominence. It occurs on his tabard, as it does on the tabard of Pisanello's St George in the National Gallery. That St George is such an exquisite that he has changed the colour scheme of his cross to harmonise with his

Jacopo Bellini, 'The Harrowing of Hell', fresco (Museo Civico, Padua).

outfit, but it is there, nevertheless. Two of the knights in the Louvre episode of the 'Rout of San Romano' wear small crosses of St George on their helmets.[98]

We cannot note the omission of St George's mark of identification without at the same time acknowledging how extraordinary it is that St George should have borne, without differentiation, the emblem as Christ Triumphant: the banner of the Resurrection. In medieval imagery the scene of Christ's victory over death was shown as his Harrowing of Hell. The word 'harrowing' actually means ploughing. The jaws of death are the jaws of the dragon which Christ pierces with a lance bearing the pennon of the red cross.

Rising from the grave to be mistaken by the Magdalen for a gardener, again he bears his red cross. By the fifteenth century, heraldic imagery was so widely used that Christ was given a range of armigerous bearings, the 'arma Christi', which include the emblems of His Passion and the wounded members of His Body displayed on shields. Even a diagram of the Trinity could be set out on a shield. And yet St George still carries the red cross of Christ's triumph over death on the Cross. If we compare the iconography – the visual language – of Christ harrowing Hell, with St George slaying the dragon, Christ is only distinguished from the Saint by being on foot instead of riding a white horse. Even that difference is lost in the Apocalypse.[99] 'And I saw, and behold a white horse, and he that sat on him went forth conquering and to conquer . . .', a passage which the Church has always read as referring to Christ. A thirteenth-century English illumination from an Apocalypse[100] combines this image with an earlier passage of the Apocalypse: 'and out of his mouth went a sharp two-edged sword . . .'[101] This Christ on a white horse leads a group of knights, each bearing a banner and shield of the red cross. These knights could be crusaders – or they could have enlisted in the army of Edward I, king of England. Edward adopted the red cross on a white ground for his army in the Welsh wars from 1277.[102] By 1303 or before ships were flying the standard of St George. The ground of the Union Jack had been laid down, though it did not acquire the rest of its bearings until the time of Henry VIII.[103] The Shining Cross was seen by Constantine the Great (288?–337) in 312, who understood thereby 'By this sign ye shall conquer.' The Roman Empire therefore adopted Christianity as the road to military victory. The red cross symbolises Christ's defeat of the Cross. It becomes appropriate for St George, and for crusaders, who conquer in the name of Christ. The red cross is then annexed by a king, Edward II, for his personal wars, which by its witness become Holy Wars. There is some comfort for us, in our generation, in the reflection that the red cross has become the banner of another organisation, born of the Geneva Convention in 1864, of which the aims are not those of conquest but the healing of war, the Red Cross itself.

It would be to read too much of today into the past to suggest that Uccello forebore to give his St George his proper armorial bearings because he knew those bearings to have been too often carried unworthily. It is perhaps more discreet to guess he might have wanted to suggest by omission that, as a man of the New Learning, he was aware that others, Theseus, Perseus,

Apollo, Hercules were dragon-slayers. We cannot suppose that his range went as far as Krishna, Gushtasp, Beowulf and Marduk.

As we have seen, Leonardo interpreted the cave as the fossilised skeleton of a giant fish, a whale or leviathan. Jonah spent three days entombed in such a creature – Jonah, type of Christ, who spent three days in the belly of the earth. At the back of Uccello's cave there is water, so it is the mouth of the dragon's passage to its ultimate lair, in the waters under the earth. The great religions of Mediterranean and Near Eastern origin personsified the act of creation as a god/hero defeating the dragon of chaos, and forcing it back under the land. It emerged again at the Flood, and is due to re-emerge at the end of time. But then again the storm-god will return – 'Behold he cometh with clouds . . .'[104]

St George was without doubt the most sincere and holy of early martyrs, but once he had acquired his dragon he attracted, like a quark, all other imagery related to the cataclysmic battle of order and life over chaos. It is no coincidence that his feast day is 23 April. The spring is the time of the festivals of rebirth, of Green George, the death of winter and the coming of new life. It is also the time of the death and rebirth of Christ, who ploughed the field of Hell, broke the jaws of Death, and emerged from the cave tomb as the new Adam – like the first Adam, in the guise of a gardener.

It is impossible for us to know how much of this mythology was consciously enlisted by Uccello in his little painting of St George: but it is here for us to discover.

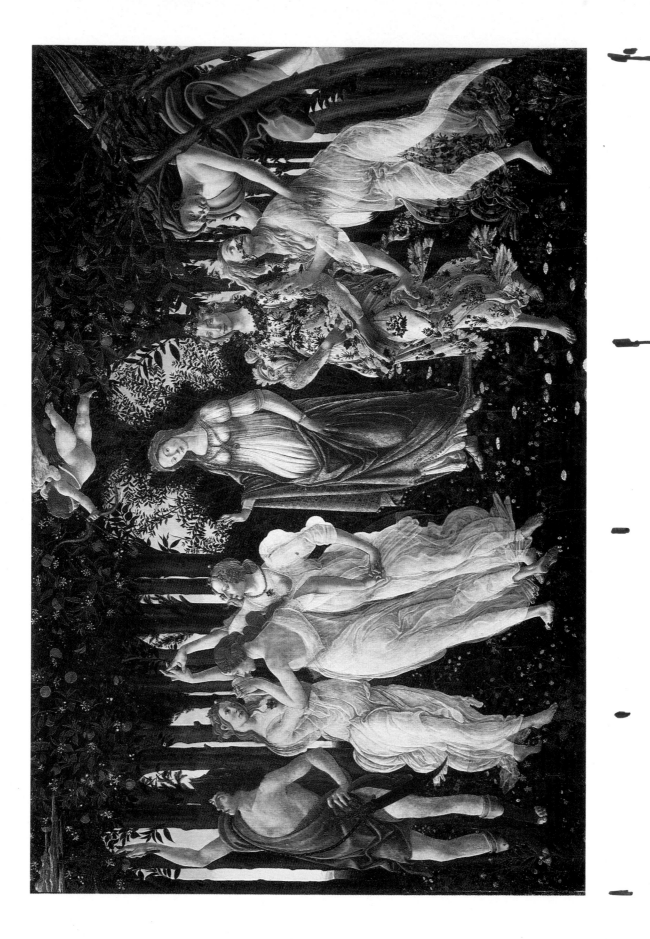

Chapter 4

La Primavera
by Sandro Botticelli

In anyone's list of the world's most beautiful pictures, you would be sure to find Sandro Botticelli's 'La Primavera'. It is one of those paintings which manages to combine a direct appeal to the senses with a sophisticated challenge to the intellect. Its complete meaning is as elusive as the remote and wistful elegance of the almost transcendental scene which Botticelli sets before our eyes. This is a picture with layers of meaning, layers that shimmer like the diaphanous veils of its dancing figures.

The present popularity of 'La Primavera', which has led to its reproduction on anything from greetings cards to tea trays, is due simply to the loveliness of its figures who, though painted in the fifteenth century, are much to modern taste. The prototype for this style of beauty was developed in the paintings of the Florentine artist, Filippo Lippi (c.1406–1469). He endowed religious figures, especially the Virgin Mary, with a graceful realism, sometimes an almost mischievous playfulness, that makes them appealingly alive. Despite being sent by his mother to a Carmelite monastery as an adolescent, Lippi was certainly responsive to female beauty. His illicit union with a nun called Lucrezia Buti resulted in a son, and caused something of an embarrassment to his Medici patrons. It was only after their intervention that Filippo and Lucrezia received a Papal dispensation to marry. Lucrezia's charms still smile in the faces of Lippi's Madonnas.

It was in Filippo Lippi's workshop that Botticelli learned his trade and inherited his master's skill in portraying this gamine type of feminine beauty. Botticelli had been born Sandro Filipepi, around the year 1445 in the Ognissanti district of Florence, the youngest son of a tanner, Mariano Filipepi, and his wife, Smeralda.[1] The name Botticelli, meaning little barrel, started as a nickname handed down from his eldest brother, but by Sandro's death it had become the family name. Little is known of his education before he arrived at Lippi's workshop around 1464. After Botticelli had been apprenticed there for three years, Filippo Lippi left Florence for Spoleto where he had been commissioned to paint a cycle of frescoes in the cathedral. Botticelli was left to strike out on his own.

For a time he may have shared a studio with Andrea Verrocchio, who was a painter and goldsmith as well as a sculptor, and later master to the young Leonardo da Vinci. After a year or two Botticelli's career began to take off, due in part perhaps to the growing interest of the influential Medici family and their associates. Paintings like the 'Adoration of the Magi',[2] commissioned by Zanobi del Lama, helped establish his reputation. Zanobi was a banking colleague of the Medici, and the painting shows the generations of the Medici dynasty, from Cosimo to Lorenzo the Magnificent, paying their respects to the Christ Child alongside other notables of Florence and a figure believed to be Botticelli's self-portrait. In less than a decade he had become a famous artist. He had at least three pupils in his workshop, one of them Filippino Lippi, son of his old master, who had returned alone to Florence after his father's death in 1469 at Spoleto.

By 1481, news of Botticelli's talent had reached Rome. Pope Sixtus IV summoned him to the Vatican where the building of the Sistine Chapel had recently been completed. There he joined Cosimo Rosselli, Pietro Perugino and his fellow Florentine, Domenico Ghirlandaio to paint frescos for the new chapel. Botticelli's recruitment to the Vatican service may not have been a great success. He painted only three subjects there: the 'Temptation of Moses', the 'Rebellion against Moses' and the 'Temptation of Christ'. After only a year he was back in Florence.

During his absence Leonardo da Vinci, finding no favour with the Medici, had left for Milan and the patronage of Ludovico il Moro Sforza. Andrea Verrocchio had moved to Venice, and the Pollaiuolo brothers, Antonio and Piero, were soon to be called to Rome to build the tombs of Popes Sixtus IV and Innocent VIII. Botticelli's position as the leading artist of Florence was now virtually unchallenged.

Though the style of 'La Primavera' is unmistakeably that of Sandro Botticelli, the painting itself bears no signature and no title. The name by which we know it, meaning 'The Spring', was first used by the pioneer art historian Giorgio Vasari who saw the painting at Villa Castello, just outside Florence, in 1550.[3] The Villa Castello had been acquired by Lorenzo di Pierfrancesco de'Medici, a junior member of the Medici family, in 1477,[4] and for many years it was assumed that 'La Primavera' had been specially commissioned that year to grace the young man's new country house. Vasari also saw Botticelli's painting of 'The Birth of Venus' at Castello, and even today, the two pictures keep company in the same room of the Uffizi Gallery in Florence. This pairing of the pictures has inevitably coloured their interpretations, leading some to see them as the sacred and profane aspects of Venus.[5] It has even been suggested that they were painted as a pendant pair, but the discrepancy in size alone would seem to make this unlikely.[6] Add to this the fact that 'The Birth of Venus' is painted on canvas while 'La Primavera' is on wooden panels, and it is clear that the painter did not originally conceive them as a pair.

Moreover, a fresh clue to the original home of 'La Primavera' has come to light through the publication, in part, of the inventories of properties belonging to the younger branch of the Medici.[7] When the senior branch of the family built the grand Palazzo Medici as their new headquarters in Florence, they moved out of the Casa Vecchia two doors down the Via Larga, leaving the 'old house' for the use of their less illustrious relatives, among them Lorenzo di Pierfrancesco. Each of the Pierfrancesco brothers came to have his own country villa, but they continued to share this town house.[8] The Casa Vecchia was later demolished when the Medici palace was enlarged and today we know it only from one old map[9] and an inventory made in 1499, two years after Lorenzo di Pierfrancesco's death.

The inventory evokes a small palazzo with three communal rooms for feasting and dancing,[10] and a succession of private apartments, rather like modern bedsitting rooms, for everyday use. Lorenzo di Pierfrancesco had two suites for himself. His rooms upstairs were furnished in blue leather. The master room of his ground-floor suite contained a pair of organs, suggesting that this was a music room. Here the hangings were of stamped leather in a brocade pattern and there were two pictures, one of Moses taking the crown from Pharoah, and the other a canvas of the Three Graces, yet to be rediscovered. The room next door was much simpler, without hangings and with furnishings only of pinewood and not the exotic intarsia described else-

Sandro Botticelli, 'The Birth of Venus' (Galleria degli Uffizi, Florence).

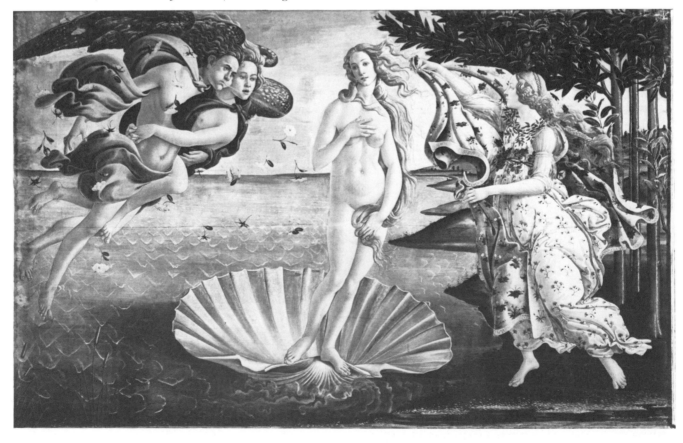

42

Map of Florence c.1472: detail showing Casa Vecchia immediately below the Palazzo Medici (Vatican Library, MS Urb. 277).

Inventory of Casa Vecchia, 1499: detail of page listing paintings (Archivio di Stato di Firenze, MAP 129, f. 517r).

where in the house. But it did have three splendid paintings. The most valuable was a round painting of the Madonna and Child by Luca Signorelli, valued at 233 lire in the 1499 inventory.[11] Over the door was a picture of Minerva and the Centaur[12] by Botticelli, now in the Uffizi Gallery. The motif of three interlocking circles on her dress is taken to be a reference to the three balls of the Medici Arms. It was valued at only 40 lire, far less than the smaller Signorelli painting. The third picture was deemed to be worth something in between, just 100 lire. But the subject of the painting baffled the writer of the inventory. So he called it simply a 'picture with nine figures, of women and men, set in a white frame over the *lettuccio*.' This, we now believe, is the first reference to Botticelli's 'La Primavera'. The measurements of the painting are comparable with those of the *lettuccio*, a sort of wooden sofa, catalogued in the inventory.[13]

Its close association with a piece of furniture is not as surprising as it may at first seem. It was through painted furniture that classical themes had found their way into Florentine homes. They were particularly popular for bridal furniture, especially the *cassone*, a wedding chest. Surviving *cassone* panels painted by Botticelli[14] testify to

the richness and expense lavished on such furniture. Botticelli's 'Mars and Venus' in the National Gallery, London, is thought to have been the back of a *lettuccio*. The inventory's description of 'La Primavera' might even be taken to suggest that it too formed part of a *lettuccio*, a rather high-backed one. Contemporary painting does show tall *lettuccios* with painted panels set in their backs.[15] However, since it is clear from the inventory that fine panelled furniture was more expensive than paintings;[16] a *lettuccio* grand enough to have incorporated 'La Primavera' would surely have been worth more than a modest 100 lire. But this is not to say that 'La Primavera' could not have been painted specially to fit in with the *lettuccio* and the room's other furnishings, particularly if they had formed a bridal suite. As it was found in 1499, 'La Primavera' had a white-wood frame. The bed-cover in this room, quite unusually, was also white. If we may read the sequence of rooms in a way in keeping with later custom, this was indeed a bridal suite. A room devoted to music led to the equivalent of a dressing room, the special province of the bridegroom, and beyond that again was the bridal chamber itself.

So we may deduce that even after Lorenzo di

43

Andrea del Sarto, 'The Birth of the Virgin': detail from fresco showing lettuccio *(SS. Annunziata, Florence).*

Pierfrancesco's death, 'La Primavera' still hung in his own suite at the town house, the Casa Vecchia. At a later date, possibly when the house was demolished, it was moved, together with other paintings by Botticelli, to the country villa at Castello. Georgio Vasari's visit there in 1550 provides us with the first, and most straightforward, account of the painting's subject matter. He decribed it as showing 'Venus, whom the Three Graces deck with flowers, denoting Spring', hence the title of the picture.

Spring is certainly the season. Seldom can flowers have been painted in such profusion and variety, and with such meticulous attention to detail. Over forty different plants can be identified.[17] The flowers are not scattered haphazardly but, as we shall see later, are carefully placed to underline the meaning of the picture. But where on earth could they all be found blooming together, the spring iris alongside the summer rose? Nowhere, for we are in no earthly garden.

This place is a sacred grove where time stands still, a place somewhere between heaven, where time is obliterated by eternity, and earth, where time waits for neither man nor beast. It is a grove of orange trees, the 'golden apples' which, according to mythology, the earth brought forth in the Garden of the Hesperides to celebrate the nuptuals of Jupiter and Juno. Not surprisingly the orange was considered to be one of the sacred

attributes of Venus, Goddess of Love. Even today, orange blossom is associated with weddings. The orange tree is unique in bearing blossom and fruit at the same time, because oranges take several months to ripen and hang on the tree over winter. The theologian Armando de Bellovisu[18] called the orange the most beautiful of trees, excelling all others, as the Virgin Mary excelled all women, by bearing the white flower of her virginity with the fruit of her chastity. So our sacred grove is not only the pagan Garden of the Hesperides, but also the *hortus conclusus*, the enclosed garden, of the Virgin Mary.

The setting of the sacred grove occurs again in another context which held particular significance for Botticelli and his patron, Lorenzo di Pierfranceso: *The Divine Comedy*, written by Dante Alighieri between 1307 and 1321.[19] This allegorical poem of his journey through Hell, Purgatory and Heaven is the most famous and important single work of medieval Italian literature. Numerous copies were made in the century following Dante's death.[20] But the work was neglected from about 1420 until 1481 when Cristoforo Landino prepared the first printed edition. The illustrations were to be by Botticelli. Only the first few designs were completed, perhaps because he was called to Rome in that year. A second series of Dante illustrations by Botticelli, in colour on vellum, were described by Giorgio Vasari, but are generally thought to be lost.[21] We know that both these sets of illustrations were paid for by Lorenzo di Pierfrancesco, but the patron for a third and final set is unknown. Perhaps there was no patron. These last drawings were made towards the end of Botticelli's life and, though unfinished, have an exquisite delicacy in which we see, perhaps, Botticelli's private vision of a text that obviously held great meaning for him.

At the end of Dante's journey through Purgatory, the spirit of Virgil, which has accompanied him from Hell, leaves him at the boundary between Purgatory and Heaven where he meets the mysterious Matilda who will lead him to Beatrice. 'Where all the soil breathed out a fragrant scent, and there appeared a lady all alone who wandered there, singing and plucking flower on flowered bay, with which her path was painted everywhere. Oh thou doest put me to remembering of who and what were lost, that day her mother lost Persephone, and she the flowers of spring.'[22] The boundary between Purgatory and Heaven is our sacred grove. The grove forms the subject of the last of Botticelli's illustrations for Purgatory and the first for Heaven. The trees are oranges. 'Here,' wrote Dante, 'was the innocent root of all Man's seed, here Spring is endless, here all fruits are.' Perhaps we should even add the Garden of Eden to our list of timeless sacred groves.

So the background Botticelli chose for 'La Primavera' was territory familiar to his informed audience. Equally familiar were the classical characters assembled in front of it. Each figure is identified by traditional attributes and associations that everyone would have understood.

Even today, Cupid is recognised instantly by his bow and arrow. In antiquity he was the sprite of Love, the playful son of Venus, Goddess of Love. The classical poet Propertius, who specialised in love poems, writes that painters of the day depicted him as a naked winged infant, carrying a bow and arrows or a torch, sometimes both.[23] In 'La Primavera' Cupid's flaming arrow unites images of arrow and torch into a single symbol of the inflamed passion of those wounded by love.

Cupid hovers above his mother, Venus who, despite her unusually modest appearance, had been correctly identifed by Giorgio Vasari in 1550. She is the central figure of the painting. Set back slightly from the rest, she alone directs her gaze towards us, and with a gentle gesture of welcome, invites us to her garden.[24] Behind her, the dark leaves of a myrtle bush form a foil for her delicate features. According to Hesiod, the Greek shepherd turned poet of the eighth century BC, the Goddess of Love had been born of the sea after the semen of Uranus had fallen upon the waters. Coming ashore in a shell, Venus clothed her nakedness in myrtle, and so the plant became sacred to her. Its berries were even considered to be an aphrodisiac.

'La Primavera': detail of the Three Graces.

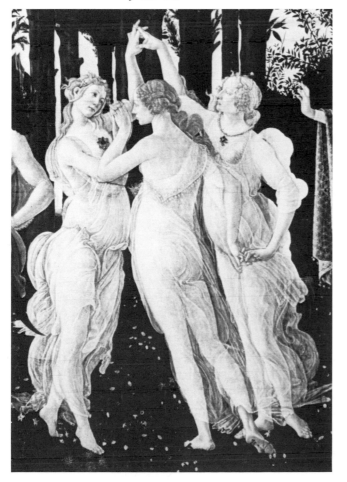

Dancing beside Venus are her three ethereal companions, the sisters known to antiquity as the Three Graces.[25] Some writers called them Chastity, Beauty and Love; some saw them as the giving, receiving and returning of blessings; others as Splendour, Youth and Abundant Happiness. The nubile beauty of the Three Graces made them a popular subject for sculptors and painters, but their meaning was not totally clear even in classical times. The poet Seneca the Younger in his *De Beneficiis* asks, 'why the Graces are three, why they are sisters, and why they have their hands intertwined, and why they are smiling, and youthful and virginal and clad in lucent and transparent garb. Why do they dance in a ring which returns upon itself?'[26] Absorbed in their measured dance, the Graces keep the answers to themselves.

There are no secrets about the identity of the male figure standing beside the Graces. The wings on his heels alone would tell us that this is Mercury, the air-borne messenger of the Gods.[27] But he is no mere go-between. His other emblem is the caduceus, a short staff entwined by two dragons. Like the Ying and Yang of Chinese philosophy, they stand for the opposing forces of Nature, held in harmony by the secret wisdom of which Mercury is the guardian.

The remaining figures tell a tale from the *Fasti*, a popular collection of amorous adventures of the immortals by the classical Roman poet, Ovid, who was known rather for his eloquence in story telling than his seriousness. The *Fasti* was originally intended to be a poem in twelve books, one for each month of the year, but only six were completed. In the fifth book, a wood nymph called Chloris was wandering through 'the happy fields where dwelt fortunate men of old' when her naked charms attracted the attention of Zephyr, the first wind of Spring. Chloris fled, but Zephyr pursued and overcame her. As she was ravished, flowers sprang from Chloris' mouth and she became transformed into Flora, Goddess of Flowers. Botticelli illustrates this moment of metamorphosis with detailed attention to Ovid's story. Zephyr's puffing cheeks trap Chloris in 'a gale of passion' and the flowers pour from her lips to decorate the gown of her new self, Flora. Ovid tells us that 'till then the earth had been but of one colour'. From Chloris' name, we may guess that single colour to have been green. The Greek word for green is *khloros*, the root of words like chlorophyll. Perhaps that is why Botticelli painted Zephyr in shades of bluish-green. He represents the world as it was before his union with Chloris brought forth all the colours of the flowers, illustrated so vividly in Flora's embroidered robe. Colour must have also been in Botticelli's mind when he painted an iris beneath the figure of Chloris. The flower was named after the goddess Iris, who was originally personified by the rainbow and appears in Homer's *Iliad* as a messenger of the gods. Later she appears dressed with attributes similar to those of Mercury, a caduceus and winged sandals and helmet.

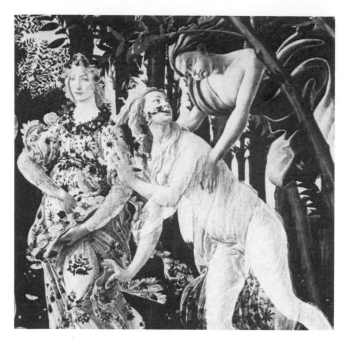

'La Primavera': detail of Flora, Chloris and Zephyr.

According to some classical writers, Iris was the wife of the west wind, Zephyr.

Her tempestuous husband flies into the picture through a bay-laurel tree and in doing so reminds us that nymph-chasing was a popular sport among the immortals, irrespective of their marital status! But passion was not always consummated. When Apollo pursued the nymph Daphne she cried for help and was turned into a laurel tree to escape his advances. So it is rather appropriate that Zephyr should make his entrance between the branches of that tree.[28]

So Botticelli has raised the curtain on a cast of stock classical characters set in a sacred grove. But what is the scene that is being played? Since the story of the nymph Chloris comes from antique poetry, perhaps there is a classical text to fit the whole plot of the picture. Well, if there is, no-one has found it yet. And since these pagan Greek immortals have stepped on to the Christian stage of fifteenth-century Florence, to search for a comprehensive classical source is probably futile. These are not the gods as the ancients knew them but survivors, battle-scarred by the Middle Ages and refurbished with a Christian gloss in the early summer of the Italian Renaissance. And it is in the light of this new Christian context that we should seek the story played out in our picture.

The ancient gods of Greece and Rome might never have resurfaced in the modern world were it not for an upsurge of learning in the twelfth century that prefigured the Renaissance in a smaller way.[29] During that century the discoveries of ancient science and logic were reintroduced to Western Europe through Latin and Hebrew translations of the Arabic texts which had preserved the precious knowledge in a kind of suspended animation. Among the works translated, those of Aristotle and Ptolemy caused most scholarly excitement and debate. They also rekindled a strong interest in astrology, which the Christian church had effectively banished.

History has a habit of turning the tables. With the revived interest in astrology, the proud gods of Olympus, who had lent their names to the planets in late antiquity, now found themselves reborn, not as gods in their own divine right but as mere personifications of the planets that bore their names. Artists fleshed out representations of the planetary gods from texts that had been translated back and forth from one language to another. As they travelled between East and West, descriptions changed emphasis and gathered local colour. Illustrations of the gods were copied and recopied, mistakes and all, by hands ignorant of their significance. The result was like the party game of Whispers on a global scale. We find Mercury, the athletic Greek youth of antiquity, looking more like an aged scribe in some manuscript illuminations,[30] and transformed into a spotty musician in others.[31] In one illustration, the wings of his helmet have grown so enormous that he seems to have the head and crest of a cockerel![32] Travesties of their antique models, the planetary gods had reached a sorry state.

With the coming of the full-blown Renaissance in fifteenth-century Italy, the fortunes of the gods changed. Not only did scholars and artists return again to original classical texts, but they also had potent new sources of reference to guide them: antique sculpture and vase painting. The discovery of actual classical works of art provided, at last, an authentic vision of the gods as the ancients had envisaged them. Here was the visual counterpoint to the elegant philosophy of ancient Greece. At the inspired hands of the Renaissance artists, the immortals emerged fresh and poised from the grotesque chrysales of the Middle Ages.

Florence, under the benign rulership of the Medici family, was at the forefront of the Renaissance. As well as being the patron of a host of dazzling artists, Cosimo de'Medici, founder of the Medici dynasty, was also an avid collector of ancient Greek and Roman manuscripts. We know, from an inventory of 1418, that he already had sixty-three books at a time when most cultivated people were lucky to have half a dozen. Twenty-six years later his manuscript collection had grown so large that he was impelled to build a great library to house the bulk of his books. The library was designed by his favourite architect, Michelozzo di Bartolommeo, who had built the Medici palace, and was put in the care of the Dominican monks of San Marco.

Cosimo's agents scoured Europe buying up, on the cheap, battered copies of classical texts that had been gathering dust on monastery shelves for some two and a half centuries.[33] Without the industry of earlier monks transcribing and re-transcribing these classical texts we

should know hardly anything at all of classical thought. But locked away in religious houses the authentic ancient foundation of philosophy had ceased to have any serious intellectual impact. In Cosimo's library, many cramped and virtually illegible books were deciphered and copied out in a spacious and eminently readable hand which reflects the same clarity of purpose as Michelozzo's gracious architecture.[34]

In 1444, Cosimo opened the doors of the San Marco library to an eager public. Such a resource had not been available since the destruction of the great classical library at Alexandria in 47 BC. But there was still one hurdle: the language. Latin had been the international tongue of medieval Europe, the language of the educated. But the most significant of the texts unearthed by Cosimo were in Greek. Ancient Greek was a mystery to most, its understanding as rare an accomplishment then as it is today. For some time, Cosimo had been fascinated by the ideas of the great Greek philosopher, Plato. The pride of his manuscript collection was a

Giam Bologna, 'Mercury' (Museo Nazionale, Florence).

'La Primavera': detail of Mercury.

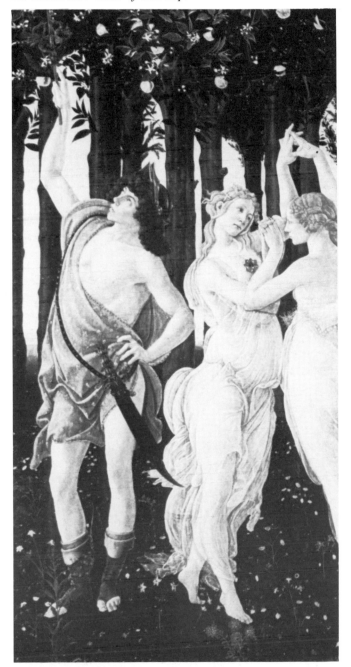

47

copy, in the original Greek, of Plato's complete works.[35] But he could approach these ideas only at second hand. Just one small part of one of Plato's works, the *Timaeus*, had been available in Latin to the medieval world. What Cosimo needed now was a scholar of Greek who could translate the rest.

He was to find that scholar in a young man called Marsilio Ficino, the nineteen-year-old son of his doctor. Cosimo fostered Ficino's talent for Greek and encouraged his interest in Plato, putting the family's collection of manuscripts at his disposal. In bringing together Ficino's inspired scholarship and Cosimo's great library, the stage had been set for a revival of that synthesis of ideas we know today as Neo-Platonism.

In any history of philosophy, Plato holds a key position. But although all his known works have survived, amplified even by others writing under his name, little is known in detail of the philosopher himself. He was born in an upper-class family of Athens and was an accomplished athlete and poet. His close association with his teacher, Socrates, led to a committed interest in philosophy, a commitment later reinforced by his master's execution on charges of impiety and corrupting the young. Plato was thirty-one years old at that time and, like most of Socrates' former associates, found it prudent to leave Athens for a while. He went to the city of Megara where Euclid lived and taught. On his return to Athens around 387 BC, Plato set up a school, his famous Academy. Although his was by no means the first of the Greek schools, it was something quite new. Earlier schools had basically been 'finishing schools' where one teacher taught well-to-do young men skills like rhetoric and speech-making in preparation for a life in public affairs. By contrast, Plato's Academy was non-vocational and offered a range of subjects taught by a variety of teachers. Its aims were strictly 'academic', the search for comprehension of the truth. The Academy was, in many ways, the forerunner of the medieval Universities.

First edition of Commento e della Traduzione di Plotino (Biblioteca Nazionale, Florence, Incun. Banca Rari 87, f.a ii r).

The core of Plato's teaching was his Theory of Forms. He believed that the objects and experiences of the everyday world take their pattern, in an imperfect way, from perfect Forms in the ideal world, a world more 'real' than ours. Plato's real world could be approached, he said, 'by the light of reason only, and without any assistance of sense'.[36] Through his teacher, Socrates, Plato had inherited much of the wisdom of the Pythagoreans, in particular the belief in a universal immortal soul from which individual souls parted and descended into mortal bodies, where they were trapped for a lifetime in imperfect material form. The point of earthly embodiment was to cleanse and enrich the soul in a series of lives to make it fit for an eventual return to the universal soul. Since this transmigration of souls united all living creatures, the Pythagoreans were strict vegetarians. These religious beliefs endorsed those of the already well-established Orphist tradition. But whereas the followers of Orpheus relied on ritual and ceremony to achieve salvation, the Pythagoreans saw the mental struggle to unravel the secrets of the universe as the only true way to bring man's nature closer to the divine.[37]

Together, the incarnation of souls and the notion of an Ideal World formed a convenient philosophical framework for the early Christian Church. The writings of Plato and his followers, especially Plotinus, found favour with the Church Fathers. St Augustine, perhaps the greatest Christian philosopher, saw no reason why Platonism should not be compatible with Christian dogma.[38]

Platonism was partly eclipsed by the re-assimilation of the works of Aristotle in the thirteenth century, and philosophy moved away from the super-reality of abstract ideals towards a revaluation of the experience of the senses. The Aristotelians concentrated their attention on the world they saw around them, arguing that what was not sensible was not knowable.

The Neo-Platonism of Renaissance Florence was not simply a revival of classical Platonism. Under the guidance of Marsilio Ficino, Neo-Platonic philosophy assimilated elements of Augustinian and scholastic Aristotelean thought so as to build a bridge between the dogma of Christian faith and the growing empiricism of natural science.

In 1463, Cosimo de' Medici turned his country villa at Careggi into a meeting place for the intellectuals of Florence who shared his fashionable interest in Neo-Platonism. At the villa, a candle was kept burning perpetually before the bust of Plato. Astrological symbols, considered appropriate for contemplation, were painted on the walls alongside philosophical slogans: 'From the good to the good' read one of them. A fresco of the Greek philosophers Heraclitus and Democritus showed one crying and the other laughing.[39] Careggi was seen as a re-creation of Plato's ancient Academy in Athens, and master of this new Platonic Academy was Marsilio Ficino. Cosimo gave him a

Ghirlandaio, 'Apparition of the Angel to Zachariah': detail from fresco showing Marsilio Ficino, Landino and de'Becchi, bottom left (Santa Maria Novella, Florence).

In 1471 the supremacy of Ficino's Platonic Academy was assured by the departure from Florence of rival philosophers in the Aristotelian tradition. From that time, Ficino lectured in the city as well as holding court as Careggi. In the years that followed, the bridge that Neo-Platonism had built between Christian theology and philosophy was paralleled in Ficino's own life by his reconciliation with the Church. At the age of forty, after much painful soul-searching, he was ordained into the Christian priesthood, and in 1487 he became a canon of Florence Cathedral.[40]

The touchstone of Ficino's Neo-Platonism was his study of one particular Platonic text, the *Symposium*.[41] Not only did he translate the work into Italian, but he also wrote his own commentary on the text called, appropriately, *De Amore*. Love, which Plato saw as the ultimate motivating force of the Cosmos, is in fact the subject of the *Symposium*. The word 'symposium' means a dinner party, and Plato literally made a meal of it, putting into the mouths of the guests at this fictional occasion a series of after-dinner speeches unfolding the layers of meaning of love. Although not published until two years later, manuscripts of Ficino's *De Amore* were

Marsilio Ficino, De Amore: *first page of the autograph manuscript (Biblioteca Laurenziana, Florence, MS Strozzi 98, f. 1).*

farmhouse nearby for his own private use, and probably as a small source of income. There Ficino engaged, in peaceful isolation, on his life's work of translating and expounding the classical texts of the Medici library.

The Platonic Academy was not an academy or college in our sense of the word: there were no students. It was more like a gentlemen's club for a learned circle of friends who came together for readings and debates centering on the teachings of Plato, as revealed by Ficino's new translations. Among its notable members were the celebrated poet, Angelo Poliziano; the brilliant humanist philosopher, Giovanni Pico della Mirandola, whose opinions were condemned by Pope Innocent III; and Cristoforo Landino, the poet and classical commentator for whom Botticelli illustrated Dante's *Divine Comedy*. Perhaps, on occasion, even Botticelli himself was to be found in the glittering company of the Platonic Academy. The purpose of their discussions was the pursuit of truth; truth as they saw it in Platonic terms. 'Yesterday I came to my villa of Careggi,' wrote Cosimo, 'not to cultivate my fields, but my soul.' Sadly, Cosimo was to die within a year of founding the Platonic Academy, but in those first twelve months, Ficino had already completed four translations. His enormous task of producing the first complete translation, into any Western language, of all Plato's *Dialogues* was under way. It was to take twenty-one years to finish the job.

first circulated among the members of the Academy in 1482, the same year that saw the publication of another of his books, *Theologia Platonica*. Together these two books provide the guidelines we need to set 'La Primavera' in its Neo-Platonic context.

In *De Amore*, Ficino demonstrates his belief that the revival of the true philosophy strengthened, rather than weakened, the true religion by uniting pagan and Christian in one bold statement: 'Those whom Plato calls gods and the souls of the spheres and stars we can call angels, ministers of God.' Neo-Platonism had reclaimed, for Christianity, a cosmology.

Returning to 'La Primavera' with new eyes, we can now see why it has such a devotional quality and why Botticelli's Venus seems strangely familiar. Her gesture and expression recall the Virgin Mary. In fact, the Venus of 'La Primavera' is closer to the conventional image of the Virgin of the Annunciation,[42] than she is to Botticelli's own portrayal of the same goddess in the 'Birth of Venus'. If we turn to the *Symposium* we can see how this identification between Venus and Virgin came to be made.

After everyone else has extolled the supremacy of love, the last of the after-dinner speeches goes to Plato's teacher and hero, Socrates. He points out that since love ever longs for the highest good, for Ficino, God, love cannot itself be that highest good, but must be the means by which it is reached. Therefore love is not God, but the road the soul must take back to God. For Christians, the Virgin Mary was the means whereby the highest good became incarnate as Christ. So it is no heresy for her to be seen as the Goddess of Love, Venus, in her purest aspect. As Ficino's Neo-Platonism unites philosophy and theology, so Botticelli's gracious lady is both Venus and Virgin.

But there is still another level of meaning to be read: the astrological. Ficino was passionately interested in astrology and its symbolism colours his surviving

'La Primavera': detail of Venus.

Andrea Baldovinetti, 'The Annunciation' (Galleria degli Uffizi, Florence).

Sandro Botticelli, Venus from 'The Birth of Venus' (Galleria degli Uffizi, Florence).

letters. In 1478, Ficino wrote, in his role of family counsellor, to the fifteen-year-old Lorenzo di Pierfrancesco de'Medici, urging him towards a virtuous and Christian life. Two years earlier Lorenzo's father had died, leaving him and his younger brother to the guardianship of Lorenzo the Magnificent, now head of the Medici family. Their father, Pierfrancesco de' Medici, had not always seen eye to eye with Cosimo and his successor, Lorenzo, but for a time the family was now reunited.[43] It was on the advice of Lorenzo the Magnificent that the two young brothers acquired the Villa Castello. He also seems to have had a hand in their education, both receiving tuition from Angelo Poliziano and, naturally, from Marsilio Ficino, the Medici's resident philosopher. It was in a paternal vein that Ficino wrote his exhortation to young Lorenzo. His consuming interest in astrology, which had been one of the hurdles on his troubled road to the Christian priesthood, led Ficino to cast his advice in the form of Lorenzo's horoscope. He singled out two particularly beneficial guiding stars: Venus and Mercury, the two leading protagonists of our painting, itself almost an illustration of Ficino's exhortation.[44] He described the planet Venus as 'humanitas', humanity. 'A nymph of excellent comeliness,' he wrote, 'born of Heaven, and more than others beloved by God all highest.'

So our Venus stands not just for Venus the antique Goddess of Love, not only for the Virgin Mary,[45] but also for Venus the evening star of the astrologers, and for that essential humanity, the soul, in all of us. Plotinus, the Greek philosopher of the second century who carried Platonism from the classical world into the Christian, had written, 'If the soul is the mother of Love, then Venus is identical with the soul.' Cupid, he goes on to say, represents the energy of the soul. In classical art Cupid was never shown as blind or blindfolded. His blindfold seems to have been acquired with his later Christianised meaning. The wantonness of Venus in her antique incarnation was sublimated and then cast upon her son. Cupid became the personification of blind passion and of the unfocussed energies of the soul, so Venus, her aspect of love now purified and directed towards the divine, could be identified with the Virgin Mary.

Like Venus, all the characters of 'La Primavera' resonate with multiple meanings unfolding the nature of Platonic love. As well as being messenger of the gods and guardian of secret knowledge, Mercury was also the god responsible for conducting souls to the Underworld of Hades. In antiquity the emblem of Death was not the familiar death's head skull but an inverted torch. In our painting, Mercury's cloak is covered with a motif of inverted flames, perhaps a scholarly reference to this gloomier aspect of Mercury's role.[46] But Botticelli also uses the same flame motif in other contexts where its meaning is quite different. In his illustrations of Dante's *Divine Comedy*, referred to above, Botticelli dots the spheres of Heaven with these upside-down flames

where they must be intended to represent either the fires of divine love or individual souls burning like stars in the crystal sphere of the firmament. The painting of 'The Virgin of the Book' in the Museo Poldi-Pezzoli, Milan, attributed to Botticelli only as recently as 1951, has the same flames in a badge-like formation on the shoulder of her cloak. Here they radiate downwards from a star, the 'stella maris' perhaps, and must surely represent divine love or inspiration. It was, after all, tongues of fire that came from heaven on the day of Pentecost and sat upon each of the Apostles 'and they were filled with the Holy Ghost, and began to speak with other tongues, as the Spirit gave them utterance'. What more appropriate motif could there be for Mercury, pagan god of communication and guardian of the secret knowledge, in his new Christian guise?

Now we can see why Marsilio Ficino singled out Venus and Mercury as Lorenzo di Pierfrancesco's guiding stars and exhorted the young man to emulate their exemplary qualities. It may even be that Botticelli takes the identification a stage further and gives us a

Sandro Botticelli, 'The Madonna of the Book' (Museo Poldi-Pezzoli, Milan).

Sando Botticelli, 'Portrait of a Young Man with a Medal'
(Galleria degli Uffizi, Florence).

'La Primavera': detail of head of Mercury.

portrait of Lorenzo as Mercury. A portrait by Botticelli of an unknown young man holding a medal[47] bears a striking resemblance to Mercury of 'La Primavera'. The flames of Mercury's cloak appear frequently in other works commissioned by the Medici,[48] and may be taken as one of their family emblems.[49] As Mercury was considered to be the guardian of peaceful commerce, the Medici bankers no doubt welcomed his patronage.

Mercury was also closely associated with music. He was said to have invented the lyre by stringing cow-gut across a tortoise shell. While Ficino credited Phoebus with the creation of serious music, by which he meant poetry, it was to Venus that he ascribed the invention of lighter music, music as we think of it. The importance of musical analogies in the philosophy of the day cannot be over-rated. Ficino followed astrology in believing that music came from Venus and Mercury, and stressed the importance of harmony almost as much as he did love. In a letter to Antonio Canigiani he wrote, 'anyone who has learned from the Pythagoreans . . . that the universal soul and body, as well as each living being, conform to musical proportion . . . will not be surprised that nearly all living beings are made captive by harmony.'[50]

According to the Pythagoreans harmony was the key to the order of the cosmos. They were the first to use the word 'cosmos', bringing together in one word the concepts of beauty and orderly structure. Order was governed by harmony. Harmony was mathematical and, ultimately, numerical. Pythagoras had studied the musical scale and discovered that the differently pitched notes that sound most pleasing when played together are related to one another by simple numerical ratios. The ratio of frequencies in an octave interval is 1:2, a fifth is 2:3 and a fourth 3:4. Since the beauty of sound depended on simple numerical ratios, it seemed obvious that the cosmos too must be ruled by such mathematical harmony. This was Pythagoras' music of the spheres. The idea that the underlying principle of existence was structural rather than material, that the building blocks of matter were not smaller bits of the same matter but harmonic vibrations, was a radical departure from traditional thinking with a strikingly modern ring to it.

Now Marsilio Ficino was himself an accomplished musician and an expert on musical theory. In his commentary on Plato's *Symposium* he uses the harmonic ratios of the musical scale as a metaphor for the soul's

return to the Ideal: rising from the tonic, through the discord of the second, the varying harmonies of the third, fourth, dominant fifth, and sixth, through the discord of the seventh until it comes to rest in the perfect harmony of unison. And astonishingly enough, this same metaphor is embodied in Botticelli's 'La Primavera', the figures strung across the painting like the notes of the octave. Mercury and Zephyr are the tonic notes. All those in harmony with them face the same way, while the discords, the second and seventh 'notes' turn the other way. These dancing figures have been interpreted as a procession. But a procession that has the people at the back charging forwards, some of those in the middle going in a circle, and the leader standing still is heading only for chaos! Not a procession therefore, but a progression. A progression 'from the good to the good'; like a scale from the tonic to the tonic, with Venus, Love, as the dominant.

The way in which Venus stands back slightly divides our scale of figures into three groups: Mercury and the Three Graces on the left, Venus and Cupid in the centre and Zephyr, Chloris and Flora on the right. Surely by more than coincidence, the groups divide the painting in the same ratios as the number of figures in each group, four, two, and three. If the painting is therefore seen as being a total of nine units long, the groups divide the length of the picture in the important ratio of 4:6:9. This ratio was known in musical harmony as the 'double diapente'.[51] The 'diapente' was the Renaissance term for what we now call the musical interval of the 'fifth', its numerical equivalent being the ratio 2:3. The composition of 'La Primavera' is built up on units of this ratio, set in the same ratio to itself: that is, two times the 2:3 ratio, (4:6), to three times the 2:3 ratio, (6:9).

The basic division of the composition into three was of special significance to the Neo-Platonists. Three was considered an important number and crops up endlessly

in their writings. Pythagoras had called it the number of completion, having a beginning, a middle, and an end. According to Neo-Platonism, God alone is Unity and he governs all else in threes. The members of the Platonic Academy spent much time arranging their ideas into neat triads. Christianity, of course, had long had its sacred triad of God the Father, God the Son, and God the Holy Ghost. In the same way, the classical deities were now resolved into triple aspects: Venus into the Three Graces, Necessity into the Three Fates, and Saturn into Jupiter, Neptune and Pluto.[52] Ficino's writings even produce triads within triads. He describes Venus as a triple love: the love felt by the Body; the love apprehended by the Soul; and the love comprehended by the Pure Intellect. Then he resolves the love of the Soul into a further three aspects: active, contemplative and voluptuous love.

But over and above all their triple divisions and subdivisions, the Neo-Platonists saw one all-embracing triadic movement. Expressed as *emanatio; raptio; remeatio*, it represented the working of divine love. *Emanatio* was the outflowing from the divine. *Raptio* was its incarnation in earthly things, by which they were seized and changed. *Remeatio* was the return through that conversion to the divine. This triple rhythm was repeated endlessly, breathing divine love into the cosmos. And it is precisely this elusive abstraction that Botticelli clothes so exquisitely in 'La Primavera'.

In his painting Botticelli personifies the triple love of Venus: in Ficino's terms, the loves of the body, the soul and the pure intellect. Guided by the principle of '*emanatio; raptio; remeatio*' Ficino describes love, born of God, progressing from the body to the soul, from the soul to the pure intellect, and from the pure intellect back to God. Botticelli personifies the love of the body as the wind Zephyr, the generative spirit of sexual desire, whose union with Chloris brings fertility and

Analysis of composition of 'La Primavera' in the proportions of 4:6:9, the ratios of the 'double diapente' (after Bouleau).

colour to the world. But this desire is not just physical. Zephyr ravishes Chloris by blowing 'a gale of passion' in her ear, for Ficino the least fleshly of the organs.[53] Breath and spirit share the same word *spiritus* in Latin. She in turn breathes out flowers to transform herself into Flora. It is breath, the *spiritus*, that is the agent of music, of generation and of change. And to underline this allusion to the incarnation of the spirit, Botticelli places an iris immediately beneath the figure of Chloris. The iris, noted earlier, was among the standard emblems of the Virgin Mary. It was the symbol of her immaculate conception, one of the legends that had grown up around the Virgin's life. Through their union, Zephyr, Chloris and Flora form a triad which enables the *emanatio* to pass to its next stage, the love of the soul.

The love of the soul, the *raptio*, is represented by Venus as *humanitas*. Following Ficino closely, the love of the soul is then resolved into its three aspects: active, contemplative and voluptuous love, personified by the Three Graces. The Grace of active love, on the right of the group, strikes a dynamic pose which echoes that of Mercury and urges the composition in his direction. Her hair is dressed into an elegant coiffure and she wears a jewel around her neck. On the left of the group, voluptuous love has wantonly flowing tresses and a more ostentatious jewel. She turns her back to Mercury and gazes rather wilfully at contemplative love, the central of the three sisters. Contemplative love, wearing no jewel and her hair braided chastely, looks wistfully over her sister's shoulder towards Mercury. Together the Graces form a second triad: a triad of conversion that enables the love of the soul to pass on to the love of the pure intellect.

The love of the pure intellect is Mercury, the guardian of secret wisdom, whose staff pierces the cloud of unknowing, directing us beyond the picture back to the ultimate source of all love. The cycle of '*emanatio, raptio, remeatio*', is completed only to begin again. The figures of Mercury and Zephyr are literally and metaphorically the bookends of our picture, the same only different we might say, like the two tonics of a musical scale.

'La Primavera' clearly expresses Ficino's Neo-Platonism both in its content and in its composition. In the musical scale of our painting the two discordant notes, the second and seventh, fall to the voluptuous Grace and poor Chloris who, turning back from Mercury to the sexual, are out of harmony with the direction of the pure intellect.

In Ficino's cosmology the ascent is from the multiple and mutable to the One and unchanging. In our impossible procession all the action is at the back where the onrush of Zephyr causes the metamorphosis of Chloris. All the stillness is at the front with the single, stationary figure of Mercury. Between them the soul, Venus, is poised with one foot in time and one in eternity, and the Three Graces choreograph a compromise between movement and stillness in their circular dance, returning forever upon itself.

Between multiplicity and unity, between movement and rest, between incarnation of the soul and its rapturous return, lies our earthly life. In July 1481, earthly life brought Lorenzo di Pierfrancesco de'Medici to his betrothal: a time for paternal advice, a time for presents and a time for the celebration of love, all of them here in Botticelli's 'La Primavera'. His bride was Semiramide d'Appiani, like the groom, an orphan. The match was almost certainly masterminded by his guardian and second cousin, Lorenzo the Magnificent. The head of the Medici family had provided the bride with a generous dowry.[54] Did he also give the couple some of the furnishings of their bridal suite as a wedding

Sandro Botticelli, 'Mars and Venus' (National Gallery, London).

54

present for the Casa Vecchia? It seems likely that 'La Primavera' was commissioned by Lorenzo the Magnificent on the announcement of his cousin's betrothal, a full year before the wedding. This was certainly the practice for *cassone* and other painted furniture which were produced between the betrothal and the actual wedding. The commission went to Florence's foremost painter of the day, Sandro Botticelli, who set to work straight away and presumably finished the picture before he left immediately for Rome to work on the Sistine Chapel. For the subject of the painting, Lorenzo the Magnificent would have turned inevitably to the man who had been counsellor and friend to the family for two generations, Marsilio Ficino. Ficino, about to publish his *Theologia Platonica* the following year and putting the finishing touches to *De Amore* at that very moment, had an eminently suitable subject for a wedding present at the forefront of his mind: love, platonic love in its true meaning. For as Ficino had written, 'If we love the Body, the Soul or the Pure Intellect, we do not really love these, but God in them. The shadow of God in bodies, the likeness of God in the soul and the image of God in the pure intellect. So in the present we shall love God in everything, so that in the future we may love everything in God.'[55] Might not our painting's forgotten title be 'The Gospel of Platonic Love'?

Ficino's *De Amore* provided a wealth of literary images of the many aspects of love. There, Botticelli found inspiration for several of his pictures. The painting of 'Mars and Venus' in the National Gallery, showing the triumph of Venus over Mars, provides a perfect visual expression of the relationship between the Goddess of Love and the God of War expounded by Ficino in his commentary: 'Venus often shackles, so to speak, the malignancy of Mars, by coming into conjunction or opposition with him . . . Here she seems to make Mars more gentle and thus to dominate him. But Mars never dominates Venus . . . Mars also follows Venus; Venus does not follow Mars, since boldness is a follower of love, not love of boldness. For men are not ensnared by love from the fact that they are brave, but very often, from the fact that they are wounded by love, they become very bold, and fearlessly undergo any dangers, for the sake of the beloved.'[56]

The harmony and tranquillity of 'La Primavera' reflect Ficino and Botticelli at the height of their powers, and Florence at the moment of its greatest glory. But such moments are certain to pass. The same year of 1482 that brought together Lorenzo's wedding, the circulation of Ficino's *De Amore* and the peak of Botticelli's career, was also the year that brought the priest Savonarola to Florence to sow the seeds of discord in the harmonious garden of Neo-Platonism. The Dominican friar was sent as a preacher to the monks of San Marco. He was a charismatic speaker whose fiery sermons called for urgent reform in the Church and voiced strong criticism of the Medici family's govern-

ment. His new brand of puritanism was much to popular taste and the old intelligentsia, Ficino among them, felt the long and dark shadow of Savanarola fall across their lives.

Within the Medici family, the concord between the junior and senior branches of the family that had marked Lorenzo di Pierfrancesco's wedding was being eroded by suspicion. Old grievances were reopened. Lorenzo and his brother Giovanni accused Lorenzo the Magnificent of witholding profits that were rightfully theirs, and refusing to repay loans that had been made to him by their father.[57] The family soon had political as well as personal problems. After the death of Lorenzo the Magnificent, the Medici, now headed by Piero, began to lose their grip on the reins of power. Within Florence opposition to Medici rule, fanned by the preaching of Savonarola, was gaining ground. Meanwhile, to the north the French army was poised across the Alps to invade Italy. Lorenzo di Pierfrancesco had acted as ambassador to France, and he and his brother were on friendly terms with the French king, Charles VIII. The brothers were charged with plotting with the King of France against Piero and confined to their country homes. But when the French entered northern Italy they broke their confinement and joined the invading forces. On their return to Florence three days later, they found their cousin Piero had been driven out by a population enraged over his mishandling of the French crisis.

Sandro Botticelli, 'La Derelitta' (Pallavicini Collection, Rome).

55

Marsilio Ficino's fortunes had been closely tied to the Medici family throughout his life. Now, with the Neo-Platonists' circle broken up and the Medici exiled from Florence, he had little choice but to leave the city himself and retire into the anonymity of the country. In the light of events, we might look back at 'La Primavera', with all its elitist and esoteric meanings, as a poignant symbol of the estrangement that had grown up between the aristocracy and intellegentsia of Florence, and the population on whom their wealth and position had depended. Botticelli painted one more picture probably derived from the text of Ficino's *De Amore*. The painting, thought to have been part of a *cassone* decorated with the story of Esther, ostensibly shows the 'Sorrow of Mordecai', but at the same time it surely draws upon Ficino's bleaker passages on the sorrows of love which may leave us 'Bare-footed . . . Humble . . . Without a home . . . Sleeping on door-steps . . .',[58] in short, rejected – just as Florence had ultimately rejected Ficino's Platonic Love.

Lorenzo di Pierfrancesco and his brother changed their family name by public decree from Medici to Populani, but their identification with the common man was probably more a matter of expediency than heart-felt committment. Lorenzo continued to employ Sandro Botticelli as his favourite artist and the painter was still in demand until the close of the century. In his last years, eclipsed by Michelangelo and Leonardo da Vinci, he retreated to the private world of his Dante drawings where Venus, *humanitas*, the soul, now walks in the guise of Beatrice.

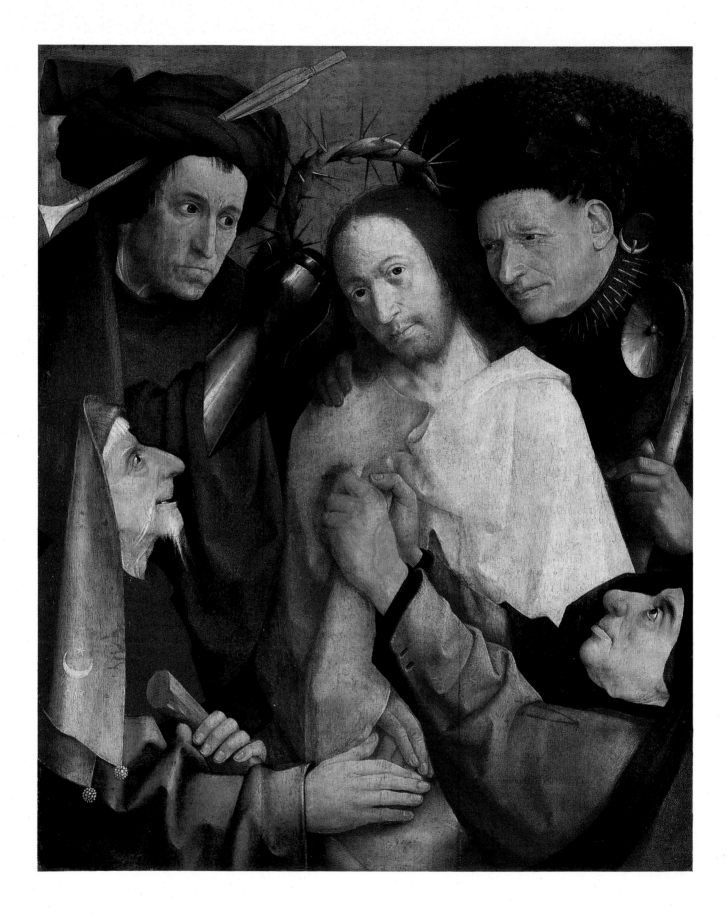

Chapter 5

Christ Crowned with Thorns
by Hieronymus Bosch

At first sight, it is hard to believe that Hieronymus Bosch's painting of 'Christ Crowned with Thorns' in the National Gallery, London,[1] could have come from the brush that stirred up a thousand and one nightmare images. Bosch is synonymous with the bizarre: his very name conjures up a world of hellish fantasy. Yet this paradoxically serene moment, frozen from the story of Christ's Passion, has none of the frenzy we normally associate with his painting. This picture is the calm 'eye in the hurricane' of Bosch's turbulent work.

The striking imagery of Bosch's paintings provokes an immediate emotional reaction, but our intellectual response is largely inhibited by the painter's enigmatic iconography, which confronts the modern mind with a mass of confusing riddles. In his vocabulary of visual expression, Bosch is the most remote of the five artists considered in this book. Although his style has affinities with other painters, it cannot be said to belong to any particular school. Bosch's individuality was the product of a fertile imagination working largely in isolation: a narrow life led in a provincial city largely untouched by the cultural mainstream of the Low Countries.

Hieronymus Bosch lived in the city of S'Hertogenbosch,[2] the capital of the North Brabant region of the Low Countries. He was born into the van Aken family who had been painters there for at least three generations. His grandfather, Jan van Aken, is mentioned in the archives of S'Hertogenbosch cathedral, which was still being built in Bosch's day. Jan van Aken is thought to have painted frescos in the cathedral, where a Crucifixion of c.1444 may be his handiwork.[3] Since the family was long established in the city, it is generally assumed, though not actually proven,[4] that Hieronymus was born in S'Hertogenbosch around the middle of the fifteenth century and adopted the shortened form of the city's name as his own, perhaps to distinguish his work from that of his father, uncles and brothers.

Although S'Hertogenbosch was a prosperous enough city, it was no hot-house of culture. It had no university and fostered no other major artist. Bosch was on his own, so to speak, insulated from the influence of artistic and intellectual centres like Antwerp, Ghent, Bruges and Louvain. To the masters of these cities, Bosch's work would have seemed decidedly 'provincial'. His painting had its roots in the International Gothic style that he had inherited from his family: a tradition embodied in the gothic cathedral still rising in the midst of S'Hertogenbosch, but already fallen out of favour in more progressive areas of Europe. Some of Bosch's puppet-like figures and crowded compostions would have looked very old-fashioned to more cosmopolitan eyes. There is no reason to suppose that Bosch ever travelled far from his home town, so it may be assumed that innovation in his work was through his own personal development, fed by the more 'portable' art of popular woodcuts, devotional prints and manuscript illuminations. It is not surprising that such a restricted environment, like the evolution of animals on isolated islands, encouraged eccentricity in Bosch's creations. The financial independence afforded by a judicious marriage must also have freed Bosch from the rigours of patronage and allowed him to explore the world of his own imagination, a privilege denied most artists for centuries to come. He had married Aleyt, a daughter of the aristocratic van der Mevenne family. The match was a step up the social scale for the son of a painter and a tailor's daughter. Judging by the high level of taxes he paid, Bosch lived in comfort and enjoyed a growing reputation for the rest of his life.

At least one of his paintings was to be seen in the palace of Henry III of Nassau in Brussels.[5] Others were owned by Phillip the Fair and his sister, Margaret of Austria.[6] Bosch had achieved a reputation that outlived his death in 1516. In the latter part of the sixteenth century, Phillip II of Spain gathered together a large collection of Bosch pictures to display in the Escorial and the Royal Palace at Madrid, where the panel of 'The Seven Deadly Sins' hung in the King's own room.[7] Then for four hundred years, Bosch's work was ignored by collectors and artists alike. From the end of the

nineteenth century onwards, however, interest in Bosch's painting was renewed, stimulated, in part perhaps, by the advent of psychoanalysis and later by the Surrealist movement – both concepts which would have been quite alien to Bosch.

Although it is the eccentric and the bizarre in Bosch's imagery that appeal most to the modern eye, the popularity of Bosch's work in his own day would lead us to believe that neither he nor his audience saw it as anything other than conventional. Yet it is Bosch's departures from the artistic norm rather than his conformities that intrigue us and urge us to try to discover the meanings of his pictures. 'Christ Crowned with Thorns' is especially interesting in this respect since it presents us with a double departure: the painting differs dramatically from the artist's own usual style, and it differs subtly from the standardised representation of the scene as it had been evolved during the preceding centuries.

Like generations of artists before him, Bosch was expected to turn out a repertoire of scenes from the Passion of Christ. The earthly sufferings and Crucifixion of Christ had gradually been given greater prominence since a shift in theological emphasis during the ninth century.[8] Until that time the veneration of Christ had centred on the exaltation of His image as Christ in Majesty ruling over the Heavenly Kingdom. But during the ninth century, the interrelationship between the Passion of Christ, the symbolic sacrifice of the mass and human sin claimed theological priority.[9] This new emphasis had two important consequences. Through the re-enactment of Christ's expiatory self-sacrifice in the mass, the Church gained a monopoly in administering salvation to the individual (though the doctrine of transubstantiation was not to be official dogma until the Fourth Lateran Council in 1215). This in turn led to a greater demand for devotional images of Christ's Passion, in particular the Body of Christ on the Cross with the Blood flowing from His wounds, the origin of the sacramental bread and wine of the mass. The icon of Christ in Majesty was relegated to secondary importance, and became increasingly identified with His portrayal as the judge of 'the quick and the dead' in the narrative scene of the Last Judgement. Preoccupation with the Passion grew steadily, fostered particularly by St Bernard of Clairvaux during the twelfth century. In 1264, the feast of Corpus Christi was made an official holy-day in the calendar of the Western Church. But it did not acquire this status in the Eastern Church where there had not been the same marked shift towards the Passion. For some time the figure of Christ on the Cross had retained much of the dignity of Christ in Majesty, ruling, as it were, from the Cross rather than the throne. But from the thirteenth century onwards, the pain and humiliation of the Passion became more evident. The Body on the Cross grew broken and pathetic, rather than triumphant and majestic. Each episode of the Passion was given special signifi-

cances and symbols. Resonances were drawn from the Old Testament, of the 'type and anti-type' kind discussed in the earlier chapter on van Eyck's 'The Madonna and Chancellor Rolin'. The mocking of the drunken Noah by his youngest son, for instance, was seen as the type for the mocking of Christ.

By Bosch's day, the Passion and the Stations of the Cross had been parcelled out into a complex system for devotional meditation, represented by a sequence of standardised scenes. These scenes were illustrated in the illuminated manuscripts of the rich, and in the block-books of the less well-off. The poor saw them in the stained glass windows of their church and painted on its walls. They were acted out in the cycles of Mystery Plays performed annually by the guilds and religious fraternities of every prosperous town. The epic story of the Bible from Creation to Last Judgement passed before their eyes, the climax being the Passion of Christ played out in agonisingly prolonged and cathartic detail. Dramatic and pictorial representations each influenced the other.[10] Together, they provided the medieval artist with a standardised vocabulary of imagery that everyone understood at a glance.

In the Biblical sequence of the Passion, Christ is mocked twice: firstly, by the Jews, and secondly, by Roman soldiers when the condemned Christ is dressed in a purple robe with a ring of thorns for a crown and a reed for a sceptre.[11] Early representations of the second mocking, the Crowning with Thorns as it is usually known, show none of the suffering and pathos that was to characterise the late medieval scene. A fourth-century Roman sarcophagus,[12] for instance, shows Christ standing upright and dignified, while a legionary places a wreath upon His head as though He were a victorious emperor. The Crowning with Thorns was seen as heralding Christ's triumph over death: it was a true coronation. The physical cruelty of the tormentors and the pain of Christ's suffering did not find overt expression until as late as the fourteenth century. Until then, it seems that the formalised irony of the mock coronation was humiliation enough. A wall painting by Giotto in the Arena Chapel at Padua, painted during the first decade of the fourteenth century, shows the first evidence of a new mood of drama and violence in the representation of the Crowning with Thorns. The body of Christ is no longer inviolate. Tormentors strike at Him with sticks and pull at His hair and beard. By the late fifteenth century the original ambiguity and irony of the Crowning with Thorns had been swamped by an obsession with its suffering and degradation. The traditional representation of the scene now shows Christ seated on a bench surrounded by tormentors, two of whom use long wooden staves to force the Crown of Thorns down on to His brow. Christ is sometimes blindfolded. Other tormentors hit Him with their fists, tear at His hair and clothes, or kneel in mock homage. In both painting and drama the Crowning with Thorns had become a standardised scene of callous violence.

Lucas Cranach, 'The Crowning with Thorns', from Passion cycle (British Museum, Dept. of Prints and Drawings).

To the contemporary viewer the most striking feature of Bosch's painting of the Crowning with Thorns must have been not what he shows but what he does not show. In a remarkable break with tradition, instead of the usual violence, we see the split second before that violence strikes. Not a drop of blood has yet been spilt. For generations the Passion of Christ had provided artists with an excuse to revel in horror, leaving the smell of stale blood as their pungent legacy. Yet in this picture Bosch, who could have outdone any one of them on that score, has held back. Why this deliberate restraint?

We can be sure that Bosch was quite capable of reproducing the absolutely standard version of the Crowning with Thorns because he does so in the grisaille painting of the Mass of St Gregory on the outside of the wings of the Epiphany Altarpiece,[13] painted around the same time as our picture. And his two other known paintings of the Crowning with Thorns, though they move towards ours in composition and emotional tone, still retain the traditional sense of violence and pathos that our painting transcends. One is known only from copies.[14] But the second, a

tondo in the Escorial,[15] is unanimously acknowledged as Bosch's own work. The border of the tondo is filled with grisaille painting of the Battle and Fall of the Rebel Angels, an invitation, perhaps, to regard the Passion of Christ in a wider dimension: as Creation went awry through the Pride of Lucifer, so it is redeemed by the Humility of Christ.

Similarly, by his departures from the artistic norm in the National Gallery's 'Christ Crowned with Thorns', Bosch is asking us to look beyond the immediate brutality of Jesus beset by four bully-boys in the spring of AD 33 to things more universal. As we shall see, the enigmatic emblems that Bosch has assembled in this deceptively simple picture lead us to allusions both topical and timeless. From the topical scandals of the Church, to Man's timeless striving for an understanding of his own nature and his place in the order of the cosmos – a journey that makes travelling companions of alchemy and theology, astrology and philosophy. To the modern mind these seem disparate, even contradictory, disciplines. To the medieval mind they were not so. The people of Bosch's day saw themselves as living within a continuum in which the physical, metaphysical and spiritual not only co-existed but interrelated. Our exposition of Bosch's 'Christ Crowned with Thorns' will present a progression of interpretations of the four figures that encircle Christ. These interpretations are not alternatives; they are concentric layers of meaning that lead us ever inwards to the crucial late-medieval theme of personal salvation through identification with the Passion of Christ.

The devout of the Middle Ages did not see the Passion of Christ as just a distant historical event. They believed that their own sins continued to torment and wound the actual Body of Christ in a perpetual Passion. When Christ's sufferings were acted out in the Mystery Plays, the performers were not dressed in the costume of the Biblical Holy Land, but in contemporary clothes that brought home the immediacy of the perpetual Passion. Bosch follows this convention in our painting, showing Christ's tormentors wearing the fashions of his time. And the contemporary costume leads us to a contemporary reference, the outermost of our layers of meaning.

In the early sixteenth century, it seemed to many Christians that the Passion of Christ was being re-enacted in scandalous attacks upon the Body of the Church by the Papacy itself. Bosch was painting 'Christ Crowned with Thorns' only a few years before the outcry against corruption in the hierarchy of the established Church reached a climax in 1517, when Martin Luther nailed his ninety-five propositions to the church door at Wittenberg, precipitating the Church into Reformation.[16] Bosch had often singled out the religious orders and upper echelons of the Church for particularly sadistic treatment in his depictions of Hell. 'Christ Crowned with Thorns' implies the same criticism, but more subtly.

61

Illuminated initial from 'The Compendium of Christian Faith' showing the emblems of the Passion.

Venice. He was resolved to recover absolute authority in the territories that had been lost by his predecessors. Europe was scandalised as the Pope took upon himself the role of a general. Money, diverted from the Papal treasury or raised by heavy loans from the Jews, was 'laundered' to pay for mercenary troops to further Julius' militaristic ambitions. In Rome, wrote Michelangelo, 'helms and swords are made of chalices: the blood of Christ is sold so much the quart: His cross and thorns are spears and shields'.[17] Something of Michelangelo's bitter-sweet attitude towards his patron was expressed in a huge and awesome statue of the Pope, commissioned to stand as an admonition to the people of Bologna whose city had recently fallen prey to the Papal troops.[18] Michelangelo showed Julius giving the benediction with a grasping gesture that seemed more a threat than a blessing. As soon as they were free of the Pope in 1511, the Bolognese melted down the bronze statue to make, appropriately enough, a cannon.

In Northern Europe, the sense of outrage among intellectuals was led by Desiderius Erasmus, the most outstanding scholar of that age. He made frequent derogatory comparisons between Pope Julius II and his namesake, Julius Caesar. In 1506, Erasmus wrote from Bologna that the Pope was 'waging war, conquering, leading triumphal processions; in fact, playing Julius to the life . . .'[19] But he prudently reserved his most acid criticism until after Julius' death. In *Julius Exclusus*, usually attributed to Erasmus, Julius is shut out of

The Bible apportions the blame for the Crucifixion of Christ between all classes of society, lay and spiritual. The standard medieval representation of the Emblems of the Passion shows the face of Christ surrounded by four heads representing the church, the ruling class, the bourgeois and the peasant. Bosch exploits the familiarity of this arrangement of heads in his composition for our painting, but he extends the parallel beyond its social generalisation to point the finger at specific targets of his day.

The para-military outfits of the upper figures would have brought to mind the mercenary armies which were the scourge of Europe. The oak leaves worn in the hat of the tormentor in the top right-hand corner of the picture would have been instantly recognised as the badge of the della Rovere family, in particular of Giuliano della Rovere (1443–1513) who had become Pope Julius II in 1503. Julius did nothing to inhibit the sale of indulgences and other corrupt practices that had brought the Church into disrepute. In fact, he made matters worse. In an attempt to enhance the Church's tarnished authority, Julius II tried to buttress the spiritual power of the Papacy by emphasising external pomp and glory, and to strengthen its temporal power by devious diplomacy and military force. In 1509, Julius joined league with the Holy Roman Emperor, Maximilian I, and Louis XII of France against the Republic of

Badge of oak leaves in the hat of Christ's tormentor.

Heaven for his earthly sins. At the gates of Heaven, St Peter voices the revulsion of Europe: 'While you wear on the outside the splendid attire of a priest, underneath you are utterly horrendous with the clatter of bloody weapons.'[20] 'Happy indeed is the Pope,' says Erasmus' St Peter, 'if he can make a mockery of Christ.'[21]

It is precisely that mockery which Bosch portrays in our painting. The tormentor with his badge of oak leaves is surely a hired soldier or official, in the pay of the Pope himself: the representative of spiritual power in the standard medieval layout of the Emblems of the Passion. By the same analogy, the second upper figure should represent temporal power, and indeed he does. This tormentor, with the bolt of a cross-bow through his hat, also appears in both Bosch's other versions of the Crowning with Thorns. The tondo in the Escorial shows him wearing a badge of the double-headed eagle of the Holy Roman Empire. So in these two tormentors we may see the alliance of the Pope and the Emperor against the Body of the Church. Having accounted for the spiritual and temporal, the bishop and the king, the standard format of the Emblems of the Passion leaves us with the bourgeois and the peasant. In our painting, the lower left-hand figure wears the costume of a rich merchant, the hanging corners of his headdress weighted with pearl-encrusted baubles, and the tormentor on the right wears the everyday dress of the period. But here again Bosch is more specific. Among the accusations levelled against Pope Julius II, the most vehement were that not only did he borrow money from the Jews, and thereby encourage usury, but he was even prepared to make alliances with the infidel Turks, universally resented by Christians since the failure of the Crusades to recapture Jerusalem. So Bosch further identifies the right-hand figure as a Jew by his physiognomy, and the left-hand figure as an infidel by the crescent moon and star of Islam on his headdress.[22]

Here then is the traditional layout of the four faces of the Emblems of the Passion, representing the apportioning of blame for the sufferings of Christ, reassigned by Bosch to illustrate the four forces that were seen to be attacking the Body of the Church in his own day: the corrupt Papacy, the Emperor, the Infidel and the Jew. But Bosch gives us far more than a thinly-disguised political cartoon. We have penetrated only the first, contemporary layer of meaning.

Compared with most of his work, the burghers of S'Hertogenbosch would probably have found Bosch's 'Christ Crowned with Thorns' shockingly 'modern', particularly in its composition. His use of a group of half-length figures isolated against a plain background, with the central figure of Christ looking out towards the viewer, had its origins in Northern Italy. There had long been a two-way traffic of artistic ideas between the Low Countries and Italy, initiated by the arrival of Hugo van der Goes, 'Portinari Altarpiece' in Florence in, or just after, 1475.[23] Van der Goes' rich, but controlled, use of colour and the sheer virtuousity of his oil technique caused a sensation among Florentine painters and patrons. Some thirty years later, Michelangelo's painting of the Madonna for Bruges cathedral was causing a similar stir in the Low Countries.

In our opinion, the composition Bosch uses for 'Christ Crowned with Thorns' can be traced back to a prototype by Leonardo da Vinci: his picture of 'Christ Disputing among the Doctors', painted in 1504, probably for Isabella D'Este. The painting is now lost and we know it only from a copy by Bernadino Luini in the National Gallery, London. The seminal influence of Leonardo hardly needs to be re-stated. His composition for 'Christ Disputing among the Doctors' is clearly reflected in other pictures of the same subject painted by his contemporaries.[24] Albrecht Dürer, whose career overlaps with Bosch's, travelled twice from Nuremberg to Venice where he was profoundly influenced by the work of Leonardo. On his second visit, between 1505 and 1507, we know that he met Giovanni Bellini, one of the artists who painted 'Christ Disputing among the Doctors' after Leonardo's composition. Was it from Bellini that he learned something of Leonardo's ideas, or did he, perhaps, meet the master himself?

Dürer's engraving of the 'Virgin and Child with a Monkey' shows a knowledge of the central figures of Leonardo's 'Adoration of the Magi' of 1481, now in the Uffizi Gallery in Florence. We do not know how Leonardo's compositions were disseminated among his admirers, many of whom were in Venice, which he had visited briefly in 1500. But Dürer's work proves that they were known, either through sketches or lost prints. A preparatory sketch for Dürer's engraving of 'The Knight, Death and the Devil'[25] reveals that he drew the horse according to a method devised by Leonardo, constructing the body from square units based on the length of the horse's head.[26]

While in Venice, in 1506, Dürer painted his own version of 'Christ Disputing among the Doctors'. Inspired, inevitably, by Leonardo's conception of the scene, the painting is in complete contrast with Dürer's engraving of the same subject two years earlier. The engraving, from a series of the Life of the Virgin, shows a spacious furnished room with pillars in perspective leading to the full-length figure of Christ sitting at a reading desk – the traditional visual representation of the story. The simple narrative scene of the engraving has none of the heightened intensity that the 'close-up' view, borrowed from Leonardo, brings to the painting. Luini, in his usual way, conventionalised and sweetened Leonardo's composition in his version of Christ among the Doctors. Dürer, acting true to his form, exaggerated and coarsened it. Leonardo's lost original will have been somewhere between these two extremes.

Although we have no evidence that Hieronymus Bosch ever left his home town of S'Hertogenbosch, equally we have no proof that he spent his entire life rooted by his own fireside. Even if he did not travel as far as Italy, a wealthy man like Bosch must have had the

*Albrecht Dürer, 'Christ among the Doctors'
(Thyssen-Bornemisza Collection, Lugano).*

*Bernardino Luini, 'Christ among the Doctors' (National
Gallery, London).*

opportunity, at least, to catch the Italian influence at second-hand. Perhaps it was Dürer who provided the link between Leonardo's innovative use of this arrangement of figures and its appearance in Bosch's work. Besides the basic composition, two other aspects of Dürer's 'Christ Disputing among the Doctors' find echos in Bosch's 'Christ Crowned with Thorns': the carefully differentiated faces of the people around Christ and the choreographed interplay of their hands. Although the connection is inferred and far from proven, there is a pleasing intellectual symmetry in seeing this episode from the very start of Christ's earthly ministry reflected in Bosch's scene from its end.

Bosch would certainly have been fascinated by Leonardo's now famous pages of drawings of grotesque heads. The grim, almost sub-human, faces packed into Bosch's painting of 'Christ Carrying the Cross'[27] tempt us into believing that, late in his life, he must have acquired some knowledge of Leonardo's work. In the painting of the Low Countries, ugliness had long been equated with moral degeneration. But the Renaissance brought a more analytical dimension to the study of physiognomy, seeking to link physical appearance to intellectual and emotional qualities. According to medieval medicine, defects of body and mind were caused by the inbalance of the four fluids which were thought to govern the constitution of the body, the four 'humours': blood, phlegm, black bile and yellow bile. The ideal man had all four humours in perfect balance. In lesser mortals, the varying mixture of humours accounted for differences of personality and physique. An excess of any one humour produced an individual of a particular temperament or 'complexion': an excess of blood made a man sanguine; phlegm, phlegmatic; black bile, melancholic; and yellow bile, choleric. This theory had first been suggested by the ancient Greek philosopher, Hippocrates (c.460–c.377 BC), the 'Father of Medicine'. It was bequeathed to the medieval world through the writings of Galen (c.129–c.200 AD), whose teachings were considered almost infallible until after the Renaissance. Through medical texts and popular almanacks, the four humours and their corresponding temperaments were made familiar to everyone from the court physician to the housewife tending her patch of herbs.

The Guildbook of the Barber Surgeons of York[28] provides a typical example of a late medieval medical text. It is really a glorified almanack giving information about the planets and the signs of the zodiac, saints' days and rules for working out the dates of the moveable feasts of the Church, beneficial times for 'bleeding', guidelines for good health and, of course, the theory of the four humours and temperaments. The Guildbook devotes a whole page to an illustration of the theory. In the centre is the head of Christ, representing the ideal man with all four humours in perfect balance, and around Him are four figures representing the human temperaments. It is

Leonardo da Vinci, drawing of grotesque heads (Royal Library, Windsor Castle, C.12495).

represents the sanguine type. St Peter, recognised by his key, is the phlegmatic. St Mark, named on the scroll in his hand, is the choleric. St Paul, identified by his sword, is the remaining temperament, the melancholic. By assigning one of the temperaments to each of the four Apostles, Dürer is making them stand as representatives of all Mankind.

Since the four temperaments are not Christ's Apostles but his tormentors in Bosch's painting, it is their least attractive qualities that we must expect to find portrayed in 'Christ Crowned with Thorns'. The more active temperaments of the sanguine and the choleric tended to be associated with the energies of youth, while the more contemplative temperaments belonged to middle and old age. The phlegmatic was usually the oldest, portrayed with pallid complexion, wispy white hair and beard, his eyes and nose watering with age – a description that admirably fits the lower left-hand face of our painting. The melancholic, lowest in spirit and often heaviest in physique, was most frequently per-

Guildbook of the Barber Surgeons of York: miniature showing head of Christ surrounded by figures representing the four temperaments (British Library, MS Egerton 2572, f. 51v).

no coincidence that we find, once again, a layout analogous to the composition that Bosch uses in his 'Christ Crowned with Thorns': the head of Christ surrounded by four precisely defined physiognomies. Like doctors, artists were professionally concerned with facial types and what they revealed about personality. Ours is not the first suggestion that the four tormentors of Bosch's painting were meant to personify the four temperaments,[29] nor was Bosch the only artist to employ this metaphor.

Albrecht Dürer, whose work has already provided one interesting parallel, produced a woodcut called 'The Men's Bath House' around 1496, two years after he first travelled to Italy with the express purpose of studying human form. He uses the subject to illustrate the five senses and to explore the differences between the physiology of the four temperaments. Thirty years later, in what was probably his last painting, we find Dürer applying the same device to his twin panel paintings of 'The Four Apostles',[30] each of whom represents a particular temperament. Dürer's intention is clearly documented in his earliest biography, published in 1546, by Johan Neudörffer.[31] Neudörffer's account of the significance of 'The Four Apostles' commands particular credence since he was the calligrapher employed by Dürer to execute the inscription at the foot of each panel. St John, identified by the words of his Gospel,

65

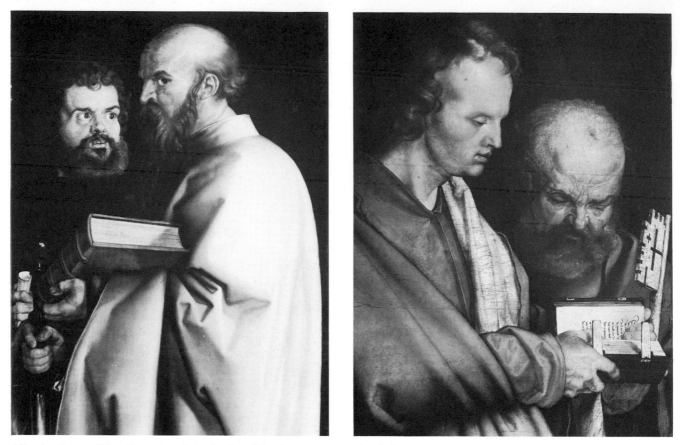

Albrecht Dürer, 'The Four Apostles': details of heads representing the choleric, melancholic, sanguine and phlegmatic temperaments. (Alte Pinakotek, Munich).

sonified as a dusky-faced man in middle age, like the lower right-hand figure who weighs Christ down and almost sinks out of our picture. Of the more active temperaments, the choleric was fierce and quick to anger. This was the temperament of soldiers, but he was often shown in almanacks as a wife-beater too. The armoured fist of the top left-hand figure, and the grimly determined set of his jaw, mark him out as the choleric. The sanguine was seen as the least detrimental of the temperaments, handsome and in the prime of life. The remaining figure, with his treacherous half-smile, does indeed appear to be the most affable of Christ's tormentors.

The temperaments are also identified by their costumes. The Denis Moslier Hours, printed by Jean Dupré in Paris c.1490, illustrates the multiple correspondances made between man and the cosmos in an engraving called the 'visceral planet man'.[32] In the four corners of the illustration, as might be expected, we find personifications of the temperaments differentiated, among other emblems, by their clothes. The choleric wears a suit of armour. The sanguine wears court dress. The phlegmatic wears the robes of a wealthy merchant, and the melancholic the sober dress of a scholar. In Bosch's painting exactly the same distinction is made in the costumes of Christ's tormentors, confirming the temperaments assigned to them.

The very popular *Shepherds' Calendar*, first published in French in 1493 and subsequently translated into several other languages, follows the Moslier Hours in also giving each temperament an emblematic animal: a lion for the choleric;[33] a monkey for the sanguine; a lamb for the phlegmatic; and a pig for the melancholic. This rather odd foursome of animals appears in no other context. The text of the *Shepherds' Calendar* provides a clue to its relevance. We are told[34] that we may discover a person's 'complexion' by observing the effect of wine upon the individual. In his cups, the choleric man has 'vin de lyon': he is driven to dance and to create a commotion. The sanguine man has 'vin de singe': he becomes playful and inclined to chase the ladies. The phlegmatic man has 'vin de mouton': he turns serious and more intent on business than ever. The melancholic man has 'vin de porceau': he wants only to sleep and to dream. This catalogue of drunkenness is not entirely frivolous. The writer was quite serious in his intent. The imagery of these four animals may be traced back to a thirteenth-century story of Noah which in turn derives from a Hebrew tradition going back to at least the sixth century.[35] According to this story, Noah

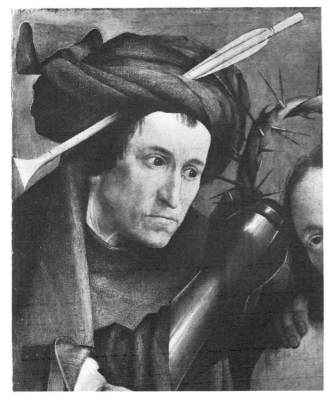

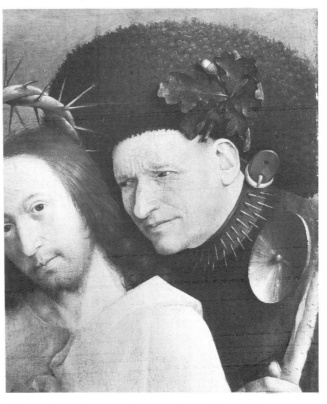

'*Christ Crowned with Thorns*': *detail of head of tormentor, top left, the choleric temperament.*

'*Christ Crowned with Thorns*': *detail of head of tormentor, top right, the sanguine temperament.*

'*Christ Crowned with Thorns*': *detail of head of tormentor, bottom left, the phlegmatic temperament.*

'*Christ Crowned with Thorns*': *detail of head of tormentor, bottom right, the melancholic temperament.*

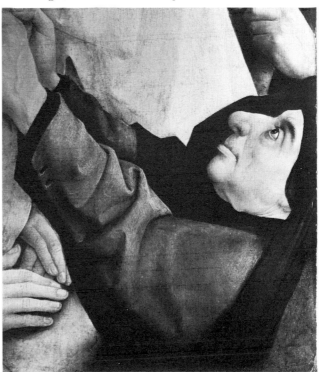

Kalendrier des Bergiers avec leur Astrologie, woodcut of four temperaments, choleric, sanguine, phlegmatic and melancholic, with their emblematic animals.

Woodcut from medieval Almanac showing Christ surrounded by the four elements (from Fred Gettings, The Hidden Art, *Studio Vista 1978).*

blended the blood of a lion, a monkey, a lamb and a pig to make fertiliser for his vines. The grapes from the vines eventually became the wine from which Noah became drunk.[36] The four animals, therefore, became a popular metaphor for the progressive stages of drunkenness. In the Biblical story, the drunkenness of Noah led to the mocking of his nakedness by his youngest son, Ham. As we have already noted, the mocking of the drunken Noah in the Old Testament was seen by medieval Christian thinkers as the 'type' for the Mocking of Christ in the New Testament – the scene Bosch sets before us. Christ himself was often referred to allegorically as the one 'true vine', His blood being the wine of the sacrament. The informed audience of Bosch's day, schooled in the contemplation of the Passion and the exegesis of its emblems, would have recognised such resonances in his painting of 'Christ Crowned with Thorns'.

But Bosch's metaphor does not end with the four temperaments. In the medieval world picture, everything connects. As Cornelius Agrippa was to write soon after Bosch's death: man 'doth contain and maintain within himself all numbers, measures, weights, motions, Elements and all other things which are of his composition.'[37] The body of Man was seen as a microcosm of the macrocosm, subject to the same celestial influences as the planets and stars. Every medieval almanack, like the *Shepherds' Calendar* or the *Guildbook of the Barber Surgeons of York*, usually included a diagram of the human body showing which parts of the anatomy were governed by which signs of the Zodiac. The feet, for example, were ruled by Pisces. Inevitably, the four human temperaments were seen to be subject to a particular planet. Jupiter presided over the sanguine man, who wears in his hat a sprig of oak leaves, the emblem Julius II had appropriated from the

god Jupiter. The phlegmatic temperament, being watery, was naturally governed by the Moon. Mars, the bringer of war was the planet ruling the excitable choleric temperament, and the melancholic came under the gloomy shadow of Saturn.

As our temperaments reflected the celestial workings of the cosmos, so they were also subject to the material nature common to the whole of manifested creation. *The Guildbook of the Barber Surgeons of York* says that the four temperaments 'are referred unto the four elements' – that is the four primary elements of which all matter was believed to be composed – Fire, Air, Earth and Water.

These four elements were first defined by the Greek philosopher, Empedocles (c.500–c.430 BC) who called them the 'roots' of all things. They represented a microcosmic dimension of the four most readily distinguishable forms of matter in the world around us: the land, the ocean, the atmosphere and the celestial 'fire' of the sun and stars. Under the action of the two opposing forces of love and hate, the combination of the elements was believed to take place within a four-period cosmic cycle. During the reign of hate the elements separate; during the transformation from hate to love, they draw together and begin to combine; during the rule of love, harmony is established between the elements to produce a perfect world; but with the return of hate comes repulsion and decomposition.[38] In *The Guildbook of the Barber Surgeons of York* these four phases are still recognizable in the terms the writer inserts between the groups of correspondences appropriate to each of the four elements: attraction, cohesion, digestion and expulsion. In his *Timaeus*, Plato (c.428–c.347) took the theory of the four elements and refined it further, assigning numerical proportions between the elements and giving each its own particular geometric form.[39]

During medieval times there was some variation in the relating of the temperaments to the four elements, but the most common was that adopted in *The Guildbook of the Barber Surgeons of York*, *The Shepherds' Calendar* and the Denis Moslier Hours. In all these sources, Fire inflamed the choleric; Air breathed vitality into the sanguine; Earth weighed down the melancholic; and Water dissipated the phlegmatic. *The Shepherds' Calendar* illustrates the figure of each temperament standing on its appropriate element. So we may also see the four faces of Bosch's 'Christ Crowned with Thorns' as representatives of the four elements.

Bosch has extended the metaphor of Christ's tormentors to include the maladies of mankind from the political to the personal, and from the personal to the universal. The ideal man, within each of us, is hedged about and confined by the human limitations of the four temperaments and the material limitations of the four elements. As in a nightmare, the circle closes in: the very elements of Creation turn upon the Creator. The thorns will burn His brow like Fire. Air will hiss corruption into His ear. Water rises to swamp Him in a stinking tide of lust. And Earth tries to drag down His spirit.

It may seem that such speculation demands a long stretch of the imagination, leading us well away from the orthodox Christianity of the Low Countries in the early sixteenth century. But a beautifully illuminated Dutch manuscript called *The Compendium of Christian Faith*[40] shows that such thinking was quite the norm in towns and cities like S'Hertogenbosch. The original manuscript of *The Compendium of Christian Faith* was written in 1404 for Duke Albert of Bavaria, Count of Holland. Several copies were made during the fifteenth century. This encyclopaedia of Christian belief was one of many such popular compendia, the sort of book that any educated person, like Bosch, would have known. Betwen concepts of God and the Trinity, and the story of Creation, it happily interweaves the signs of the Zodiac, the four temperaments and the four elements. One illuminated capital shows the four elements stratified in just the same way as Bosch's representatives of the elements in our painting: Earth being the lowest, Water just above, then Air and finally Fire. *The Compendium of Christian Faith* makes no distinction between Christian dogma and such secular, even pagan, beliefs. They were all integrated parts of the medieval world picture. And the inclusion of such matters was not just a sop for the superstitious. In his writings, the great thirteenth-century theologian, St Thomas Aquinas, debates at length the question of whether the form of the four elements remained in the Body of Christ as He hung on the Cross.[41] Such matters, then, were hardly alien to Bosch, his painting of 'Christ Crowned with Thorns', or his audience.

But where does Bosch's layered metaphor lead us? Four tormentors, four humours, four temperaments, four elements, all conspiring to trap mankind in its base

nature. How can we escape from this imprisonment? The picture does provide an answer. When Erasmus wrote the introduction to his *Enchiridion Militis Christi* in 1518,[42] he must have had in mind an image very like Bosch's painting of 'Christ Crowned with Thorns'. 'I will paint a certain image of thyself,' he writes, 'as it were in a Table and set it before thine eye; that thou mayest perfectly know what thou art inward and within

Illuminated capitals from 'The Compendium of Christian Faith' showing the four elements (above) and the signs of the Zodiac (below).

69

thy skin . . . Some vices accompany the complexions of the body. As appetite and lust accompany the sanguine man; wrath, fierceness, cursing followeth the choleric man; grossness of mind, lack of activities, sluggishness of body, to be given to much sleep followeth the phlegmatic man; envy, inward heaviness, bitterness and to be solitary, self-minded, sullen and churlish followeth the melancholy person . . . Christian man hath not war unto another but with himself. If you call the sky, the earth, the sea and this common air the world, so is there no man which is not in the world. But if you call the world ambition, desire of honour, covetousness, bodily lust, so art thou worldly. Verily a great host of adversaries springeth up out of our own flesh.'[43] so Erasmus gives us yet another set of four that we might apply to Christ's tormentors: four categories of sin. But he also points to the only way out of the limitations of our human weakness:

> The chief hope and comfort of victory is if thou know thyself to the uttermost. . . . There was never no storm of vices that did so overcome and quench the heat of charity but it might be restored again at this flintstone of Christ. Let Christ continue and abide as He is indeed a very centre or middle point unmoved.[44]

Here is the stillness that we find in the heart of Bosch's painting: the face of Christ, unmoved and unmarked by his assailants. Here is the stillness that marks off Bosch's scene from a hundred others. Here is the stillness that endowed the crowned Christ of that Roman sarcophagus with such calm dignity.

Time stands still. The Crown of Thorns is poised, almost like a halo, to bite down on Christ's head; the wooden poles are at hand ready to drive the thorns into His skull; the seamless white robe is about to be ripped; a hand hints at more intimate abuse; and a last, insidious whisper suggests that even now collaboration with the authorities might reverse this regrettable chain of events.

Bosch's freezing of the action at the moment just before the violence strikes is a successfully ambiguous device. On one hand, it heightens the horror of the scene by leaving the violence to our own imagination – and everyone knew what happened next. On the other, the suspended animation prevents an overwhelming emotive response by alienating us from the violence and forcing us to consider the situation and its context instead of the action. We are set outside the scene to be better placed for a rational contemplation of its meaning. We might take a modern analogy for this alienation. To those involved in a car crash, time seems almost infinite in the last few inches before collision. Space collapses and time expands. Bosch presents just that experience in 'Christ Crowned with Thorns'. All the faces are crushed into the same picture plane, flattened against a blank background. There is no breathing space in the picture, yet there is all the time in

the world: a single moment is projected beyond its present into an eternal dimension.

This is the stuff of meditation, and the real function of any devotional image. This is why the people of late Middle Ages dwelt so obsessively on the sufferings of Christ. It was not just morbid fascination. They believed that identification with the Passion of Christ was the only way through the torments of this world to personal salvation. 'If any man will come after me,' says the Gospel of St Matthew, 'let him deny himself, and take up his cross, and follow me.' For more than a century, Christians in the Low Countries had been struggling beyond passive participation in the formalised ritual of the Church towards a more personal mysticism based on just this kind of meditation.

Bosch's home town may not have had much by way of 'avant garde' culture, but what it did have was religion. And paradoxically that religion was progressive rather than conservative. S'Hertogenbosch was unusually well-provided with monasteries and convents, even for the late Middle Ages. Although laxity within the traditional Orders gave Bosch material for some of his most biting satires, one religious society, the Brethren of the Common Life, continued untarnished the simplicity and holiness with which it had been founded over a century earlier. The Brethren of the Common Life began as a grass-roots movement, made up mostly of lay members who took no formal vows. It grew up outside the hierarchies of the established Church and independent of the Universities.

The Order was founded by Gerard Groote and approved by Pope Gregory XI in 1376. The Brethren first met at a private house in Deventer. Ten years later, they set up the monastery of Mount St Agnes at Windesheim, near Zwolle, financed by the copying of Bibles, prayer books and other manuscripts. But the meeting-houses in towns were not abandoned. They continued as centres for preaching and pastoral care, and as informal schools for religious study. Erasmus was educated at the houses of the Brethren of the Common Life at Deventer and at S'Hertogenbosch, where he spent three years. The school set the religious tone in Bosch's home town and in his work. It is not surprising that we find such strong parallels between the caustic writing of Erasmus and the often savage painting of Bosch. Although the Brethren remained loyal to the Pope, they still saw it as their duty to denounce the abuses and scandalous behaviour of many priests: the corruption which both Erasmus and Bosch satirised in their work, and which led, eventually, to the Reformation.

In the early fifteenth century, the Brethren of the Common Life became part of the wider 'devotia moderna' movement. It was called 'modern' in contrast to the 'old' spirituality of the thirteenth and fourteenth centuries which had been tied strongly to the ritual and central authority of the Church. The new emphasis was on self-knowledge and morality, individual meditation

and devotional reading. Above all it stressed the personal responsibility for salvation through an earthly life modelled on the humanity and virtues of Christ. The testament of the Brethren of the Common Life was *The Imitation of Christ* by Thomas à Kempis (1380–1471), written at the monastery of Mount St Agnes around 1413 and still in print today. In his book, we find eloquent expression of what was seen as the only escape route from imprisonment by the torments of sin, the temperaments of humanity and the elements of material existence: 'the only road to oneness with God is by treading the "Royal Road to the Holy Cross" – devotion to Christ Crucified.'[45] It is against this devotional background that Bosch's 'Christ Crowned with Thorns' must ultimately be placed. The Imitation of Christ could, indeed, be a sub-title for the painting.

A meditative picture like this must have been intended for the private chapel of someone deeply religious – a member of the Brethren of the Common Life perhaps, or one of their lay houses. Since Bosch was wealthy enough not to depend on patronage for his work, the picture may even have been painted for himself, his own personal prayer. Dürer sometimes gave his own features to his pictures of the Christ in a particularly personal kind of identification with the Saviour. Perhaps we may sense something of the same identification in Bosch's painting.

As meditation takes the adept beyond the daily round to a fifth dimension, so we must now escape from the circular interpretations of our four tormentors to focus on the fifth face, Christ. Each of the contexts in which we have set the four tormentors provides its own fifth dimension, its own escape from the prison of Man's nature to a more perfect world. If the tormentors are taken to be the vices that spring from our flesh, then Christ is Erasmus' still centre unmoved. If they represent the four elements, then Christ is the ether, called the fifth element by Aristotle. His 'quintessence' gave celestial bodies their perfect circular motion. It stood for the 'soul' of the stars and was latent in the four material elements. If we see them as the four human temperaments, then Christ is the Ideal Man in whom the balance of humours achieves perfection.

Francesco Giorgio's *Harmonia Mundi*, written in 1525, less than a decade after Bosch's death, calls Christ 'Le Grand Homme Archetype' who, because of his perfection, contains within himself all things inferior.[46] For Giorgio, following in Plato's footsteps, the harmony of the world to which his title refers was primarily numerical: the cosmos was created and functioned on the basis of mathematical proportion. Number, if not quite divine, was the next best thing to it. Quaternities recur throughout the book. Mathematics itself is subdivided into four: number, measuring, music or harmony, and celestial arithmetic.[47] This division corresponds to the four disciplines of the 'quadrivium', the medieval university course that led to the Master's

Degree and which we meet again in the next chapter: Arithmetic, Geometry, Music and Astronomy. In the introduction to the French translation of Giorgio's book,[48] Guy Le Fevre de la Boderie attaches special importance to the number four because it contains all number: its integers add up to ten, the decad, and thereby return to the divine unity. So our four tormentors, be they vices, elements or temperaments, are purified through the Passion of Christ and re-forged into a unity with the divine. The devout Christian, meditating on such an image as Bosch presents in his 'Christ Crowned with Thorns', saw before him Thomas Aquinas' 'Royal Road' to oneness with God.

All philosophies contain an expression of the transcendental in some shape or form. For the alchemist it was the philosopher's stone which could turn base metal into gold. Alchemists were not merely eccentric experimenters, likely to blow themselves up at any moment as they stumbled towards the 'proper' science of chemistry. Alchemy had always had a serious philosophical dimension. From the begining there had been two types of alchemist: the practical man and the armchair theorist. The enlightenment sought by the alchemist was quite comparable to that of the Christian mystic, so it is not surprising that several great theologians are known to have dabbled in the theory, if not the practice, of alchemy. A treatise on the philosopher's stone was

Alchimie de Flamel: Melusina surrounded by the four elements (Bibliothèque Nationale, Paris, MS fr.14765, f. 315).

attributed to Thomas Aquinas during the Middle Ages. Any educated man, like Bosch, would have been familiar with some of the symbolism of alchemy, and it provided a quite legitimate source of imagery, even in the context of overtly Christian paintings.

An illustration from a later manuscript[49] of the work of the most influential alchemist of the Middle Ages, Nicholas Flamel (1330–1417), provides yet another parallel for the composition used by Bosch in 'Christ Crowned with Thorns'. Here again the four material elements are shown surrounding a symbol of the supernatural – this time the mermaid-like Melusina. She was Flamel's metaphor for the feminine spirit of nature, the primal mother of being and the first of many such exotic creatures met on the long road that led to the production of the Philosopher's Stone. Melusina stood for the perpetual cycle of generation and regeneration that led eventually to the pefection of balance between the four elements.[50] We are reminded of Erasmus' 'flintstone of Christ' at which charity might be continually rekindled to overcome and quench the 'storm of vices'.

As the alchemists observed in detail the chemical processes in their retorts, they conjured up a fantastic world of such cryptic beings, both to explain what they saw and to protect the secrecy of the Work. Melusina is a symbol of the transmutation of the material world. She is both creator and destroyer: a manifestation of the Earth Mother that devours the dead and disgorges the newborn. She must be sealed in the vessel with the Water and purified by the Fire. From her body the waters of creation arise like vapours. Through them shine the Sun and Moon, the children of the suffering of the Mother in the Fire. The Sun, the male principle, and the Moon, the female, must now conjoin in an intimate union from which will be born a wondrous child: the androgynous Mercurius, guider of souls. But the Dragon of Time lies in wait to devour the Child and initiate yet another cycle of transmutation.[51] These alchemical creatures sprang from the same subconscious sources as the characters of ancient mythology and the imagery of the Bible. The alchemical image of the Dragon of Time waiting to devour the child Mercurius, offspring of the Sun and Moon, calls to mind the Woman of the Apocalpyse described in the Revelation of St John the Divine: 'And there appeared a great wonder in heaven; a woman clothed with the sun, and the moon under her feet . . . and behold a great red dragon, having seven heads and ten horns . . . stood before the woman which was ready to be delivered, for to devour her child as soon as it was born.'[52]

The alchemist and the Christian mystic trod the same road. For both the goal was transformation of the base into the pure and incorruptible. Alchemical texts repeatedly stress that the Work, the production of the fabulous philosopher's stone, can only be achieved by one who is motivated not by greed or by power, but by enlightenment; one who is worthy of the personal spiritual purification that was symbolised by the chemical processes of his retort. The philosopher's stone, we are told, was most precious and spotless, and capable of purifying all things. So evenly was it tempered that 'neither fire, air, water or earth have the power to corrupt it'[53] – a parallel image surely for Christ the Redeemer, Erasmus' 'flintstone', and the Christ of Bosch's painting who, though assailed by the four elements in the form of His tormentors, appears strangely inviolate and unmoved by their attack. As the philosopher's stone of the alchemists would transmute base metal into a gold purer than earthly gold, so the mystics believed that through the crucible of Christ's Passion, the human soul might be tempered for salvation. For them, Christ was the philosopher's stone.

Bosch was painting for an audience who, over a century or so, had acquired, through their religious life, a taste for the progressive revelation of deep meanings. Their metaphors and images were built upon facets of popular religious beliefs, of folklore, and of mysticism in it many guises. Over the centuries we have disjointed and compartmentalised many concepts that seemed to the Middle Ages to be intimately related. The imagery of Bosch now seems the language of an 'in-group', and we are at a loss to explain the apparently incongruous and bizarre that we find in his work. To fill the vacuum in our understanding, it has sometimes been suggested that Bosch belonged to some secret and heretical religious sect, such as the Adamites, but we hope to have shown that there is no need to resort to such extravagant theories. The little we know of Hieronymus Bosch points to his orthodoxy within the context of late medieval religious belief in the Low Countries. The knife-edge of his irony was the taste of the times, paralleled in the scalding sarcasm of the writings of Erasmus. His savage brutality reflected the contemporary obsession with violence: suffering on earth as the only hope of salvation, and suffering in Hell as the price of failure.

Almost all the biographical information we have of Bosch comes from the records of the Confraternity of Our Lady at S'Hertogenbosch, an othodox religious society sometimes called the Swan Brethren. Bosch was elected to the prestigious society in 1486–7 and soon became one of its leading figures. The Fraternity had its own chapel in the city's cathedral, and Bosch is known to have painted the wings of its altarpiece between 1488–9 and 1491–2.[54] The chief duties of the Fraternity were veneration of the Virgin and philanthropic work among the less fortunate. This would have been the common aim of all such societies, but the Confraternity of Our Lady also had a special interest in the production of the city's mystery plays.[55] Bosch's talents were very likely to have been employed in designing the sets. The influence of medieval drama on contemporary religious painting has already been discussed, and it may well be that Bosch's association with the productions of the

Confraternity accounts for some of the more theatrical elements of his paintings.

Drama in the Low Countries led Europe. By the mid-sixteenth century, S'Hertogenbosch itself boasted five 'chambers of rhetoric'. These institutions were organised rather like guilds and depended for their existence on the public performance of poetry and drama. Both the most famous late fifteenth-century miracle plays, *Mariken van Nieumeghen* (*Mary of Nijmegen*) and *Elckerlyc* (the original of the English *Everyman*), were written, not by religious orders, but by members of these secular chambers of rhetoric.[56]

While English drama was still relatively simple, the Low Countries had evolved complex plays within plays, levels of action like the levels of Bosch's painting. Their miracle or morality plays opened in the everyday world. Then, through some dramatic device like a dream or a tale being told, the action shifted to a parallel story on a metaphorical plane in which personifications of temptation, called 'sinnekens', interacted with the human characters. At the climax of the play the third, innermost level was reached. A curtain was drawn back to reveal the 'toog', a tableau vivant or sometimes a life-size statue or painting, which represented the kernel of the play's message – its universal dimension. Bosch's 'Christ Crowned with Thorns' presents these same three layers telescoped into one image: the contemporary, the metaphorical, and the universal – Christ himself. A S'Hertogenbosch company mentioned as earlier as 1493, which later became one of the city's five chambers of rhetoric, was known as 'de gesellen van der Passie'. As its name suggests, it had a special responsibility for performing the Passion of Christ, and, remarkably, it appears that the Passion was shown mainly, perhaps even entirely, as a series of tableaux vivants.[57] It is tempting to see here the inspiration for the suspended animation of Bosch's painting.

All Bosch's pictures are libraries of meaning. And, despite its apparent simplicity, 'Christ Crowned with Thorns', as we have discovered, is no exception. Some of its many layers we may never, now, hope to unravel. What, for instance, is the significance of the cross-bow bolt through one tormentor's hat? A proverb perhaps? If we knew, we would doubtless be led into another round of fascinating speculation. What direction it would take, we may not know, but we can be sure that the road would lead to that same 'still centre': the imitation of Christ.

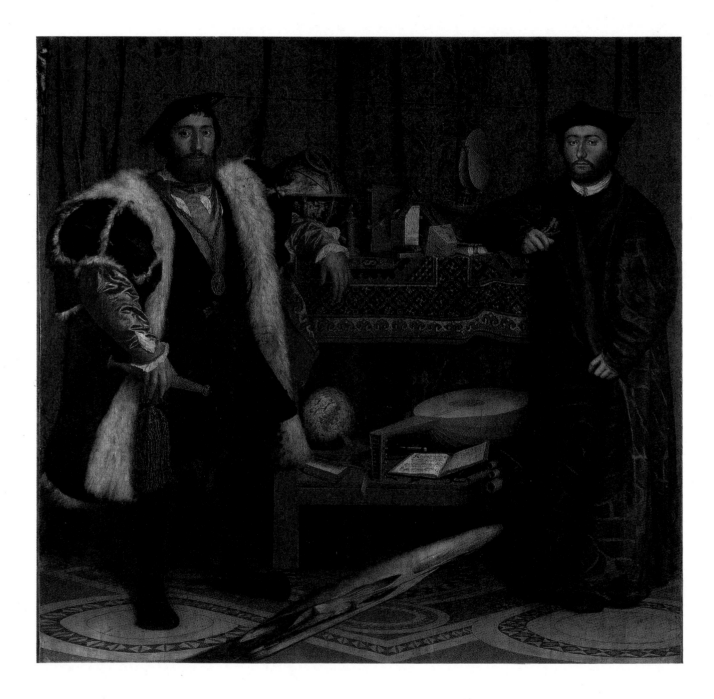

Chapter 6

The Ambassadors
by Hans Holbein the Younger

For our last painting we return to portraiture – but portraiture with a difference. The century that separated Jan van Eyck's portrait of Nicholas Rolin with the Madonna from the two gentlemen of Hans Holbein's 'Ambassadors', painted in 1533, confirmed a new attitude towards the portrait.

Until the fifteenth century, artists had relied mainly on dress and heraldic devices to identify a particular person. They were not much interested in producing accurate likenesses. The job of the medieval painter had always been to point beyond the here and now to the glories, and the perils, of the world to come. Portraits were subservient parts of sacred scenes: a rich patron of the church joining the caravan of the Magi to adore the Christ Child, a donor kneeling piously at the foot of Christ's Cross.

But, during the fifteenth century, the spirit of enquiry that illuminated the Renaissance led to a greater emphasis on the value and responsibilities of the individual.[1] Artists acquired a fascination with physiognomy, the cast of features distinguishing one face from another. In the preceeding chapter we saw this new interest reflected in the grotesques of Leonardo and Bosch and in a preoccupation with defining the physiognomy of the human temperaments. But the spirit of individuality also found more gentle expression. Van Eyck, and artists for two generations before him, captured the likenesses of their patrons in portraits of acute observation and subtle character.[2]

By the sixteenth century, the portrait had become a subject permissible in its own right. The realism that had formerly been valued for its effectiveness as a 'stand-in', for the real person in intercessary pictures like 'The Madonna and Chancellor Rolin', was now valued for its own sake. The 'stand-in' was no longer between Man and God, but between Man and Society. The propaganda value of art, long exploited by the Church, was turned to the service of the State. In the last decade of his career, Holbein's skill was to be harnessed by Thomas Cromwell to create and promote an imperial, icon-like image of Henry VIII in a campaign geared to winning for the Crown the authority and popular loyalty accorded to the Church of Rome before the Reformation. The portrait became a symbol of personal prestige rather than humble supplication. Faces gaze out boldly towards the spectator, their names, and often their ages, neatly inscribed above their heads. The assertive stance of 'The Ambassadors' seems to proclaim their mastery of their world. The dominance of the sacred appears to be completely broken. But here, as we shall see later, Holbein's fashionable realism is deceptive.

Born in Augsburg in 1497/8, Holbein settled first in Basel. There his work for the printer, Johann Froben, introduced him to the humanist circle of Europe whose leading light was Desiderius Erasmus, the most famous scholar in the West, adviser to princes and bishops. Holbein illustrated Erasmus' *In Praise of Folly* and designed title pages for Martin Luther's translation of the New Testament and Thomas More's *Utopia*. But the growing religious uncertainties of the Reformation in Basel meant bad business for painters,[3] and in 1526 Holbein left for London, carrying with him impeccable humanist credentials. 'The arts are freezing in this part of the world,' wrote Erasmus in a letter introducing Holbein to a friend in Antwerp, 'and he is on his way to England to pick up some angels there.'[4]

Apart from four relatively unproductive years back in Basel (1528–1532), Holbein worked in England until his death from the plague in 1543. His 'angels' varied with the political wheel of fortune. Erasmus had given Holbein introductions to the Archbishop of Canterbury, William Warham, and to Henry VIII's Chancellor, Sir Thomas More, with whom he stayed in Chelsea for two years. But while Holbein was away in Basel, the wind of change reached England. By the time he returned, William Warham had died and Thomas More, fallen from his position of power at court, was already

treading the path that led him to the scaffold in 1535. Holbein was forced to look outside the court for patronage.

Holbein found his new patronage among fellow expatriots: the Hanseatic merchants of the German Steelyard in London. Two large wall paintings on canvas painted to decorate their guildhall, 'The Triumph of Riches' and 'The Triumph of Poverty', became famous even in Europe.[5] But it was on small half-length portraits of the merchants that his livelihood came to depend. The success of portraits like the merchant 'George Gisze of Danzig'[6] confirmed his reputation as a portrait painter and set the pattern for the rest of his career. His sitters are mostly shown from the waist up, usually accompanied by the accessories of their trade painted in meticulous detail. Their names and ages were often inscribed in Latin against the background or wittily incorporated into the picture, on a book or letter, for instance.

By the mid-1530s Holbein had found his way back into the patronage of the court, and this time at the very highest level. Not only did he paint the King himself, but Henry entrusted Holbein with the delicate assignment of travelling abroad to paint his prospective wives. The realism of the painter's brush was now something truly to be relied upon. But it was not infallible. Though the portrait of Anne of Cleves[7] is quite charming, Henry was more than disappointed with the lady in the flesh!

It is tempting to think that the large and ambitious, life-size double portrait of 'The Ambassadors'[8] was the painting that re-opened the door to court patronage for Holbein. The self-confident pose of the man on the left certainly prefigures the later imposing image of Henry VIII. He must obviously have been a gentleman of some importance, but who? The painting does not tell us directly. Holbein has not labelled the sitters in the way he often did, but there is a trail of clues within the picture. It was first argued that these are portraits of the poet, Sir Thomas Wyatt, and the antiquary, John Leland.[9] The two men had been friends from their youth. Sir Thomas also served Henry VIII as a diplomat and had been Marshall of Calais for the four years leading up to our painting. Leland was Henry's chaplain and, in the actual year of the painting, was appointed Antiquary to the King. As late as 1903, William F. Dickes insisted that the two men were really Germans: the Counts Palatine, Otto Henry and Philipp.[10] Even the Holy Roman Emperor, Charles V, was suggested as a possibility for the flamboyantly dressed gentleman. The question of identity was finally settled in a masterly piece of detective work by Mary Hervey at the beginning of this century.[11]

Although we are not given their names, we are given the men's ages and the date of the painting. In the shadow of the figure on the left, the artist signs his picture: 'Joannes Holbein pingebat 1533'. The same figure rests his hand on a dagger whose design includes the inscription 'AET SVAE 29'. An abbreviation of the Latin phrase 'aetatis suae . . . 29', 'his age . . . 29'. Ages can be more reliable clues than names. Names were all too often changed or added later to enhance family prestige, but ages were seldom altered.

The next clue to his identity is the splendid pendant worn on a chain round his neck. It shows St Michael overcoming the Devil in the form of a dragon. Any courtier in Europe would have recognised this immediately as the badge of the exclusive Order of St Michael. The Order of St Michael had been instituted by Louis XI in 1469 and was one of the great orders of chivalry of Europe, the French equivalent of the English Order of the Garter. Henry VIII had been made a member of the Order by François I in 1516. When the two kings met in great state at the Field of Cloth of Gold four years later, a chapter meeting of the Order of St Michael formed part of the ceremonial proceedings. The badge of the Order was supposed to be worn at all times. On important occasions it was worn as the 'Grand Ordre', suspended from a gold collar of cockle shells linked by intricate chain-work. On lesser occasions the pendant was worn as the 'Petit Ordre' on a fine ribbon or chain, as it is shown in our painting. A sketch by Holbein of the medallion of the Order is preserved in Basel.[12] At any one moment there were only thirty six members of the Order, so our man must have been held in some esteem by the French court.

Here then we have a member of the Order of St Michael, most probably a Frenchman, who was twenty-

'The Ambassadors': detail of pendant of the Order of St Michael.

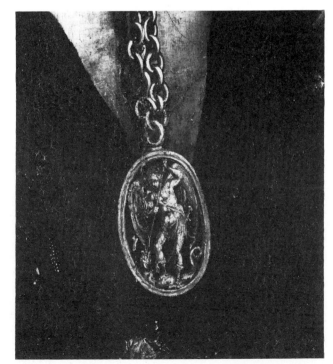

76

nine years old in 1533. His dress provides no further clues. A carefully painted signet ring might have shown the owner's seal, but he wears no rings. The skull brooch in his hat seems a strange choice for a young man but, curiously enough, this sort of death's head emblem enjoyed a macabre popularity at the time.[13] To narrow the field down further, we must turn to the history of the painting.

Fortunately the provenance of 'The Ambassadors' is better known than many.[14] The painting came to England at the beginning of the nineteenth century when the Earl of Radnor bought it from an English art dealer in Paris. There the painting had passed between several owners[15] having been brought to Paris in 1653 by the Marquis de Cessac, François de Cazillac, from a small village near Troyes called Polisy. Now on the terrestrial globe painted beside our man, Holbein indicates the village of Polisy as prominently as the centres of the French court, Paris and Lyons. Why should he mark such an unimportant place if it was not of some significance to the sitters?

The Château of Polisy was the ancestral seat of the de Dinteville family, who were intimately associated with the French court. At the time of our painting the Seigneur of Polisy was Jean de Dinteville. Like his father, he was a member of the Order of St Michael and, in 1533, Jean had been sent by François I as ambassador to England. Born in 1504, he was just twenty-nine years old when he was in London – the age Holbein painted on his dagger. The identification is complete. But what of his companion whose relatively sober dress might suggest a priest or scholar?

When the painting was in the gallery of the Paris art dealer, Jean-Batiste-Pierre Le Brun, in 1792, we know from an engraving that it was described as showing two ambassadors, one of them a Monsieur de Selve.[16] The de Selve family were all in the French diplomatic service. Georges de Selve was a good friend of Jean de Dinteville and we know that he visited him briefly in England during April of 1533. He was just 25 at the time, and that is the age we find inscribed on the fore-edge of the book under the elbow of de Dinteville's companion – 'AETATIS SVE 25' – 'aged 25'. But Georges de Selve was Bishop of Lavaur. If this is a bishop, why is he not wearing the splendid robes and mitre of his office, to match de Dinteville's extravagance of dress?

In 1533, de Selve was not yet consecrated. He had been only 18 years old when François I nominated him as Bishop of Lavaur and he had to wait until he was 25, the minimum age allowed by the Church, before he could receive the full canonicals. So in our painting he wears a discreet, but nonetheless sumptuous, black gown appropriate for a bishop–elect. De Selve's appointment was, in part perhaps, a gesture of gratitude from François I to George's father, Jean, who had helped negotiate the French king's release from imprisonment in Spain after the Battle of Pavia in 1525. But the son may well have attracted François' attention by his own

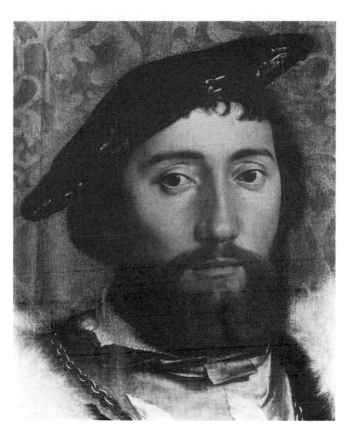

'The Ambassadors': detail of hilt of dagger showing age.

talents. Georges seems to have benefitted brilliantly from an exceptionally early education and developed skills of diplomacy even as a teenager. Serving as François' ambassador, he travelled all over Europe until he was finally released from diplomatic service in 1540 to take up the duties of his diocese.[17]

So before Holbein's easel in 1533 stood two highly respected diplomats, cultured and intellectual members of the French court. At first, it seems rather surprising

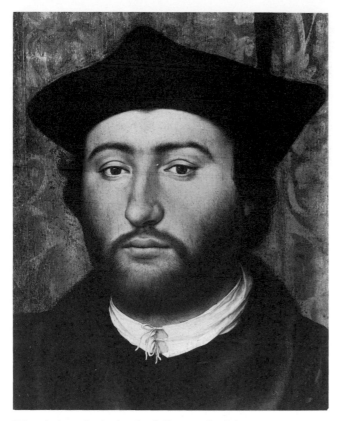

'The Ambassadors': detail of Georges de Selve.

'The Ambassadors': detail of fore-edge of book showing age.

that Holbein should allow such distinguished sitters to be virtually upstaged by a table. Loaded as it is with an elaborate still-life and painted with as much care and precision as the two figures, it dominates the composition and demands a closer look – not only for its own meticulous detail. This is no random assembly of objects. From their careful choice and arrangement we learn of the ambassadors' interests and beliefs, the circumstances of their visit to England and the occasion of their painting.

The terrestrial globe on the lower shelf of the table which gave us the clue to Polisy, de Dinteville's home, is the earliest known representation of a terrestrial globe in painting.[18] It represents the very latest in map making. The north-west passage of America is indicated, probably for the first time in the history of cartography. Two possible models for Holbein's globe have been suggested,[19] neither of which are known to have survived: a globe by Maximilian Transsylvanus described in *De Orbis Situ* by Franciscus Monarchus, 1526, and a globe by Gemma Frisius published to accompany his book, *De Principiis Astronomiae et Cosmographiae deque uso globi* of 1530. Whatever the original model, Holbein's reproduction of it is so convincing that, until recently, scholars accepted as genuine the gores of a fake globe copied from the painting and 'discovered' in the late nineteenth century.[20]

The same attention to detail in Holbein's painting of the little book in front of the globe allows us to identify it as an arithmetic primer for merchants, published by Peter Apian in 1527: *Eyn Newe und wolgegrundte underweysung aller Kauffmanns Rechnung . . .* The book is propped open at page 8 of Book III in the section on division. Here Apian demonstrates the division of 81,648 into grosses, that is by 144, using the 'doubling method'. The book is of great mathematical interest because Apian's method of division anticipates the first use of decimals more than a century later. It also prints, on the title page, the first European example of the number pattern which came to be known as 'Pascal's Triangle' after the mathematician, Blaise Pascal, who published it in 1665.[21]

Peter Apian was clearly a man of exceptional ability and we meet his genius elsewhere in our painting. He was professor of mathematics and astronomy at Ingolstadt University in Bavaria. His most famous and frequently reprinted work was the *Cosmographia*, published in 1520, which named the new-found continent of 'America' as such for the first time on any printed map. Perhaps it is to Apian we should look for the design of the terrestrial globe. The year before the painting of 'The Ambassadors', 1532, was an important year for Apian and one which no doubt brought him much public attention. That year saw the publication of two major works, the *Quadrans Astronomicus* and *Die Practica*, as well as a monograph on comets. The inclusion of Apian's arithmetic book in the painting, like the globe, was obviously intended to show the ambassadors as men in the intellectual forefront of their time.[22]

The arithmetic book is held open by a set square and lying behind it is a pair of compasses, both symbols of geometry and architecture. The rest of the lower level of the table is given over to music: a lute, a set of flutes in a leather case and an open hymn book.

In arithmetic, geometry and music we have three of the four subjects of the 'Quadrivium', the medieval university curriculum leading to the degree of Master of

Arts. The lower bachelor's degree required the study of the 'Trivium': grammar, logic and rhetoric. Together the subjects of the Trivium and Quadrivium made up the seven liberal arts. The fourth discipline of the Quadrivium was astronomy, and this subject we find represented on the upper level of the table by a battery of the sixteenth century's latest technology for charting the heavens and measuring time.

The fine celestial globe is the counterpart of the terrestrial globe below. Again it is most likely the work of Peter Apian whose celestial globes were famous for their beauty throughout Europe. Beside it is a cylindrical or column sundial set to a date that could be either 11 April or 15 August.[23] Since de Selve made his brief visit to London in April, we may reasonably assume that the earlier date was intended.

In the centre of the shelf are two navigational instruments, a wooden astrolabe and a white quadrant, possibly made of ivory. The astrolabe had been used in primitive form by the Greeks but was not seriously developed until the twelfth century, mainly by the Arab and Jewish mathematicians and astronomers of Moslem Spain. A rule rotating against a circular scale was used to measure the position of the sun and stars. In the fifteenth century the perfection of this instrument and its adaptation for navigation made possible the great Renaissance voyages of discovery by Columbus and others. The quadrant is a simplified form of the astrolabe, developed late in the fifteenth century. It is, in essence, a quarter-circle divided into 90 degrees and fitted with a movable radius carrying a sight. The quadrant in our painting is very like one illustrated by

'The Ambassadors': detail of lower shelf of table showing emblems of arithmetic, geometry and music.

Peter Apian, Well-grounded Arithmetic Book for Merchants, *1527: page on division (British Library, 1391a7 f. RR).*

'The Ambassadors': detail of map of France on globe.

'The Ambassadors': detail of arithmetic book.

'The Ambassadors': detail of upper shelf of table showing astronomical instruments.

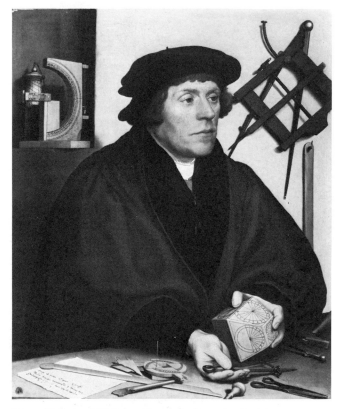

Hans Holbein, 'Nicholas Kratzer' (Louvre, Paris).

Peter Apian under the name of 'horarium bilimbatum', 'double-sided dial'.

To the right of the quadrant is another instrument illustrated by Apian, in his *Introductio Geographica*. It is a torquetum, designed to measure the position of any heavenly body by day or night. Peter Apian's own torquetum still exists. In front of the torquetum is a decagonal sundial. The shadows of the gnomons on

three faces of the sundial are clearly visible, two giving the time as 10.30 and one as 9.30.

All these instruments are of the very latest design, and although several were illustrated in works by Peter Apian, Holbein has not just copied them from engravings. The careful arrangement and detailed painting show that he had the real objects before him. These were no ordinary studio props: such instruments were very precious. A similar astrolabe and cylindrical sundial appear in the background of Holbein's portrait of Niklaus Kratzer, painted in 1528. Kratzer was Henry VIII's astronomer and instrument maker. Holbein shows him working on a decagonal sundial very like, if not identical to, that in the painting of 'The Ambassadors'. Holbein had known Niklaus Kratzer, another German expatriot, since his first visit to England when Kratzer was tutor to the children of Sir Thomas More with whom Holbein had stayed. Their friendship may have led to some degree of practical collaboration. It has been suggested that a short astronomical treatise by Niklaus Kratzer, *Canones Horoptri*, has capitals illuminated by Holbein and that a drawing of an astronomical clock attributed to Holbein has annotated notes in Kratzer's handwriting.[24] Perhaps the Astronomer Royal lent his friend the valuable instruments for the ambassadors' show of learning. We know of de Dinteville's own interest in scientific instruments from a letter to his brother in which he asks to be sent 'a drawing of the oval compass of which you wrote; I cannot at all understand the fashion in which it is made.'[25]

The delight in scientific instruments and mathematical precision that 'The Ambassadors' reflects both in content and style was the legacy of the scientific impetus of the late fifteenth century. This surge forward had been a result not of the Italian Renaissance but of the Reformation in Southern Germany, where the dissemination of scientific thinking was made possible by the printed book. Techniques of engraving sheet metal with precise scales for the manufacture of instruments, like the quadrant and astrolabe, contributed to the invention of printing. In its turn, printing fuelled further scientific developments. It was no coincidence that Augsburg and Nuremburg became the great centres for both printing and instrument making.[26] Holbein had spent his childhood in Augsburg, and Nuremburg, where much of Apian's work was published, is prominently marked on the terrestrial globe of 'The Ambassadors'. The mentality of the picture is firmly rooted in the scientific and humanist traditions.

Here then, are two well-bred young men on top of their world and surveying their enlarged horizons. Between them an elaborate still life bears ostentatious testimony to their appreciation of the arts and their up-to-the-minute knowledge of science. By subtle delineation of space and form and a masterly understanding of the play of light on differing surface textures, the painter demonstrates his supreme ability to capture for ever a fleeting moment of the real world: a

moment, it seems, of justifiable confidence in the march of progress.

The ambassadors stand four-square on an inlaid floor which has one surprising parallel. Its geometric pattern matches closely the thirteenth-century pavement before the High Altar of Westminster Abbey. Should this parallel, in such a celebration of the human intellect, lead us to interpret the ambassadors' 'furniture of the mind' as a secular altar to learning? After all, in the thinking of the Reformation the altar was no longer the mystical stone of sacrifice and sepulchre but the simple table of the Lord's Supper.

If we pursue religious analogies, we may see the composition of 'The Ambassadors' as heir to the 'Sacra Conversazione' format developed by Italian painters during the fifteenth century. The subject of an enthroned Madonna and Child surrounded by serried ranks of saints and angels had been a staple element of Italian altarpieces since the time of Duccio (for example, his 'Maestà' painted for the High Altar of Siena Cathedral in 1308–11). As artists extended the skills of perspective in the fifteenth century, the formalised rows of superimposed faces gave way to a more naturalistic setting. Instead of crowded two-dimensional rows of saints, the patron's favourites were painted, with

convincing solidity, standing in a heavenly throne room being politely received by the Queen of Heaven and her Son. Sometimes, as in the Canon van der Paele altarpiece by van Eyck, the patron who commissioned the painting is privileged to join the 'sacred conversation'. This type of composition has a prototype six centuries earlier in representations of the Carolingian emperors.[27] The emperor appears enthroned with his representatives of spiritual and temporal power on either side, just as de Dinteville, the diplomat, and de Selve, the bishop, flank their symbols of the new learning.

Stepping forward in time, we may see how Henry VIII attempted to usurp both the religious and the imperial significances of this type of composition. In 1537 Holbein was commissioned to paint a large wall painting for the Privy Chamber in the Palace of Whitehall. The painting was intended to glorify the Tudor dynasty. Latin verses added to the wall painting sometime before 1600 tell us 'If it pleases you to see images of great men, look on these: no picture figures greater. . . . The son (i.e. Henry VIII) born to greater things, removed the unworthy from their altars and replaced them by upright men.'[28] And very effective the painting must have been, if a contemporary description

Giovanni Bellini, 'Holy Conversation' (S. Zaccharia, Venice).

Gospel Book of St Emmeram (Regensburg): miniature of Carolingian emperor enthroned (Bayerisches Staatbibliothek, Munich, MS CLM 14000, f. 5v).

81

of visitors abashed and annihilated before the King's image is to be believed. Holbein had obviously hit upon a formula to impress. The Palace of Whitehall has since been destroyed, but we do know Holbein's wall painting from a painted copy made by Remigius van van Leemput. In the centre is an altar-like stone pedestal which surely represented the throne.[29] To the left are Henry VIII and Henry VII, and to the right their wives: Jane Seymour, mother of Henry's male heir, Edward VI, and Elizabeth of York. Not only is the overall composition modelled on the same pattern as 'The Ambassadors', but there are other echos too. Henry VIII stands, legs astride and hand on dagger, in an imperious pose that is almost exactly the mirror-image[30] of Jean de Dinteville's in 'The Ambassadors'. The comparison between Henry VII and de Selve is even closer, though again reversed. Each stands with an elbow resting on a ledge and a pair of gloves clasped in his hand.[31] So, in the pedigree of this symmetrical composition, the power of the early emperors had been replaced by the medieval Church; the Church by Renaissance learning; and now, Henry's imperial ambition hoped to encompass all three.

Although de Dinteville and de Selve no doubt had humbler aspirations, their painting connives to impress us by employing the same compositional device. But are these two confident sons of the Renaissance as in control of their world as they would have us believe? A closer look at some of the details of the painting suggests there are cracks in this facade of confidence. The lute, for instance, has a broken string – a suggestion perhaps that all is not perfect. Could it be that the ambassadors entertain some misgivings about the direction of 'progress'?

Holbein is at great pains to let us know the precise time and date in the ambassadors portrait. As we have seen, the cylindrical sundial sets the day as 11 April. Now in the year of our painting, 11 April was a Friday. To be precise, it was Good Friday[32] and Easter 1533 wasn't just any Easter – it proved to be a turning point not only in the history of England, but in the delicate balance of power in Europe. This was the very weekend that Henry VIII had set as the deadline for the resolution of 'the King's great matter' – his divorce from Catherine of Aragon.

After six years of haggling with Rome, it wasn't only Henry's patience that had run out – Anne Boleyn was now four months pregnant. This had to be the son and heir that Henry so desperately needed. And he had to be born legitimate. France was acting as a go-between with the Pope, Clement VII, in the cause of Henry's divorce. François I had a vested interest in supporting England. On the mainland of Europe, French territory and influence was threatened by the growing power of the Holy Roman Emperor, Charles V. Henry was François' key ally against Charles, who was, inconveniently for all concerned, Catherine of Aragon's nephew. The Pope was in the Emperor's pocket and playing for time. Could France sanction a total breach between England and Rome? Could she protect her own Papal interests without alienating her new-found English friendship or provoking the powerful Emperor? These were the explosive contents of the diplomatic bag that brought de Dinteville and de Selve to London.[33]

Hans Holbein, 'The Ambassadors' (National Gallery, London).

Remigius van Leemput, 'Henry VII and Henry VIII with their wives' (painting after lost fresco by Hans Holbein) (Hampton Court Palace).

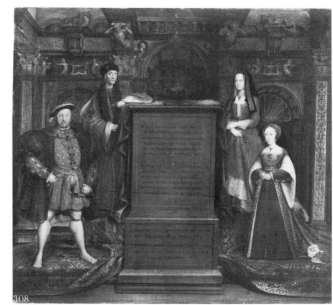

82

It was not Jean de Dinteville's first visit to London as ambassador. Relations between England and France had become uncommonly cordial in the preceeding years. While François I had been imprisoned in Spain after the Battle of Pavia in 1525, Henry had not only resisted the temptation of invading France in his absence, but had been actively involved in securing his release and later that of François' sons who were held as hostages in their father's stead. Not only did François owe Henry a debt of gratitude for refraining from exploiting this humiliating chapter in France's history, but it also suited his own interests to keep Henry at variance with the Holy Roman Emperor. Upholding the cause of Henry's divorce from the Emperor's aunt seemed guaranteed to serve both purposes. François and Henry lodged permanent ambassadors at each other's courts. As the 'King's great matter' came slowly to a head, special envoys were sent between the courts, entrusted with matters that were perhaps too delicate to commit to pen and ink. It was on such a short confidential errand that Jean de Dinteville first arrived in London in the autumn of 1531. His mission seems to have been concluded satisfactorily and he left for France at the beginning of December. The success of this visit was, no doubt, noted by François I. Meanwhile the bishop of Auxerre, François de Dinteville, Jean's elder brother by six years, was pursuing the cause of Henry's divorce in Rome.

Apart from the expediency of supporting England, there was a genuine dismay in France over the Pope's continual vacillations. By refusing to commit himself to a decision based solely on canon law and free from intimidation by the Emperor, the Pope appeared to be putting considerations of personal safety before the duties of his high office. Respect for the Papacy was increasingly eroded – especially among those with Reformist leanings. Until the Pope pronounced, the King of England's divorce would remain the talking point of Europe. Eminent lawyers, theologians and philosophers were persuaded by interested parties to write treatises for or against the case. Even the great Erasmus was approached, but prudently avoided taking sides in arguments between such powerful adversaries. Henry's advisers sought the judgements of all the major universities on the Continent. Even the conservative University of Paris, for centuries the foremost theological authority, eventually came out in favour of the king of England after some none-too-subtle ballot rigging ordered by François I.

In October of 1532, the kings of France and England met in great state at Boulogne and Calais. The official reason for the meeting was to discuss measures for the defence of Christendom against the Turks, but the real object was to unite in a common strategy against the Emperor and to further the cause of Henry's divorce, both matters in which circumspection was prudent. The Emperor's ambassador in England, Eustace Chapuys, was deliberately excluded from the most sensitive discussions, much to his chagrin.

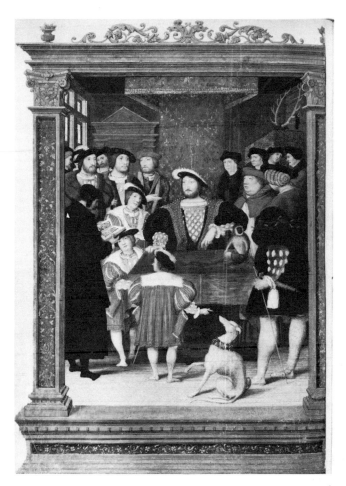

Antoine Macault, translation of Diodorus Siculus: miniature showing translator reading from book, François I, Jean de Dinteville and his brother and Georges de Selve (Musée Condé, Chantilly, MS 1672, f. 1).

Though not matching in ostentatious luxury their famous meeting of the Field of the Cloth of Gold twelve years earlier, the celebrations were lavish and lasted for ten days. The meeting marked the high spot of the 'entente cordiale' between Henry and François. Each seemed bent on outdoing the other in exchanging civilities and gifts. François brought with him his three young sons, whose freedom had been bought with money lent by Henry. The English king embraced the boys as if they were his own. Although we have no record of it, the de Dinteville family were almost certainly among the French king's attendants. As well as being established favourites of the court, each brother had charge of one of the king's sons. Jean had been in attendance on the royal children since the age of only seventeen. When he was later officially appointed Governor to Charles, Duke of Angoulême, the king's other sons François, the Dauphin, and Henry, Duke of Orleans, were put in the care of Jean's brothers, Guillaume and Gaucher, respectively. A manuscript illumination of around 1532 shows François I listening

to a reading from the works of the Greek historian, Diodorus Siculus.[34] To the king's right are his three young sons and behind them stand a group of men whom it is not unreasonable to suppose are the children's governors, the de Dinteville brothers. The figure on the left of the group bears a strong resemblance to Holbein's painting of Jean de Dinteville. If, as is likely, the de Dinteville brothers accompanied their charges to Boulogne and Calais, Jean would have had the opportunity to renew his acquaintance with the English king. De Dinteville also had another reason to be present. François I called a chapter meeting of the companions of the Order of St Michael, to which Jean belonged, as part of the celebrations and 'to show himself loving to the noblemen of England'[35] bestowed the order upon the dukes of Norfolk and Suffolk.

On the last Sunday of the sojourn at Calais, the French court came to dine with the king of England. The dining chamber was sumptuously hung with fine fabrics embossed with gold and silver and edged with pearls and precious stones. After the meal, seven ladies entered the chamber, dressed in exotic costume and masked. Each lady took a lord and they began to dance. Henry removed the ladies' masks as they danced and the French king found himself, much to Henry's amusement we may be sure, dancing with Anne Boleyn. They danced for a while, exchanged a few words and then François took his leave. Anne Boleyn was no stranger to the French court. Her father, Sir Thomas Boleyn, had been keeper of the Foreign Exchange and ambassador to France. When she was about fifteen, Anne had been a maid of honour at François' court. Jean de Dinteville was then a young man, two years her senior. It is unlikely that he would not have noticed the beautiful young English girl with her dark eyes and fashionably pale skin.

The kings of England and France parted if not the sincerest, at least the most politic, of friends. A triumph of diplomacy had enabled each to gain the other's support without sacrificing their own particular interests.

Two months later Anne Boleyn was pregnant and by February of 1533 Henry had married her in secret. The urgency of the king's divorce was redoubled. François had arranged to meet the Pope at Marseilles in the autumn and promised to champion Henry's cause in person. But Henry could not now wait that long. The matter must be settled by Easter. Jean de Dinteville had been sent to England at the begining of February, perhaps in an attempt to disuade Henry from taking any irrevocable step before François' interview with the Pope later that year.

Henry's marriage to Anne had been kept secret to ensure that the Pope would not oppose the king's choice of Thomas Cranmer as the new, and accommodating, archbishop of Canterbury. Due in no small part to pressure from France, Clement VII accepted Cranmer's nomination and issued the bulls for his consecration.

Unknowingly he had opened the door to the English Reformation.

On the Monday of Holy week, 7 April, the English Parliament passed an act in Restraint of Appeals which openly defied Papal authority. All appeals to the Court of Rome, by anyone, were summarily abolished. England was declared an Empire. The king's 'great matter' was now to be determined by England alone, without heed to any other earthly power whatsoever. As a monarch supreme over both State and Church, Henry could do as he wished. On 10 April the dukes of Suffolk and Norfolk were sent to Ampthill to inform Catherine of Aragon that she was no longer Queen but Princess Dowager. Within the country Catherine's predicament commanded much popular sympathy. Chapuys, the Emperor's ambassador in England, reported discontent among the people and urged his master to raise a rebellion among the English against their king: 'You cannot imagine the fear into which all these people have fallen, great and small, imagining they are undone . . . so that they are willing to incur great losses, if your Majesty would send an army and root out the poison of the Lady and her adherents'.[36] Chapuys may well have exaggerated the extent of unrest but writing to Henry on 11 April, the actual day of our painting, Archbishop Cranmer begged the king to 'allow him to determine his great cause of matrimony, as belongs to the Archbishop's spiritual office, as much bruit exists among the common people on the subject'.[37] Henry grudgingly agreed but in his own mind the matter was closed.

The next day, Easter Saturday, Anne accompanied the king to High Mass 'with all the pomp of a Queen, clad in cloth of gold, and loaded,' Carlo Cappello wrote disparagingly, 'with the richest jewels'.[38] This first public appearance of Anne with Henry confirmed her as his wife in all but name. Later that month, Archbishop Cranmer led a convocation of sixty-six divines to a majority decision that the king's marriage to Catherine had been against God's law, since she had been carnally known to his brother, and the marriage was therefore null and void. By the end of April all obstacles, spiritual and temporal, in the king's path to matrimony had been removed.

Jean de Dinteville's second visit as ambassador to England covered the turbulent nine months from the king's secret marriage to the birth, not of the hoped-for son, but of Elizabeth. And in the critical month of April, de Selve made his lightning visit. During Easter all diplomatic activity in Europe was at fever pitch. In Rome, the cardinals complained that the business was keeping them from the great services of Passion week.[39] In Westminster, Henry kept Parliament in permanent session, right through the official Easter recess until Whitsun. De Dinteville was doubtless busy reporting back to the French king and to Montmorency, his Prime Minister. No-one had a holiday that Easter. In this desperate moment for diplomacy, de Dinteville and de

Selve found themselves at the centre of the biggest political storm of the century. It was certainly the most crucial day of de Dinteville's diplomatic career, perhaps of de Selve's too. No wonder the ambassadors wanted Holbein to commemorate this Good Friday in their portrait.

Not, of course, that the painting was completed, or even begun, on that day. De Dinteville must have been more than usually occupied that weekend and Georges de Selve's visit to England was very brief. Since de Selve's portrait could not have been finished before he left, Holbein probably prepared a chalk sketch from life to use as the reference for the actual painting.

The purpose of de Selve's visit is not known for sure. It may have been a purely social visit to a close friend who was not much enjoying his stay in London. De Dinteville suffered from poor health and the English climate did not suit him. He was home-sick for the French court. 'I assure you earnestly that I am the most melancholy, weary and wearisome ambassador that ever was seen,' he wrote to his elder brother, the Bishop of Auxerre, and Georges' company had afforded him 'no small pleasure'.[40] In the same letter Jean writes that the French chief minister, Montmorency, need hear nothing of his friend's visit. Was this simply because the event was of no political consequence or was there some real reason for secrecy?

Henry's break with Rome would inevitably move England closer to the newly-reformed Protestant areas of Europe. Although de Dinteville was now an experienced diplomat, he was no expert on theological matters, in particular the implications of the turn of events that Easter. Perhaps he felt the need for the advice of someone better qualified, the bishop-elect of Lavaur, his old friend, Georges de Selve. De Selve's career centred largely on healing the rift between the breakaway groups of Protestant Germany and the mainstream of the Catholic Church. He saw faults on both sides and argued for the purging of corruption within the Church without repudiating the power of Rome. He believed that it was the conduct of religious life rather than the dogma of the Church that needed reform. De Selve, then, belonged to what might be called the liberal Catholic party in France, as did de Dinteville. In fact, Jean's sister, Charlotte, married into a family of German descent and eventually became a Protestant herself. But not everyone shared their liberal opinions. Earlier this century the great French historian, Lucien Febvre, described the 1520s in France as a time of 'magnificent religious anarchy'.[41] As well as the liberal Catholics and the Reformers, there were the conservative Catholics, hardliners who would tolerate no breath of reform and no weakening of the Church's hierarchy. To this party belonged Montmorency, François' chief minister. So, if de Dinteville was indeed seeking the advice of one of France's leading liberals, it was prudent that the conservative Montmorency should be kept ignorant of the fact.

Some six weeks after de Selve's visit to de Dinteville, Archbishop Cranmer had set the stage for Anne Boleyn's coronation. The event was bound to entail the French ambassador in considerable expense. He wrote urgently to Montmorency 'begging him to ask the King to give me some money to meet with it'.[42] However, time was short and it seems that de Dinteville was forced to meet the expense himself. It is very likely that one of the most complete surviving descriptions of Anne's coronation festivities, printed in Camusat's *Mélanges Historiques*,[43] is a first-hand account written by de Dinteville for Montmorency: '. . . On Saturday at about five o'clock in the afternoon, the said Lady, attired in her royal robes, which are in the fashion of those of France, or nearly so, mounted a litter, covered within and without with white satin. The litter was open, and above her was carried a canopy of cloth of gold. Behind came twelve ladies on hackneys, who were all dressed in cloth of gold, and their hackneys draped in the same. Then came twelve young ladies on hackneys, all arrayed in crimson velvet. There followed a chariot covered with cloth of gold, with trappings to match. In this chariot were only the Duchess of Norfolk and the Queen's mother. Then came three gilt chariots, where sat various young ladies; and, behind these, twenty or thirty others on hackneys draped with black velvet . . .'[44] The splendid procession, some two to three hundred strong, seemed to go on for ever as it threaded its way through the streets of London to the clamour of trumpets, hautboys, tambourines, flutes – and carefully orchestrated cheering. At its head, twelve of the French ambassador's men lead the way 'clothed in coats of blue velvet with sleeves of yellow and blue velvet, and their horses trapped in close trappings of blue sarcenet powdered with white crosses.'[45] De Dinteville must have dug deep into his pocket. It was not until his return to France at the end of the year that a grant of five hundred gold crowns was made by the French Treasury to defray the costs Jean had incurred in the line of duty.

The coronation provided work for Holbein too. The merchants of the steelyard commissioned him to design a triumphal arch for the occasion. It was the centre-piece of 'a costly and marvellously cunning pageant',[46] the first of several such that greeted Anne as she made her way through the city. Holbein's arch represented Mount Parnassus and the Fountain of Halcyon. The fountain was made of white marble and from it sprang four streams running with wine. On the summit of the mountain sat Apollo with Calliope at his feet and four Muses playing musical instruments on either side. Two tall columns rose beside the arch carrying shields surmounted by crowns – not just ordinary crowns, but imperial crowns.

Jean de Dinteville and Thomas Cranmer rode in the procession in the same carriage. As the French ambassador and the English archbishop drove beneath this gesture of Henry's imperialism, what thoughts must

Emblems Alciati presents a series of engravings accompanied by Latin verses. He commends the lute to the duke of Milan as the emblem of a treaty 'welcome at this time when you are bent on new alliances'. The new alliance to which Alciati refers was probably the League of Cognac which had been formed by England, France and the Italian princes in 1526 to weaken the political power of the Holy Roman Emperor. But the verse goes on to warn:

'Tis hard, save for skilled hands, these chords to tune;
And be there one ill-tuned or broken string,
Easy mischance! all grace of music dies;
And disconcerted is the concert fair.

A 'concert' of princes was the ideal that Erasmus had set before the monarchs of Europe as the solution to the territorial and spiritual squabbles that disrupted peace in Europe: harmonious rule by a European council of Christian princes instead of the continual power struggle between the Holy Roman Emperor and shift-

'The Ambassadors': detail of lute.

Hans Holbein, 'Parnassus': sketch for triumphal arch for Anne Boleyn's entry into London (Staatliche Museeu, Berlin, KdZ 3105).

Alciati, Emblemata, *'The Lute' (British Library, C 175i).*

they have exchanged, sitting side by side with the gulf of the Reformation now opening between them? As they smiled and waved at the crowds, their political realism, like the visual realism of Holbein's painting, masked the fears aroused by this break in the thread of history. A break that Holbein illustrates almost literally. By snapping one of the strings of the lute, he turns the most eloquent symbol of harmony into a symbol of discord.

Symbols and emblems were the common currency of the intelligentsia. The most popular book of emblems had been published at Augsburg just two years before the painting of 'The Ambassadors'. It was written by Andrea Alciati and dedicated to his patron, the duke of Milan.[47] Alciati was a friend of Erasmus and had taught law in Avignon and Bourges from 1529 to 1534. So it is certain that both Holbein and his sitters would have been familiar with the man and his book. In his *Book of*

ing alliances of lesser rulers.[48] But what chance of such harmony was there now that Henry VIII had broken with Rome, putting his considerable political weight behind the growing religious division of Europe into Protestant and Catholic factions? It is at the section on division, we may recall, that Apian's arithmentic book is propped open on the same shelf as the lute of discord.

The open hymn book beside the lute underlines the contemporary concern over the widening divisions of the Church that gave de Selve such 'exceeding pain at the calamity of the times'.[49] The hymn book is written not in Latin or French, but in German. At that time, German was not a particularly well-known or respected language. Its presence is unexpected, to say the least, in a painting of two French Catholics and would inevitably have had strong Reformist overtones. From Holbein's careful painting it can be identified as a book of Latin hymns translated by the leader of the Protestant Reformers, Martin Luther, and set to music by Johann Walther, Kapellmeister to the Court of Saxony. It was published in five different parts for different voices at Wittenburg in 1524 and became the standard hymn book used in the reformed churches of southern Germany. 'The Ambassadors' shows two pieces from the tenor volume. On the right-hand page is Luther's introduction to the abbreviated version of the Ten Commandments and on the left hand is his translation of the 'Veni Creator Spiritus' – 'Komm heiliger Geyst'. The choice of these two pieces, probably made by de Selve himself, must have been intended to emphasise the common ground between the two religious factions rather than highlight their differences. Both recognised the authority of the Ten Commandments and the inspiration of the Holy Ghost, as the only true sources of earthly justice and happiness. Perhaps there was also a more personal dimension to the choice. The Whitsun hymn, 'Come Holy Ghost', was sung on many specially solemn occasions, among them the consecration of bishops. Georges de Selve at the age of twenty-five would soon be officially enthroned in the bishopric of Lavaur to which he had now been nominated for six years.

Was the book for Holbein's painting perhaps borrowed from Thomas Cranmer? The year before our painting, he had married the daughter of one of the leading German Reformers.[50] Or it might have belonged to Holbein himself. Holbein's career had been nurtured in Humanist circles and buffetted by the Reformation in Europe, but his personal religious convictions are not clear. He had illustrated Reformist broadsheets: an engraving of 'Christ the True Light', dated 1526, shows the faithful following Christ while the Pope stumbles blindfold after Aristotle and Plato into the ditch of error.[51] Though we may surmise that Holbein sympathised with the Reformers' aims, he shared with Erasmus some doubts as to the course they were taking. The most likely owner of the hymn book was Georges

de Selve himself. He spoke fluent German, had visited the country on diplomatic business many times and was, after all, a theologian by profession. His avowed ambition was the re-unification of the Church and the establishment of a lasting peace between Charles V, the Holy Roman Emperor, and his own king, François I.

France, while remaining orthodox, had not shared in the violent antipathy towards the Reformers of her more extreme neighbour, Spain. Through the international circle of Humanist scholars, the philosophical background to the Reformation had gradually filtered into France. At the beginning of the century, the mystical, highly personalised religious flavour of the Brethren of the Common Life had been brought to France by John Standonck who came first to study at the University of Paris and was then appointed head of the College of Montaigu.[52] There he introduced a curriculum, typical of the Brethren's schools, based on the study of Biblical texts, the writings of the Church Fathers and the *Imitation of Christ* by Thomas à Kempis. In 1519, Luther's writings had first appeared in Paris, and were apparently received with open arms. Johann Froben, the Basel printer with whom Holbein was then working, wrote enthusiastically to Luther to tell him that his works 'are being read even at the Sorbonne; they meet with everyone's approval.'[53] But approval of the University of Paris did not last. Once the full implications of Luther's ideas became apparent, the University published a *Determinatio* condemning a hundred and four of his propositions.[54] The French king himself had shown signs of interest in Humanism and some aspects of reform. François had entrusted the education of his son, Charles, to Lefevre d'Etaples who produced the first complete translation of the Bible into French. He had also intended to bring Erasmus to France to establish a college of classical learning. But Erasmus, already receiving a pension from François' rival, Charles V, declined the offer, anxious as ever to avoid sticking his neck into politics.

It was against this background that the liberal Catholic faction had grown, rooted in orthodoxy but spreading its leaves in the sunshine of tolerance. The king's own beliefs were pragmatic, and religious opinion at court, as we have seen, was mixed. Since the defeat of the French by the ultra-Catholic Spanish, however, and the humiliating imprisonment of François I, coolness towards Spain tipped the scales against the more conservative Catholics and in favour of the liberals. In his writings,[55] de Selve firmly supports the traditional doctrines of the Church, blaming discontent on disputes between the secular and spiritual leaders of Christianity which he saw as deforming the Church and playing into the hands of the Lutheran heresy. He bitterly attacks cardinals who enjoy a cushioned life as Papal officials when they should be renouncing wordly interests in the name of Christ. He condemns the centralisation of power in the individual person of the Pope which weakens the authority of the Church's councils and

constitutions, and he criticises secular princes who presume to interfere in the running of the monasteries and colleges for their own political and financial interests.

Among de Selve's collected works are two orations addressed to the German Reformers and intended to be read at public debates for the promotion of religious unity. The earlier of them may have been composed for a speech to the Diet of Speyers of 1529. This Diet was one of the most reactionary of the great Church congresses held during the Reformation years. It proved a temporary setback for the Reformers' cause and forced a minority declaration of dissent at the end of the proceedings, the famous 'Protestation' of Lutheran princes and cities which first gave rise to the term 'Protestant'. De Selve's probable presence as a representative of France at this important gathering shows the high esteem accorded by the French Court to this young man's grasp of theological matters. To whom better could de Dinteville have turned for advice during that fateful Easter of 1533?

So, in the discreet symbolic language of 'The Ambassadors', the Lutheran hymn book, the lute with its broken string and the page of arithmetical divison present a plea for reform, but reform without rupture. Now, however, all hope of peaceful reform had been prejudiced by the king of England's public defiance, not only of Rome, but of one of the Ten Commandments themselves: 'Thou shalt not commit adultery'. For Luther, the Commandments rather than the Pope claimed ultimate allegiance, a view that de Selve would probably have shared. But Henry's overriding concern was the line of succession. He was forty-two years old and well aware that if he were to die without an adult male successor there would be little hope of harmony in his own kingdom. Lutes had long been considered effective in calming the passions of princes[56] but without the passion of this prince there could be no son and no heir. For that Henry would risk discord in the Church. This was one lute string that had to snap . . .

With the suddeness of a snapping string Holbein disrupts the meticulous realism of his scene with a strange shape that rips across the foreground. The significance of this mysterious object is not apparent at first sight. To find it we must literally take a sidelong glance at the painting. When seen from one particular viewpoint, half way up the right-hand edge of the frame, the ambassadors and their world collapse – but the distorted shape of the foreground resolves itself into a skull. The perspective of the skull is so designed that it can be 'read' only from this point. Holbein has turned the rules of perspective on their head, using the conventional framework of realism to provide the spectator with a macabre surprise.

The use of perspective to distort an image beyond immediate recognition is called anamorphism, meaning formed again, from the Greek roots 'morph' and 'ana'. The term was first used in the seventeenth century.

'The Ambassadors': detail of distorted skull.

'The Ambassadors': detail of distorted skull undistorted.

Until then such distortions were known simply as 'perspectives'. The earliest example of an anamorphic drawing is to be found in Leonardo's sketch-books[57] and shows a child's face and an eye distorted along one axis. By the sixteenth century, the rules of perspective, which painters of Uccello's generation had struggled to grasp a hundred years earlier, were taken for granted. Dürer had developed a perspective 'window', a box-like device that enabled him to perfect the reproduction of normal perspective using sightlines. The first anamorphs were drawn by similar mechanical methods or by shining light at an angle through perforations pricked along the lines of an original in correct perspective on to another piece of paper and joining up

88

the points of light. It was not until a hundred years later that the geometric techniques for constructing anamorphic drawings were explained in detail in treatises like *La Perspective Curieuse* by François Niceron, published in 1638.

The oldest known anamorphic print is a 'puzzle picture' by Erhard Schon, a pupil of Dürer, dated between 1531 and 1534. The picture shows an undulating landscape of streaky lines which, viewed alternately from the extreme right and left, reveals four portraits: Charles V, François I, Ferdinand I of Austria and Pope Clement VII. Undistorted details in the landscape background recall events associated with the individuals concealed. In a later version, Clement VII is replaced by Pope Paul III. Two other anamorphic prints by Schon are known, both from the 1530s and both rather scurrilous.

Shakespeare, with his usual sharp eye for metaphor, compared anamorphic painting to the confused vision of sorrow:

Leonardo da Vinci, anamorphic sketch of a child's head and an eye (Biblioteca Ambrosiana, Milan, CA 35va 98).

Engraving showing use of Dürer's perspective 'window'.

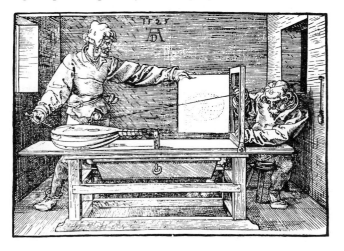

For Sorrow's eye, glazed with blinding tears,
Divides one thing entire to many objects;
Like perspectives which, rightly gaz'd upon,
Show nothing but confusion, – eye'd awry,
Distinguish form!'

(Richard II, act 2, scene 2)

Perhaps he had in mind the the anamorphic portrait of the young Edward VI, dated 1546 and attributed to William Scrots. It hung in Whitehall Palace where the Company of the Lord Chamberlain's men, to which Shakespeare belonged, often performed.[58] The double viewpoint of anamorphic art made it a ready symbol for the limitations of the human intellect. From our standpoint, life is a chaos; a chaos whose hidden order is revealed only in the sight of God. In this century, Jean Cocteau compared the anamorph to the labyrinth: 'the place where the senses are lost, where knowledge is led astray. And at its centre, patiently waiting, the monster, the minotaur, Death.'[59]

Holbein's skull in 'The Ambassadors' may represent the first serious use of anamorphism as an integral part of the programme of a painting. Knowledge of perspective was, of course, part of his repertoire as an artist, and this may have extended to a practical familiarity with the principles of optics. Holbein's portraits were uncannily life-like, and it is likely that he used a box with a lens, a 'camera obscura', to capture the likenesses of his sitters in preliminary sketches. Holbein's friendship with Niklaus Kratzer would, no doubt, have fostered an interest in optics. Just two years after 'The Ambassadors' was finished, Peter Apian, whose intellectual presence is felt elsewhere in this painting, published a treatise on mathematical perspective.[60] If Holbein or the ambassadors knew him, which is at least possible, then it may have been Apian who provided the mathematical know-how for constructing the anamorphic skull.

But why should Holbein and the ambassadors have contrived to conceal this unnerving reminder of mortality in their painting? De Selve was only twenty-one years old when his father, Jean, had died. De Dinteville had lost both his father, Gaucher, and one of his brothers within four months in 1531, and his own ill-health often gave cause for concern. Holbein may have been deeply disturbed by the sudden deaths of his father and his brother, Ambrosius. If the attribution, often made to Holbein, of the portrait of Johannes Zimmermann in Nuremberg is correct,[61] then we know that this melancholy turn of mind had been expressed in his work as early as 1520, the year after his brother's death. The portrait shows Zimmermann playing a harp, oblivious to the figure of Death stalking behind him. Over a doorway in the background is an inscription which says that the subject of the painting is Time 'which puts an end to happy days. You can see how fleeting are the favours of Youth and how Beauty vanishes through illness or simply through the swift

William Scrots, anamorphic portrait of Edward VI, 1546 (National Portrait Gallery, London).

painting, the prelude to the theme of the Dance of Death was the subject of the 'Three Living and Three Dead Kings' which began to appear in church wallpainting and in manuscript illumination from the thirteenth century. Three kings in the prime of health and wealth are confronted with the decaying corpses of three kings from the grave. 'Such as I am, so shall ye be; such as ye are, so once was I' reads the sobering inscription on one early example.[63]

The first known painting of the fully developed cycle of the Dance of Death was in the cloister of the cemetery of the Holy Innocents in Paris. It was painted in the 1420s and seems to have served as the prototype for similar cycles all over Northern Europe. Although it was later destroyed,[64] at the time of the painting of 'The Ambassadors' it was still intact. The English poet, John Lydgate, a monk at Bury St Edmunds, visited Holy Innocents around 1440. The Dance of Death made such an impression upon him that, with the help of the monks there, he made an English translation of the verses. 'Death first speaketh unto the Pope', he begins, 'and after to every degree as followeth.' Lydgate's verses were used as the basis for an English Dance of Death cycle painted on wooden panels around the cloister of Old St Paul's Cathedral. Thomas More knew the paintings well and refers to their impact upon him in his 'Four Last Things'. Holbein, who lived in More's house during his first stay in England, was likely to have studied the cycle with great interest. He had already designed an Alphabet of Death before coming to England and on his return to Basel he began work on a complete set of fifty-one Dance of Death illustrations. In Basel he had two models to hand: one in a former convent of Augustinian nuns at Kleinbasel and the other in the churchyard of the Dominican Friars at Grossbasel. Both cycles conformed to the pattern established at Holy Innocents in Paris.

Holbein's designs for the Dance of Death were made into woodblocks by Lutzelburger, the same craftsman who had engraved his Alphabet of Death, and the book was eventually published at Lyons in 1538. Most of the drawings, however, were already completed by 1527, so de Selve and de Dinteville would have had the opportunity to see the originals or, perhaps, proofs from the printing blocks before the conception of their own painting. The Dance of Death prints do seem to have had an influence on the composition of 'The Ambassadors'. The frontispiece of Holbein's melancholy catalogue is the Coat of Arms of Death. Two people, in the splendour of youth and fashion, stand as supporters to a shield bearing a skull and surmounted by an hour-glass. 'The Ambassadors' presents precisely the same configuration of emblems and can be read in the same heraldic way. The sumptuously dressed ambassadors act as supporters; between them, the emblem of the skull; above the skull, instruments for measuring time, the equivalent of the engraving's hour-glass.[65]

march of time'. Death was an ever-present reality; a fact that war, plague and infant mortality made unerringly clear. The *momento mori*, the remembrance of death, was a clarion call to repentance for the people of the late Middle Ages and Renaissance.

The obsession with death is typified by the popularity of the theme of the 'Dance of Death', a gruesome pageant in which the skeleton of Death extends his unavoidable invitation to all stations of life, both rich and poor, young and old. The Dance of Death may have had its origins in medieval drama or dumbshows. It is recorded[62] that a *tableau vivant* of the Dance of Death was presented, rather inappropriately, to guests at the marriage of Alexander III of Scotland to the daughter of a French count, in 1285. The macabre show was unfamiliar to the Scots and caused such dismay that the company was immediately drained of merriment! In

The discovery of the familiar theme of the Dance of Death in a new key leads us to the deeper resonances in the orchestration of our painting. The distorted skull is not the only emblem of mortality here. The broken lute string and the skull badge in de Dinteville's hat point to the same end. Even the floor on which the ambassadors stand shares in this dark meaning.

The pattern of the floor is said to have been inspired by the pavement before the high altar of Westminster Abbey.[66] This mosaic floor was laid down by Italian craftsmen in 1268, during the reign of Henry III, and is unique in Northern Europe. The interlocking squares and circles of its geometric pattern are clearly recognisable in Holbein's painting, though he does not produce a totally accurate copy. The design of the pavement originally included an inscription which stated that its pattern carried a special meaning. It may seem strange today to think of pattern as carrying meaning but abstract ideas were often expressed through what has been called 'sacred geometry'. Ever since classical times, diagrams or schemata had been used to convey the relationships between elements of both the physical and the spiritual worlds, and to fit them into some universal order of things. The sanctuary pavement at Westminster presents just such a cosmology. Most of the bronze letters of its inscription are now lost, but fortunately it was copied down in the fifteenth century by John Flete, a monk at the Abbey.[67] Enough random letters and indents remain to confirm a good part of his transcription. It tells the reader that if he 'prudently considers all that is set around him, he will

Hans Holbein, 'The Dance of Death' (engravings): 'The Emperor', 'The Child', 'The Arms of Death' (Mansell Collection).

91

Odoricus, Cosmati pavement in Westminster Abbey sanctuary.

discover the end of the *'primum mobile'*, the motivating force of the Universe. So the pattern of the pavement sets out a philosophical plan of Creation – and its end. Using an elaborate formula of multiplied lifespans,[68] the inscription proceeded to predict the exact year of the ultimate calamity.

By his reference to the Westminster Abbey pavement in 'The Ambassadors', Holbein reminds us that not only is Death the common fate of all men, but even the days of the Universe are numbered. As the double perspective of the picture shows the ambassadors from one viewpoint and reveals a skull from the other, so the meaning of our painting shifts its ground. The celebration of human knowledge falls beneath a deep shadow of pessimism. 'How dieth the wise man?' asks the Wisdom literature of the Old Testament: 'as the fool.' Knowledge, like the rules of perspective, can distort as well as reveal the truth. The artist's perspective produces an illusion of reality; the scholar's learning the illusion of enlightenment. A story is told of the patron saint of Lyons, St Bonaventure. He was asked by Thomas Aquinas from which of his books he had acquired his deep understanding of God. The saint replied by drawing back a curtain in his library to reveal a crucifix, the sole source of all his wisdom.[69] The ambassadors were sure to have been familiar with this moral story of St Bonaventure since the French Court was often in Lyons. Holbein probably knew it too, for

he pulls back the green brocade curtain behind the ambassadors to give just a glimpse of a silver crucifix in the top left-hand corner of the picture. Here we may read again the saint's reply.

A tradition of ultimately scorning the sophistication of great learning in favour of the profound simplicities of Faith has always existed among the intellectual of Christianity – though a cynic might suggest that it is rather like a rich man saying money cannot buy happiness! Most religious philosophies have an undercurrent of the futility and vanity of earthly power and learning. At times of uncertainty, it wells up. The early sixteenth century was such a time. The condemnation of all vanities was the common cry of reformers, Protestant and Catholic alike. There was but one bulkhead against the swell of pessimism. As the skeleton of Death danced his way through humanity in the Kleinbasel painting, he was stopped in his tracks by the image of Christ on the Cross, placed exactly in the middle of the cycle. The inevitability of Death could be ameliorated only by the hope of Resurrection. The road to real understanding and ultimate truth was through faith: all else was 'vanitas'.

The *vanitas* theme in literature and art began in the uncertainties of the early sixteenth century and reached the height of its popularity the following century. It encapsulated what Alberto Veca has called 'the fragility of man and of his world of desires and pleasures – vain, empty and temporary – in the face of the unavoidable and definitive nature of Death'.[70] A medal of Erasmus, made in 1519, has Terminus, patron deity of philosophers, on its reverse and carries the motto *Mors ultima linea rerum*: 'Death is the final frontier of all things'.[71] As the *vanitas* theme developed fully in seventeenth century painting, its hallmarks became more defined: Mortality, in the form of a skull or other such emblem; Learning, symbolised by books and globes; the Passage of Time, indicated by horological instruments or objects of transitory nature, like flowers; and the hope of Resurrection, represented by ears or corn, for example. A sense of arrested time usually pervades the somewhat self-conscious composition of *vanitas* pictures – a 'still-life' in its literal sense.[72] All these elements are already present in Holbein's 'The Ambassadors', wrought harmoniously together with such subtlety and surety that they appear completely natural and uncontrived parts of the scene.

The term *vanitas* derives from the opening verses of the Wisdom literature of the Old Testament: 'Vanity of vanities, saith the Preacher, vanity of vanities; all is vanity.' (*Ecclesiastes*, 1,2.) In the sixteeenth century the theme was taken up in literature from Erasmus' *In Praise of Folly* onwards. Published in 1511, the book ran to fifty editions in Erasmus' lifetime and is still available in paperback today. It is a work of scalding sarcasm. Through the mouth of a woman called Folly, Erasmus pillories the vanities of the world, setting the condemnations of *Ecclesiastes* in a contemporary context:

Francisco Zurbáran, 'St Bonaventure refers St Thomas
Aquinas to the Passion of Christ' (Photo Staatliche Museen,
Berlin).

'The Ambassadors': detail of silver crucifix.

what pleasure it is for intellectuals 'when in a philosophical
ecstasy they create countless numbers of different
worlds in the Universe, when they give us the sizes of
the the sun and the moon, the stars and other globes as
our ruler and line . . . when they pile triangles, circles,
squares and an infinity of mathematical figures on top of
the other, interlaced in labyrinthine forms . . . and
throw shadows on things that are clearest . . . They
know absolutely nothing and they boast of knowing
everything.' The book reaches the inevitable conclusion
that the only folly on which we may depend is that
unseen, immeasurable, unprovable 'folly' of Faith.
Other writers followed Erasmus in this vein: Thomas
More in his *Utopia* of 1516, Cornelius Agrippa in *The
Uncertainty and Vanity of the Sciences and Arts* of
1530.

Cornelius Agrippa (1486–1535) was a colourful
character, famous, notorious even, throughout Europe.[73]
He had fought as a soldier in Spain, acted as a secret
agent for Charles V, practised as a lawyer and a
physician, written works on the occult sciences, lectured
as a philosopher in the great universities, and, as a
debtor, served his time in prison. He received offers of
patronage from the best quarters of Europe: the court of
the Holy Roman Empire, the Italian Marquis of
Montferrat, the duke of Bourbon, Mary of Austria and
even Henry VIII. Although his own circle of followers
appear to have held Agrippa in virtual reverence, his
sharp tongue and total lack of tact soon alienated most
of his patrons. He stayed no longer than seven years in
any one country. His restless and controversial career
wove its way through the political intrigues of Europe
and touched occasionally the threads drawn together in
our painting.

In 1524, Agrippa accepted the office of physician to
Louise of Savoy, mother of François I and a powerful
figure at the French court. She had ruled as regent
during her son's imprisonment in Spain. At that time
Jean de Dinteville was a young man at court, in special
attendance upon the king's children. He was certain not
to have missed the opportunity to meet such a celebrity
as Agrippa. Agrippa spent two and a half years in the
service of the Queen Mother, but they were far from
happy times. His salary went unpaid, forcing him and
his family to live on loans and handouts. The post itself
was not what he had hoped. Louise expected him to cast
horoscopes for her – something Agrippa was perfectly
able to do but which he considered a vain trivialisation
of his art. Matters came to a head in 1527 when he was
asked to cast a horoscope for the king himself. After
great pressure, Agrippa agreed. He gazed at the
configurations of François' stars and confidently pre-
dicted that the king would be threatened by death
within six months![74] Agrippa, unaware it seems that
discretion is the better part of valour, had made a
prediction tantamount to treason. He tried to flee the
country, but was detained in Paris. Eventually he found
sanctuary in a friend's house in Antwerp.

Peter Apian, contemporary engraving.

Cornelius Agrippa, contemporary engraving.

Before long, Agrippa was back under the patronage of the Emperor, to whom he was appointed historiographer and judicial councillor. But he was not to stay in the Emperor's favour for long. In 1530, Agrippa published his best-known work on *The Uncertainty and Vanity of the Sciences and Arts*. 'I write,' he says by way of introduction, 'because I see men puffed up with human knowledge, condemning the study of the scriptures and giving more heed to the maxims of philosophers than to the laws of God.' The book went on to contain enough invective about secular and spiritual courts to set both against him at once. The monks called for his punishment as a heretic and the Emperor demanded a public retraction of his opinions. Agrippa refused. The controversy made the book a best seller. Erasmus wrote saying that everyone was talking about him and his new book, 'I do not know it yet, but I am setting about obtaining a copy'. After he had read the book, Erasmus wrote again, praising the work but counselling Agrippa with caution. Theologians 'are not to be overcome even if one had a better cause than St Paul himself,' he warned.

The Uncertainty and Vanity of the Sciences and Arts was being read enthusiastically in England too. Here interest centred on Agrippa's criticism of the universities that had ruled in support of Henry VIII's divorce and a thinly disguised reference to the king's rejection of Catherine of Aragon in a chapter on prostitution.[75] The delighted ambassador of the Emperor in England, Eustace Chapuys, wrote to Agrippa urging him, as a lawyer, to defend Catherine against divorce. By way of encouragement he said that all learned men in London were praising his book, and it was the Queen's own wish that he should take up her case. But Agrippa, no stranger to playing with fire, was unwilling to risk having his fingers burned by yet another prince of Europe, and declined the offer.

Did Holbein and the Ambassadors know of Agrippa's book? They could hardly have avoided it. A selection of extracts from the book could furnish a step by step description of Holbein's painting:

Arithmeticians and Geometricians number and measure everything, but the soul still remains unnumbered and unmeasured. Musicians treat of sounds and songs, but fail to hear the dissonances which are in their minds. Astrologers seek the stars and discourse on the heavens, and presume to fortell what will happen to other people in the world, but pay no attention to what is near them and is present every day. Cosmographers have knowledge

94

of the land and sea, they teach us about the boundaries and limits of every country but they do not render Man better or worse . . . He who has learnt everything and has learnt only these things has learnt all that he has learnt in vain. For the Word of God is the way, the rule, and the target at which whoever does not wish to err should aim, and thus attain truth. All other knowledge is at the mercy of time and oblivion and will perish; for all the sciences and arts will vanish and others will replace them . . . Divine Knowledge alone has no end and embraces everything.'[76]

What better testimony could be given to claim 'The Ambassadors' as a complex statement of the philosophical dilemmas of the early sixteenth century? The double meanings of Holbein's painting symbolise the intellectual crisis of the Renaissance. The ambassadors, Janus-like, look foward to the expanding horizons of the modern scientific world with one face, and backwards to the comfortable security of the medieval world picture with the other. One world is that of Peter Apian the practical scientist; the other of Cornelius Agrippa, the mystical philosopher. The two seem incompatable and, at the same time, inextricable. Both views exist simultaneously but our human limitations, like the rules of perspective, enable us to see only one image clearly at a time. Do we celebrate human achievement, or condemn its vanities? Do we choose the fascination of science or the skull of mortality?

In his occult writing and teaching, Cornelius Agrippa describes a 'precious Death' which is the necessary prelude to enlightenment. True and sound philosophy, he writes in a letter from Lyons, in 1527,[77] is to be found only by being one with God, 'but to be one with God, it is necessary to be detached from material things, and become dead to the world, to the flesh, to all the senses . . .' It is not a literal death but a metaphorical one: the death of all worldly sensibilities that leads the adept to a awareness of the true mystical dimension of knowledge – Wisdom. Agrippa's precious Death 'is granted only to a small number of people beloved of God, or bestowed on them by the fortunate influence of the stars, or sustained by their own merits and the secrets of the Art.'

In the vivid imagery of the alchemists, this death was the *negredo*, the phase of their secret work in which the ingredients of the retort lay fused, black and inert beneath the vapours and dews that condensed above. In his mind, the alchemist pictured the spirit of life returning to the decayed corpse. His prayers reflected the theme of the desire for purification of the corrupt and broken body.[78] Then the work began again, distilling and re-distilling, moving imperceptibly towards that final goal of transmutation. Death for Holbein and the ambassadors was not a finality, but a transformation: a transformation illustrated so aptly by the shifting perspective of the anamorphic skull, a perfect symbol for Agrippa's precious Death which turns our human perspective inside out and brings us just a step closer to that Divine Wisdom 'which alone has no end and embraces everything.'

Georges de Selve's own death came only eight short years after 'The Ambassadors' was painted. We may leave the last word to the 'envoi' of his epitaph:[79]

The Spirit of the same de Selve to humankind:
It is not I, but you, who is not in life.
It is not you, but I, who am exempt from death.
Neither I nor you, but God is the strength and
 the power,
And you and I owe Him a soul at His service.

Notes

Notes to Chapter 2.

[1] Jan van Eyck was born at Maaseyck near Maastricht about 1390, and from 1425 until his death in July 1441, he was court painter to Philip the Good, Duke of Burgundy. He lived from 1425 until 1429 in Lille, and the rest of his life in Bruges. He lived to no great age, but his brother Hubert, who died in 1426, in even greater youth, was more highly regarded still, going by the inscription on the Ghent altar, which Jan finished in 1432. Jan van Eyck's major achievements are all crowded into the following nine years.

[2] It is recognised by all Eyckian scholars that the van Eycks worked on the miniatures in the Turin Hours (partly very damaged, and partly in the Musée Civico in Turin), and most agree with a date within the lifetime of Hubert, probably circa 1416, which would make these illuminations nearly twenty years earlier than the Rolin Madonna.

[3] 'Tymotheus Leal Souvenir' (National Gallery, London) as well as the Ghent Altar in 1432; 'Man in a Red Turban' (National Gallery, London), as well as the Madonna and Child in Melbourne in 1433; the Madonna of the Fountain in the Musée Royale in Antwerp, and the portrait of his wife in 1439 to name but a few.

[4] (a) The Virgin in the Church, Berlin, Dahlem Museum; (b) Ince Hall Madonna, Melbourne National Gallery; (c) Annunciate Virgin, Washington National Gallery; (d) Dresden Triptych; (e) Madonna of the Fountain, Antwerp Musée Royale; (f) Madonna with Canon van der Paele, Bruges Musée Communal des Beaux Arts; (g) Thyssen Annunciation, Lugano; (h) Madonna in Frankfurt, Stadelsches Institute.

[5] The Madonna and Child with Saints in the Frick Collection, New York, and the Madonna of Maalbeke in Berlin State Museum.

[6] Antwerp Musée Royale.

[7] The Virgin in the Church in the Dahlem Museum of Berlin, the Annunciate Virgin in Washington, the Virgin at the Fountain in Antwerp. The Thyssen Virgin is in grisaille.

[8] The Virgin in the Church, Berlin, the crown (painted over foil covering earlier work) at the foot of the central figure of God in the Ghent Altar, the crown of Elizabeth of Hungary in the Virgin and Child with Saints in the Frick Collection and this crown.

[9] There is a contemporary account of this occasion in the Kronijkvan Vlaenderen quoted by O. Cartellieri, *La Cour des Ducs de Bourgogne*, Paris 1946, pp. 265–267.

[10] Portrait of Jan de Leeuw in the Kunsthistorisches Museum in Vienna.

[11] Quoted by J. Huizinga, *The waning of the Middle Ages*, (1924, quoted from Penguin edition, 1976) p. 246.

[12] The Dahlem Museum Virgin in a Church. There was an ancient liturgical custom of dressing one of the deacons as an angel on the Feast of the Annunciation in order that he might enter and take the part of Gabriel in the Gospel.

[13] Dresden triptych.

[14] Both in the Frick Virgin and Child with Saints, and in the drawing in Antwerp.

[15] Virgin in the Church, Berlin.

[16] Ince Hall Madonna, Melbourne.

[17] Dresden triptych.

[18] Madonna with Canon van der Paele, Bruges.

[19] Madonna of the Fountain, Antwerp Musée Royale.

[20] Frankfurt, Stadelsches Kunstinstitut.

[21] Cf. M. R. James, *The Sculptures of Ely Cathedral*, London 1895, p. 62 et seq.

[22] For the Eton cycle, cf. M. R. James & E. W. Tristram, 'The Wall Paintings in Eton College Chapel and in the Lady Chapel at Winchester Cathedral', *Walpole Society*, vol. xvii (1929), and my *Richard III*, National Portrait Gallery, 1973, item 40, pp. 20–21.

[23] Cf. Nigel Wilkins, *Two Miracles from the MS Paris Bibl. Nat. fr.819–820*, Edinburgh 1972, including Bibliography p. 11. Nigel Wilkins discusses the possibility that this unique MS was presented to Queen Isabella upon her entry into Paris in 1389, which would make this a second cross-reference between the picture and that occasion.

[24] Cf. G. Doutrepont, *La Littérature Française à la cour des Ducs de Bourgogne*, Paris 1909, especially pp. 90–119, discussing the character of Philip's Library. Something like 900 of his MSS are now in the Bibliothèque Nationale in Paris. For those still in the Royal Library in Brussels, cf. R. Vaughan, *Philip the Good: the Apogee of Burgundy*, London 1950, pp. 155–7.

[25] The text of Bodleian Douce 374 was edited by G. F. Warner for the Roxburghe Club in 1885.

[26] For the Virgin as the seat of wisdom, cf. especially Ilene Forsyth, *The Throne of Wisdom*, Princeton 1972.

[27] Illustrated Forsyth, op. cit. pp. 154 & 155.

[28] New York, Metropolitan Museum, the Cloisters, purchased 1947, Reg: 87. Illus. Forsyth pp. 152–153.

[29] Nicholas Rolin (1380–1462) has been the subject of two full-length monographs, (a) by Arsène Perier, *Nicholas Rolin*, Paris 1904, which is extremely full and careful and has been much used in the biographical details of this paper, and (b) by Roman Berger, *Nicholas Rolin, Kanzler der Zeitenwende in Burgundisch-Französischen Konflikt, 1422–61*, Freiburg 1971.

[30] Cf. Ann Hagopian van Buren, 'The Canonical Office in Renaissance Painting, Part II: More about the Rolin Madonna', *Art Bulletin* 60, 1978, pp. 617–33. For this point cf. p. 631. This article is one of the most important sources for the understanding of this picture.

[31] Cf. Carol J. Purtle, *The Marian Paintings of Jan van Eyck*, Princeton 1972, another essential source for this picture.

[32] Brussels, Bibliothèque Royale MS 9242, cf. *Catalogue of*

Roger van der Weyden Exhibition in Brussels, 1979, no. 36.

[33] Preserved in the archives of the Louvre in Paris. We are grateful to the staff of the Louvre for allowing us to examine their documentation of this picture.

[34] Quoted by A. Perier, op. cit. Two belts covered with silk and similarly ornamented survive in the Cluny Museum in Paris.

[35] Portrait by Petrus Christus in the collection of the Earl of Verulam, on loan to the National Gallery, London.

[36] Quoted by Joan Evans, *Art in Medieval France, 987–1498*, Oxford 1948, p. 249.

[37] Jacob Burckhardt, *The Civilization of the Renaissance in Italy*, (1860, quoted here from the London edition, 1944) p. 303: 'Their powerful individuality made them in religion, as in other matters, altogether subjective . . .'

[38] Meister Eckhart (1260–1329), Heinrich Suso (1295–1366), Johannes Tauler (1300–1360) in Germany and the Low Countries, immediately followed by Richard Rolle (1300–49), Julian of Norwich (1342–1420) and the author of the Cloud of Unknowing (later 14th century). Most apposite for the climate of religion in Rolin's milieu were perhaps the Blessed John Ruysbroeck (1293–1381), and Gerald Groot (1340–84) who founded what was to become the Brethren of the Common Life, which flourished particularly in the Netherlands. Their follower Thomas Kempis, (1380–1471) author of *The Imitation of Christ*, was Rolin's exact contemporary.

[39] 'Private boxes' giving a view of the service without the necessity of mingling with the crowd below for abbots and their guests survive at the west end of the nave of Westminster Abbey, on the north side of the nave at Malmesbury Abbey, and the south side of the choir of St Bartholomew's church in Smithfield. A similar arrangement gave access to the choir of Old St Paul's cathedral. A special oratory links the house of Louis de Gruthuse at Bruges with the triforium of the adjacent cathedral.

[40] Or are we to imagine that Rolin went down the stairs to join the congregation to receive the Eucharist? or that the priest climbed the private staircase in full vestments to administer to him? The same restriction applies to the royal west gallery of the chapel at Hampton Court, and the popularity of this arrangement in post-reformation England is witnessed by The Vyne in Hampshire, Hatfield, Burghley, Grimsthorpe, Charles II's Windsor Chapel, and Chatsworth. The social distinctions here expressed were described, of course, by Jane Austen in *Mansfield Park*: 'Now,' said Mrs Rushworth, 'we are coming to the Chapel, which probably we ought to enter from above and look down upon . . .'

[41] Cf. in particular the miniature of Margaret of York at prayer within such a curtained area while her ladies kneel outside it, in the MS of moral and religious treatises, Oxford Bodleian Douce 365 of 1475; discussed and illustrated by Otto Pächt, *The Master of Mary of Burgundy*, London 1948, p. 63, no. 3 and pl. 2.

[42] The later 14th century play of the Castle of Perseverance.

[43] Illustrated in many romantic 14th century mirror backs.

[44] In the Roman de la Rose, especially as illustrated from the expanded later medieval text in the MS BL Harley 4425, f. 39, illustrated by J. H. Harvey, *Medieval Gardens*, London 1981, p. 9.

[45] The castle of Piers Plowman.

[46] A persistent image of Meister Eckhart's sermons, cf. for

instance R. Schürmann, *Meister Eckhart, Mystic and Philosopher*, 1978. Eckhart was followed by St Theresa with her Interior Castle.

[47] The north facade, then the main entrance to Westminster Abbey, perhaps the galilee porch at Ely and followed in the 14th century at Exeter.

[48] Illustrated by Jean Le Jeune, *Les van Eyck, Peintres de Liège et de Sa Cathédrale*, Liège 1956, fig. 75.

[49] Chartres, north west spire; Strasbourg, single north west spire.

[50] The locus vivendi of the imagery of castles c.1400, is the Très Riches Heures du Duc de Berri in the Musée Condé at Chantilly. Note for example the castle of Vincennes with its central donjon and seven surrounding towers in the calendar illustration for December. The 'gloriette' finds its closest parallel here in the mirador at Mehun-sur-Yèvre where the duke kept his treasury. It soared like a monstrance of goldsmith's work upon the surviving high tower. Jacques Coeur kept his treasure in the top room of the highest tower of his house in Bourges.

[51] Cf. Harvey, *Medieval Gardens*, op. cit., especially pp. 103–07.

[52] For the Medieval affection for the architecture of the impossible, cf. that seminal work by John Summerson, *Heavenly Mansions*.

[53] One copy is in the Musée Nationale in Versailles; the other in the Château of Azay le Rideau. Cf. R. Hughes, *The Complete Paintings of the van Eycks*, 1970, no. 60 of Catalogue, p. 101, illus. Cf. also Harvey, op. cit. frontispiece. Harvey dates the original to 1442, Hughes to c.1425. Harvey's date would rule out the suggestion that the original was by Jan van Eyck.

[54] For Raglan cf. Anthony Emery, 'The Development of Raglan Castle and Keeps in Later Medieval England', *Archaeological Journal* 132, 1975, pp. 151–87.

[55] Where the Chambre des Comptes was permanently installed from 1404.

[56] Ezekiel 43:12: 'This is the law of the temple: the whole territory round about upon the top of the mountain shall be most holy . . .'

[57] Keri Hulme, *The Bone People*, London, 1st published 1983, 1985 edn, p. 7. 'The idea of a tower became increasingly exciting; a star-gazing platform on top . . .'

[58] French?, Paris, 2nd quarter 14th century, Cleveland Museum of Art, gift of J. H. Wade, 24.859.

[59] The terminology used here is not yet fully established. We are grateful to Dr A. J. Taylor for pointing out the lack of consistent documentation, and for quoting the 'magnam operacionen ligneam super magnam turrim castri de Flynt . . .' quoted in his *History of the King's Works*, I, p. 318.

[60] Tattershall Great Keep, started in 1433 by Lord Cromwell, after his return from the French Wars, according to the official guide 'the machicolations of the roof line are useful, but it was surrounded by a roof garden'.

[61] Cf. the background of Jan Mostaert's Portrait of a Man of c.1541 in the Musée Royal des Beaux Arts at Brussels, illus. John Harvey, op. cit., p. 53. Here it appears that a mature estraded tree four times the height of a man was growing on a roof terrace.

[62] A particularly beautiful rendering of the *hortus conclusus* forms the background of the Predella panel of the Annunciation from the St Lucy Madonna by Domenico Veneziano of

1439, now in the Fitzwilliam Museum, Cambridge.

63 Peonies are recorded since 1275 in the royal gardens at Westminster, cf. Harvey, op. cit., p. 82. The paintings of a paradise garden by a Flemish master of c.1410 in the Stadelsches Kunstinstitut in Frankfurt-am-Main (illus loc. cit., pl. v) gives pride of place to a very similar single red peony.

64 Quoted by the indispensable Harvey, loc. cit., p. 131.

65 For Philip the Good's exotic parks, cf. Richard Vaughan, *Philip the Good, the Apogee of Burgundy*, London 1950, pp. 137–9 & 145, and O. Cartellieri, *La Cour des Ducs de Bourgogne*, Paris 1946 etc.

66 As we all know, one magpie is for sorrow or ill-health but two spell joy.

67 The peacock, with the swan, the staple of medieval feasts, had made great gardens its habitat since Roman times.

68 Prime version in Louvre. Variants in the ducal palace at Dijon, etc. There is a similar portrait not requiring a different sitting, where he is bare-headed. For the problems of the portraiture of Philip the Good, cf. Lorne Campbell, *The Early Flemish Pictures in the Collection of Her Majesty the Queen* (Cambridge 1985) cf. The portrait in my forthcoming catalogue of the pictures in the Society of Antiquaries.

69 In the Boymans Museum in Rotterdam, illus Hughes, op. cit., p. lxii, often attributed to Hubert rather than Jan van Eyck.

70 Apocalypse Chapter 21, vv.22–23: 'And I saw no temple in the city for its temple is the Lord God the Almighty and the Lamb. And the city has no need of sun or moon to shine upon it for the glory of God is its light, and its lamp is the Lamb.'

71 Cf. Gene Brucker, *Renaissance Florence*, New York & London 1969, pp. 5–65, plan p. 9.

72 Listed in the catalogue of the exhibition, *Liège and Burgundy*, held in Liège in 1968. The Maastricht suggestion depended upon the version of the tower of Utrecht, which, copied from Utrecht, was not built until 1450.

73 We are grateful to Monique de Ruette for putting us abreast of the current literature on the struggles to identify van Eyck's city.

74 Joseph Philippe, *Van Eyck et la Genese Mosane de la peinture des anciens pays bas*, Liège 1960, expanding upon Jean Lejeune, *Les van Eycks Peintres de Liège et de sa Cathédrale*, Liège 1956. The researches of Joseph Philippe go into great depth and include all intervening topographical views. They only just fall short of conviction. But the presence of the tower of Utrecht in Liège, and the absence of van Eyck's castle on the island are against the identification.

75 'Acts of Mercy of Margaret of York', miniatures by Jean de Dreux, Bibl. Royale, Brussels, MS 9296, f. 1. Illus pl. p. 74 of Charles Ross, *The Wars of the Roses*, London 1976.

76 The term applies to any fantastic assembly, but is usually used to describe the grouping of an imaginery relationship of a series of famous buildings, which are not really placed so conveniently together. It was a highly popular form of cityscape for the 18th century patron returning from the Grand Tour. With the help of one or two pictures of this kind he could expound on all the antiquities he had seen.

77 Zdzislaw Kepinski, 'Madonna Kanclerza Rolin', *Rocznik historii Sztuki* VII, Warsaw 1969, pp. 107 onwards, with, fortunately for us, a French précis at the end of the article.

78 Quoted by Richard Vaughan, *John the Fearless* (London 1966), p. 272, from the contemporary account by the chronicler Juvenal des Ursins.

79 A print of it made in 1825 is pl. 27 of Kepinski's article, op. cit., from which most of these particulars are drawn.

80 Nicholas Rolin's passionate response to the murder is recorded in his speech of 23 December 1430.

81 *Les Grands Chroniques de France*, Paris Bibl. Nat. fr.6465. The actual blow is struck by an armoured soldier while two smartly dressed and callous gentlemen look on, and a third – a youth in a tall hat – the Dauphin?, looks squeamishly in the other direction. The Burgundian troops are lounging, in all ignorance, to the southeast of the Tour du Pont, while the French troops have approached from the north west bank, exactly as would have been the case. Rolin's view of the murder was expressed in a passionate speech interpreting the feelings of the widow. He accused Charles, so-called dauphin of Vienne 'of homicide and requested that he and his accomplices be put in tumbrils and taken through all the crossroads of Paris, their heads bare, on three Saturdays or feast-days, each one holding a burning taper in his hand, saying aloud that they had wickedly, treacherously, and damnably murdered the duke of Burgundy through hatred, without reasonable cause whatsoever'. Quoted by M. G. A. Vale, *Charles VII*, London 1974, from Beaucourt, *Histoire de Charles VII*, vol. 1, p. 218.

82 Since the destruction of all but the portal and Puits de Moise at Champmol, the two great tombs have reposed in the Grande Salle of the Ducal Palace at Dijon.

83 Dresden, Kupferstichkabinett, illus Hughes, op. cit., p. 102.

84 Vienna Kunsthistorisches Museum, Hughes, *Catalogue* 11 and pl. xxxiii.

85 Originally by Charles de Tolnay, *Le Maitre de Flemalle et les Frères van Eyck*, Brussels 1939.

86 Imitated by Petrus Christus in his 'Madonna and Child in a Gothic Room' in the Nelson Gallery, Kansas City, USA.

87 The relationship between van Eyck's Rolin Madonna and Roger's St Luke has been appreciated by all scholars, cf. for example M. D. Whinney, *Early Flemish Painting*, London 1968, who illustrated them both and discussed the connection, p. 61, and Hughes op. cit. Cat. 16 etc. Cf. also the catalogue of the Roger van der Weyden exhibition at Brussels in the Museum of Fine Arts, 1979, no. 1. Here Panofsky's suggested date for the St Luke of 1443–5 is quoted: 'It is agreed that Roger's picture should be dated between 1432 and 1436, during which years he may have been in Bruges, Jan van Eyck's headquarters.' A possible context would be that Roger saw the Rolin Madonna in van Eyck's studio just before he moved to Brussels in 1436, and that it was reflected in what must have been one of his first official Brussels commissions. Since no one imagines van Eyck borrowed from Roger, an earlier date for the painting by Roger not only puts aside the body of the Montereau evidence, but pushes the execution of the Rolin Madonna earlier into the career of Jan van Eyck than can be justified by any evidence as far as van Eyck is concerned, or by the evidence of Rolin's age. For the Roger version, cf. Martin Davies, *Roger van der Weyden*, London 1972, catalogue pp. 204–5 & pl. 76.

88 BL Yates Thompson MS 3.

89 F. 161 verso, followed by Psalm and illustration on f. 162 recto.

[90] For the more usual illustrations for the Penitential Psalms in Books of Hours, cf. Janet Backhouse, *Books of Hours*, London 1985, pp. 57–8, and John Harthan, *Books of Hours and their Owners*, London 1977, p. 29.

[91] St Augustine's *City of God*, written between 413 and 426, (Everyman, 1945) book XVI, Chapter 2, pp. 98–101: 'What prophetic mysteries were in the sons of Noah'. The Augustinian theology behind the choice of these subjects is discussed by Carol J. Purtle, op. cit., pp. 77–9.

[92] Genesis 14, vv. 18–20.

[93] It is only fair to quote the alternative interpretation of the capital on the Virgin's side of the picture as Ahasuerus crowning Esther, according to the *Biblia Pauperum*, the most extensive document of the later medieval passion for matching Old and New Testament scenes, a 'Type' for the crowning of the Virgin Mary. Against this interpretation is the beard worn by what ought to be Esther. In the van der Paele picture there can be no real doubt as to the Melchizedek interpretation, as Abraham and Isaac stand beside it.

[94] For a general discussion of the importance of these MSS and their use, cf. Backhouse and Harthan, op. cit.

[95] Cf. the *Catalogue of Opus Anglicanum*, Victoria and Albert Museum 1963, no. 40 and pl. 7.

[96] For this point cf. Harthan, op. cit., p. 37.

[97] The discovery of the actual texts of the Office was published by Heinz Roosen-Runge, *Die Rolin-Madonna des Jan van Eyck*, Wiesbaden 1972, pt. 3, diagram of inscriptions around the robe on p. 30, and reprinted by Carol J. Purtle, op. cit., pp. 67–8 and Appendix A.

[98] The connection with the early 12th century theologian Honorius of Autun is expanded by A. H. Van Buren, op. cit., pp. 618–22, referring to his *Sigillum Beatae Mariae Virginis* and his *Gemma Animae*, a manual of the symbolism of Church liturgy and furnishings. For Honorius, cf. J. P. Migne, *Honorii Augustodunensis: Opera Omnia*, Paris 1895. The text of 'Sigillum Beatae Mariae' (a commentary on the Song of Songs) is here published pp. 495–542, and the 'Gemma Animae' pp. 542–738, cf. especially p. 261 and, with its striking echo of the sequence of capital sculptures by van Eyck, p. 622, with the commentary on Abel, Noah and Abraham.

Notes to Chapter 3

[1] For the circumstance of the purchase, cf. Martin Davies, *Burlington Magazine*, CI, 1959, pp. 308–15, and *National Gallery Catalogue: Early Italian School*, London 1961, pp. 532–3. The picture was previously in the collection of Count Lanckoronski in Vienna.

[2] Other than by A. Venturi in *Storia dell' Arte Italiana*, VII, 1911, p. 340, and Pudelko, 'Der Meister der Anbetung in Karlsruhe' in *Das Siebente Jahrzehnt: Feschrift zum 70. Geburtstag von Adolf Goldschmidt*' 1935, p. 127.

[3] In a letter to Piero de'Medici listing the most important artists working in Florence in 1438, written by Domenico Veneziano, Uccello was not mentioned: cf. J. Pope-Hennessy, *Paolo Uccello*, London 1969, p. 5. The four distinguished painters selected by Bartholomaeus Facius for his *De Viris Illustribus* in 1456 were Gentile da Fabriano, Jan van Eyck, Pisanello and Roger van der Weyden. See M. Baxandall, 'Bartholomeus Facius on Painting', *Journal of the Warburg and Courtauld Institutes* 27, pp. 90–107.

[4] See John Pope-Hennessy, *Paolo Uccello*, op. cit. pp. 156–7.

[5] Above the entrance to the church of that name in Florence, cf. Pope-Hennessy, op. cit. pp. 178–9. It is always assumed that the element which Uccello revealed (and which Donatello thought ought to have been concealed) was the perspective construction of his paintings. With hindsight we can see that the compositional distortions of Uccello's frescoes, such as the 'Nativity' and 'Annunciation to the Shepherds' from San Martino alla Scala (Pope-Hennessy, pp. 154–5), or of his 'Sacrifice of Noah' and 'Drunkenness of Noah', once in the Chiostro Verde, Santa Maria Novella, (ibid., pp. 145–8), were to be of direct inspiration to later artists, first Mantegna and then Tintoretto.

[6] Pope-Hennessy, pls 77–82.

[7] The Jacquemart-André panel is 5 centimetres lower, but 17 centimetres longer than the National Gallery one, i.e. 52 x 90 cm for Paris compared with 57 x 73 cm in London. The Jacquemart-André version could well have been the front panel of a *cassone*, as has been suggested (Pope-Hennessy, op. cit. p. 154).

[8] The first reference to the Paris panel appears to have been C. A. Loeser, 'Paolo Uccello' in *Repertorium für Kunstwissenschaft* XXI, 1898, p. 89.

[9] For the pose of the 'Rocking Horse' in the Paris panel see the left-hand horse of 'The Hunt' in the Ashmolean Museum in Oxford (Pope-Hennessy, pl. 103). For the anatomy of the dragon see a page of drawings attributed by Vasari to Uccello (Pope-Hennessy, pl. XLII, p. 176 – dragon beneath unicorn standing on ?ass). The profile princess can be matched by several of the profile figures in the 'Profanation of the Host' (Pope-Hennessy, pls 87–100). The landscape rising in neatly defined strips to the city beyond is not so much a hill as a fold of land – a compromise that Uccello also employed in the background of 'The Rout of San Romano' (National Gallery, Pope-Hennessy pl. 51), Uffizi (Pope-Hennessy pls 61–4) and probably also Louvre (Pope-Hennessy pls 71–6) if that work were in a less tragic condition. The puzzle which Uccello appears to have addressed in the San Romano backgrounds was like this: granted his total mastery of the technique of making shapes whose circumference was predictable appear to recede in space, how was he to apply his knowledge where as in a landscape, the actual shapes were arbitrary? The answer lay not with linear, but with aerial perspective, and with the next generation. In 'The Rout of San Romano' Uccello got round part of the problem by bridging the gap between the foreground and the background with a hedge.

[10] For which cf. Jacopo da Voragine, *The Golden Legend*, ed. F. S. Ellis from Caxton's translation (London 1900), III, pp. 125–134.

[11] Jacopo da Voragine, loc. cit. p. 128. 'He said to the maid deliver to me your girdle and bind it about the neck of the dragon and be not affeard. When she was done so the dragon followed her as it had been a meek beast and debonair'. The girdle incident is relatively seldom illustrated except in the fullest account of George's legend.

[12] F. Edward Hulme, *Symbolism and Christian Art*, 1891, p. 111.

[13] The Order of the Garter was established in 1348 by Edward III. According to legend he picked up the garter dropped by the Countess of Salisbury, and buckled it beneath his knee with the phrase 'Honi soit qui mal y pense' (shamed be he who evil thinks on it). The insignia of the Garter are a garter worn beneath the knee, the red cross of St George and a pendant of St George and the Dragon.

[14] Norman Brommelle, 'St George and the Dragon', *Museums Journal* 59, 4 July 1959.

[15] Dieric Bouts (fl.1448–died 1475) 'The Entombment', tempera on flax, 35½" x 29¼", National Gallery no. 664.

[16] Giorgio Vasari (1511–74), *Le Vite de piu eccellenti Architetti, Pittori et Scultori Italiani*, 2nd edn, 1568.

[17] Cf. James, *Dictionary of Subjects and Symbols in Art*, 1974, *Acta Sanctorum*, 23 April, pp. 120–7, and many popular compilations. There is an account of the martyrdoms of St George which purports to be written by his servant Pasikrates, which was known to Theodosius, bishop of Jerusalem, c.450, and Theodotus, bishop of Ancrya (early 5th century). The impossible martyrdoms of St George were already referred to by St Ambrose in the 4th century, cf. R. A. Jairazbhoy, *Oriental Images in Western Art*, Bombay, London etc. 1965, pp. 193–5.

[18] Cf. Prudentius' hymn of the 5th century. For the Roman flying banners of dragons cf. *Folklore* 61, 1950, pp. 180ff.

[19] Cf. John, chapter III, verses 14–15.

[20] *Baedae Opera Historica* edited C. Plummer, Oxford 1896, vol. I, pp. 100–101, quoting British Library, Add. 18150. op. cit. Jacopo da Voragine quotes the calendar of Bede where he says that he suffered martyrdom in Persia in the city of Diaspolin.

[21] Cf. Ovid, *Metamorphoses*, IV, 665–739.

[22] Cf. The *Shahnama*, completed in AD 1010.

[23] For example, 2 Kings chapter 19, verses 35–6: 'And it came to pass that night, that the Angel went out, and smote in the camp of the Assyrians an hundred four score and five thousand: and when they arose in the morning, behold, they were all dead corpses.'

[24] See Apocalypse chapter 11, verses 7–9; Michael, God's vicegerent was named in the later books of the Old Testament.

[25] Cf. T. H. White, *The Book of Beasts* (London 1957), pp.165–7. It is possible to be lost without trace in the coils of the bibliography, ancient or modern, of dragons. One of the most provocative works is Francis Huxley, *The Dragon, Nature of Spirit, Spirit of Nature*. Cf. also R. A. Jairazbhoy, *Oriental Influences in Western Art*, especially the chapter on the Primeval Dragon Myths.

[26] Herodotus, c.484–5 BC, *Historia*. A Latin version of Herodotus' history was published by Laurentius Valla in c.1450 in Rome.

[27] Cf. S. H. Hooke, *Middle Eastern Mythology*, London 1966, especially pp. 105ff., 'Creation Myths'.

[28] Quoted by Plato in the *Symposium*.

[29] Reprint published by Hildesheim, New York 1972.

[30] S. H. Hooke, op. cit pp. 105: 'Even when the earth as a globe was generally accepted to be spherical, it was still thought that "the underneath" was entirely water. It was by crossing this water that Christopher Columbus hoped to reach India from the other side. He didn't expect to be interrupted by America.

[31] Rabbi Lewis Jacobs, 'Jewish Cosmology' in *Ancient Cosmologies*, eds Carmen Blacker & Michael Loewe, London 1975, pp. 66–86. We are greatly indebted to his book, and more to the editors for their advice and encouragement.

[32] Hooke, loc. cit. quoting Gunkel's *Schöpfung und Chaos*.

[33] Hooke, loc. cit. pp 70–3.

[34] Hooke, *Early Hebrew Myths and their Interpretations*, p. 162.

[35] Michael Baxandall, 'Bartholomaeus Facius on Painting', op. cit. '(At Venice) he also painted a whirlwind uprooting trees and the like, and its appearance is such as to strike even the beholder with horror and fear'. Pope-Hennessy (op. cit. p. 2) associates this reference with Gentile's fresco in the Ducal Palace at Venice.

[36] Ibid., John Heath-Stubbs, *The Hero as a Saint: St George*, p. 9. Crocodiles are vulnerable only by piercing the eye, and John Heath-Stubbs suggests that the Copts imagine the dragon to be a giant crocodile, 'Girgis the Roman' appears and disappears in the course of the saga.

[37] Cf. H. R. E. Davidson (ed.) *The Hero in Tradition and Folklore*, The Folklore Society, Mistletoe Series, vol. 19, 1984, Appendix pp. 156–80.

[38] Jairazbhoy, op. cit. pp. 180–1.

[39] Cf. Heath-Stubbs, loc. cit.

[40] Jairazbhoy, p. 194 and Heath-Stubbs, op. cit. p. 6.

[41] The Green Man and the Wild Man or Woodehouse are not the same thing. For the Wild Man, cf. Timothy Husband, *The Wild Man Exhibition Catalogue*, 1980, The Cloisters, New York. The Wild Man is shaggy, and somewhere between a man and a beast. If you can catch one in a net and baptise it, it will acquire an immortal soul. The Green Man is a vegetation spirit.

[42] J. G. Frazer, *The Golden Bough: a Study in Magic and Religion*, 1st published 1922, from edn of 1963, pp. 158–67.

[43] Cf. Lucy E. Broadwood, 'Notes on the Padstow May songs and ceremonies and their possible significance', Appendix, *The Journal of the Folk Song Society*, 20, 1916, pp. 328–33, from the version collected by George Boase in 1887. For this reference, and for her guidance in all matters to do with folklore, we are deeply indebted to Marie Slocombe. The views here expressed, however, are ours, and frequently heretical.

[44] Cf. Violet Alford, *The Hobby Horse and other Animal Masks* London 1978.

[45] Known from a painting of that date by Joost Amman in Munich, National Museum.

[46] Cf. Alex Helm, *The English Mummer's Play*, Woodbridge 1981.

[47] John E. Matzke, 'Contribution to the History of the Legend of St George', *PMLA* XVII, 1902, p. 464.

[48] Published 1596, and turned in 1638 into a five act play.

[49] Cf. *Catalogue of the Norwich Castle Museum*.

[50] As illustrated and described by Pope-Hennessy, op. cit. pp. 170–2. The alternation of silvery ground and tufts of sparse vegetation can still be observed in travelling across the Apennines from Urbino to Arezzo in the high summer. It is faithfully reflected in the background for instance, of Piero de la Francesco's 'Baptism of Christ' and 'Nativity' in the National Gallery (nos 665 & 908), but there the plants are set at random, or follow the folds of the hills, as they do in the landscape itself. The highly artificial arrangement of Uccello's

foreground is best appreciated by comparison with these contemporary works.

[51] As all city children know, you mustn't tread on the cracks between the paving stones. The layout of the game of hopscotch bears more than a passing reference to the gaming board found at Ur.

[52] Cf. M. Baxandall, 'A dialogue on Art from the court of Leonello d'Este', *Journal of the Warburg and Courtauld Institutes*, p. 310.

[53] Pietro Tomasi, the celebrated doctor, Greek scholar and friend of Humanists, was practising in Venice while Uccello was there in 1425–30. His Greek books had been dispersed before 1458, but the inventory upon his death in that year still included a Ptolemy, a Plutarch on Music and a Raymond Lull, and several Arabic books on medicine, plus a Geraldus Sabloneta. (Surely Cosimo de'Medici must have met Tomasi when he was living in exile in Venice in 1443.) Tomasi had lived in Crete from 1414–18. Cf. Susan Connell, 'Books and their Owners in Venice 1435–80', *Journal of the Warburg and Courtauld Institutes*, 35, 1972, pp. 163–86. Chaucer knew about the Minotaur – 'Duke Theseus of Athens' carries an image of the Minotaur he has slain on his pennant at the siege of Thebes in the Knight's Tale.

[54] We are grateful for the help of the staff of the Coins and Medals Department of the British Museum on this point.

[55] Margaret Dean-Smith, 'The Life Cycle or Folk Play', *Folklore* 69, Dec. 1958, especially p. 241, quoting the field work done between 1900 and 1912 on the observations of survivals in Northern Greece.

[56] Quoted by C. N. Deedes, *The Labyrinth*, p. 35, from Trapp's translation of 1718.

[57] 'Beowulf' ed. E. van Kirk Dobbie, *Anglo-Saxon Poetic Records* IV, 1954, pp. 68–71.

[58] Deedes, op. cit. pp. 39–41.

[59] Loc. cit.

[60] Cf. Teresa McLean, *Medieval English Gardens*, London 1981, pp. 99–105. 'It was called "a secret chamber of Daedalean Workmanship" by medieval chroniclers.'

[61] Cf. the definitive source for medieval gardens, John H. Harvey, *Medieval Gardens*, London 1981, p. 92.

[62] Harvey, op. cit., esp. pp. 103–106.

[63] There are six engravings of knots of prodigious complexity, of which one is inscribed 'Accademia Leonard Vin'. Leonardo's involvement with these designs is attested by Vasari, but they seem to have attracted very little attention from the critic. Kenneth Clark's biography, *Leonardo da Vinci* (London 1961) only allots them one footnote (p. 99). Dürer did a woodcut copy of each of them during his second visit to Venice in 1505–7. Cf. *The Graphic work of Albrecht Dürer*, Exhibition at the British Museum 1971, no. 121 and especially no. 343.

[64] Quoted by all Uccello's biographers; for example, Pope-Hennessy, p. 24.

[65] James Beck, 'Paolo Uccello & the Paris St George 1465', *Gazette de Beaux Arts*, Jan. 1979, XCIII.

[66] Perspective study story quoted from Vasari by Pope-Hennessy, op. cit. p. 26.

[67] Of these there are three in the Gabinetto di Disegni in the Uffizi, nos 1756a, 1757a and 1758a. Two of the framework of the elaborate headbands known as Mazzocchi, and one of a chalice. Cf. Pope-Hennessy, pp. 155–6.

[68] Cf. Evert M. Bruins, 'Leonardo da Vinci's "Remarks on the centre of the pyramid related to ancient mathematical method"', pp. 52–72, esp. 54–60 of *Leonardo nella Scienza e nella Tecnica*, Florence 1969, edited Carlo Maccagnie; and K. D. Keele, *Leonardo da Vinci's Elements of the Science of Man*, New York & London 1983, pp. 143–58, illustrating polyhedra on p. 144, where Leonardo's relationship between polyhedra and spirals is discussed.

[69] E. MacCurdy, *The Notebooks of Leonardo da Vinci*, The Reprint Society 1948, pp. 222–3.

[70] For which cf. the translations and annotations of John R. Spencer, Yale University Press, revised edn 1966.

[71] The front and back view are illustrated in Pisanello's fresco of St George and the Princess in S. Anastasia, Verona, (illustrated) Pope-Hennessy, op. cit. pl. 2, p. 4. No doubt, before its destruction, the battle of George with the dragon on the other spandrel of the chancel arch offered a fine display of the horse in profile in full action.

[72] Illustrated Pope-Hennessy, pl. 61.

[73] A. E. Popham, *The Drawings of Leonardo da Vinci*, London 1946, reprinted 1971, no. 53.

[74] Pope-Hennessy, op. cit. pl. 16 and catalogue pp. 141–2.

[75] It is not possible to decide which is intended, as, until the invention of photography, it was thought that a galloping horse proceeded like a rocking horse invisibly propelled, which is all that the eye can see.

[76] Popham, op. cit. no. 64, also associated with the 1481 Adoration of the Magi.

[77] Especially Popham op. cit. 62.

[78] Although the subject matter of Leonardo's sketches may seem impossibly confused, in the end most of his drawings (however slight) can be related to some specific purpose.

[79] Popham 86. Popham wondered whether Leonardo was engaged on a commission of St George.

[80] Ibid., p. 27.

[81] Printed MacCurdy, op. cit. p. 247.

[82] Variously dated betwen 1444 and 1460, cf. Pope-Hennessy, p. 147.

[83] Cf. Gene A. Brucker, *Renaissance Florence*, New York 1969, pp. 2–3.

[84] MS in the Pierpont Morgan Library, New York, and MS F, in the Institute de France. The series of drawings is in the Royal Library at Windsor, Popham nos 279–96.

[85] MacCurdy, p. 15.

[86] The cave roofs of the 'Scenes from Monastic Legends' by the Karlsrühe master, follower of Uccello, are modelled, but not in the symmetrical way of our cave. (Pope-Hennessy, pl. XXXVI, p. 172).

[87] MacCurdy, pp. 472–3.

[88] E. R. Dodds, *The Greeks and the Irrational*, Berkeley 1963, pp. 141–6.

[89] The Phaedo purports to describe Socrates' last day in prison, in 399 BC, though it was of course written some years later. Cf. H. Tredennick, *Plato: The Last Days of Socrates*, Penguin 1962, p. 170.

[90] Fra Angelico, 'The Flight into Egypt' (Florence, Museo di San Marco). It was once one of the panels decorating the silver chests for the church of the Santissima Annunziata in Florence, another Medici commission. Santissima Annunziata is the church at the end of the street in which the Medici Palace stands. The background of the double portrait of Federigo da Montefeltro and Battista Sforza by Piero della Francesca of

c.1470 in the Uffizi in Florence, looks like nothing so much as a group of magnified mole hills, but the horizon is again comparable with Uccello's. It begins to look as though Uccello's horizon favours a late date for the picture within his career.

[91] The holes either side of the head of Donatello's St George of 1415–20, presumably commissioned by the armourers and swordsmith's guild for Or San Michele, contain metal. Surely, as Jansen claimed, they represent the fixing for a metal helmet suplied by the armourers themselves for the lifesize figure. It would no doubt have been gilded. (Pope-Hennessy, *Italian Renaissance Sculpture*, Phaidon 1963, 2nd edn 1971, pl. 5 and p. 251) Pope-Hennessy objects that Vasari knew nothing of the helmet in 1550. But the almost exactly contemporary silver head and hands of the effigy of Henry V was stolen from their place just beside the shrine in Westminster Abbey in 1546. A gilt helmet out of doors in a niche of Or San Michele probably survived an even shorter time. Do we have a reference to it in the helmet that St George is lifting from his head in Jan van Eyck's 'Madonna and the Canon van der Paele' of 1436 in Bruges Museum? That St George is wearing strongly Italianate armour. His helmet is of a type that does not require a chin piece. A chin piece would have been an embarrassment on a statue designed to stand above eye level, as it would have obstructed the view of the face. Donatello's St George could only have worn a helmet tilted well back. The facial type of van Eyck's St George is curiously similar to Donatello's St George and exceptional among van Eyck's heads. Could he have seen a drawing of the Donatello statue?

[92] We are grateful to Claude Blair for dating St George's armour for us.

[93] For which cf. Eve Borsook, 'L'Hawkwood d'Uccello et la vie de Fabius Maximus de Plutarch', in the *Revue de L'Art* 1982, no. 55, pp. 44–51.

[94] Cf. Giorgio Boccia, 'Le Armature de Paulo Uccello', *L'Arte*, Dec. 1970, new series 111, no. 11–12, pp. 55–91.

[95] Pope-Hennessy, p. 153.

[96] Martin Davies, *The National Gallery Catalogues*, op. cit. pp. 532ff.

[97] Studies of costume (recto) with studies after the antique (verso) Oxford, Ashmolean Museum KP41. Exhibition: *Drawings in the Italian Renaissance Workshop*, Victoria and Albert Museum 1983, no. 18, p. 112, illus.

[98] Pope-Hennessy, pl. 72.

[99] Apocalypse chapter VI, verse 2, picking up the imagery of Psalm 45, verses 3–5, 'Gird thy sword upon thy thigh, O most mighty, with thy glory and thy majesty. And in thy majesty ride prosperously because of truth and meekness, and righteousness, and thy right hand shall teach thee terrible things. Thine arrows are sharp in the heart of the king's enemies . . .', imagery which has been used in the liturgy of the church for Palm Sunday and the Resurrection rituals.

[100] British Library MS Royal 19B XV, f. 31, illus R. Barber, *The Reign of Chivalry*, David & Charles 1980, pl. p. 143.

[101] Apocalypse chapter I, verse 16.

[102] We are greatly indebted to Dr A. J. Taylor for giving us the following references to the provision of the arms of St George to the Welsh army in the year 1277, the first known reference to the use of the cross of St George for England: *PRO. Exchequer Accts., E 101/3/15* (Rotulus forinsecus de Guerra Wallie, 5 Edward I).

Flint, 10 Aug. 1277
For three pieces of bukeram and three pieces of Aylsham cloth bought by Adinet the tailor for making 500 armbands (*bracer*) and 120 pennons of the arms of St George and for cutting and sewing the same armbands and pennons, 101s. 6d. Item, for six pieces of Aylsham cloth bought by the same Adinet to make armbands and pennons for the king's foot soldiers, 30s. Item, for 150 ells of coloured cloth (*tele tincte*) bought for the same, 100s. Item, for the cost of 120 pennons of the arms of St George bought by the same Adinet, 23s.

Rhuddlan, 20 Aug. 1277
For white and coloured cloth (*pro tela alba et tela tincta*) and five pieces of bokram bought by Adam the King's tailor, £14 3s. 4d., for making armbands of the arms of St George.

Rhuddlan, 22 Aug. 1277
For white cloth and for making armbands of the arms of St George, by hand of Adam the King's tailor, £23 4s. 9d. For purchase of cloth and making armbands of the St George, by hand of Adinet the King's tailor, £14 9s. ½d.

[103] The Union Jack as we know it first appears among the flags carried on the Mary Rose.

[104] Apocalypse chapter 1, verse 7: 'and every eye shall see him, and they also which pierced him . . .'

Notes to Chapter 4

[1] In our opinion the best of the many biographies of Botticelli is Ronald Lightbown, *Sandro Botticelli: Complete Catalogue*, London 1978, 2 vols.

[2] Also known as the 'Del Lama Adoration'; in the Uffizi Gallery, Florence.

[3] Giorgio Vasari, *Le Vite de'piu eccellenti Architetti, Pittori, et Scultori Italiani . . .* (1550).

[4] Alison M. Brown, 'Pierfrancesco d'Medici, 1430–1476: a radical alternative to elder Medicean supremacy?' *Journal of the Warburg and Courtauld Institutes* 42, 1979, pp. 81–103; see p. 99.

[5] Cf. the later painting by Titian of 'Sacred and Profane Love' in the Borghese Gallery, Rome.

[6] 'La Primavera' measures 203 x 314 cm: 'The Birth of Venus' is 172.5 x 278.5 cm.

[7] John Shearman, 'The Collections of the Younger Branch of the Medici', *Burlington Magazine* CXVII, no. 862, Jan. 1975, pp. 12–27; Webster Smith, 'On the Original Location of the Primavera', *Art Bulletin* LVII, March 1975, pp. 31–9.

[8] Alison Brown, op. cit.; Isabelle Hyman, *Fifteenth Century Florentine Studies* (London & New York, 1977) p. 46ff., figs 63 & 64.

[9] Discussed by Hyman, op. cit.

[10] One communal room was upstairs, one on the ground floor, and the third, a summer room for alfresco meals, was under the loggia on to the garden.

[11] Probably the tondo now in the Louvre, Paris.

[12] The inventory describes the picture as 'Chamillo and the Centaur'. Chamillo was a devotee of Minerva.

[13] The *lettuccio* was 3.19 metres wide: 'La Primavera' measures 3.14 metres wide. See Shearman, op. cit. p. 18.

[14] E.g. the *cassone* panels showing the story of Nastagio degli Onesti (taken from Boccaccio's *Decameron*), 1483. Three panels are in the Prado, Madrid, and one in a private American collection.

[15] E.g. the fresco of the 'Birth of the Virgin' by Andrea del Sarto, 1514, in the narthex of SS Annunziata, Florence, and the late 15th century fresco of the Annunciation, school of Filippo Lippi, at the head of the stairs to the upper gallery of the cloister of S Lorenzo, Florence.

[16] The innermost room of Lorenzo's groundfloor suite contained an elaborate set of wooden panelling with built-in cupboards, valued at 1440 lire, the most valuable item in the inventory.

[17] See Mirella Levi d'Ancona, *Botticelli's Primavera* (1983) and her *The Garden of the Renaissance*, 1977.

[18] Aura y Astorga, 'De Beata Virgine Maria', *Bibliotheca Virginalis*, vol. III, p. 181, col. 1D. Cited by Levi d'Ancona in *The Garden of the Renaissance*, op. cit.

[19] Botticelli's preoccupation with Dante's verbal imagery during the early 1480s is illustrated by the inscription on the base of the Virgin's throne in the San Barnaba Altar-piece showing the Virgin and Child attended by angels and saints (Uffizi Gallery, Florence). It reads *Vergine Madre Figlia del tvo Figlio* and is taken from the first line of the last canto of Dante's *Paradiso*, one of the most famous passages describing the Virgin.

[20] One of the last, and the finest, was illuminated in Siena at the beginning of the 15th century in the school of Niccolo di Ser Sozzo Tegliazzi (Biblioteca Laurenziana MS Plut. 40.3, c.).

[21] Unless Vasari was referring to Biblioteca Nazionale, Florence, Banco Rari 341; see Catalogue 81 of the exhibition 'Marsilio Ficino e il Ritorno di Platone', Florence, 1984.

[22] Dante, *The Divine Comedy: II. Purgatory*, tr. Dorothy L. Sayers (1955), canto XXVIII, v. 142, p. 293.

[23] Erwin Panofsky, *Studies in Iconography* (Oxford 1939, rp. New York 1962), p. 96.

[24] Michael Baxandall, *Painting and Experience in Fifteenth-century Italy* (Oxford 1972), especially pp. 67–70.

[25] Edgar Wind, *Pagan Mysteries in the Renaissance* (London 1958), pp. 31–8, for further discussion of the Three Graces.

[26] *De Beneficiis* Book I, iii, 2–3, see Seneca, *Moral Essays*, Loeb Classical Library, tr. John W. Basore (London 1935), vol. III, p. 13.

[27] See Levi d'Ancona's *Botticelli's Primavera*, op. cit. pp. 12–13 for interesting symbolism of flax plant in connection with Mercury.

[28] The laurel tree may also be a pun on the name of Lorenzo, either the Magnificent or di Pierfrancesco.

[29] Erwin Panofsky, *Renaissance and Renascences in Western European Art* (London 1972).

[30] Andalo di Negro, *Introductorius ad Iudicia Astrologiae*, British Library MS Add. 23770, f. 36r.

[31] Abu Masar, *Liber Astrologiae*, c.1403, Pierpont Morgan Library, New York, MS 785 f. 48.

[32] Illustration from a MS in the tradition of Albericus, Bodleian Library MS Rawlinson B.214, f. 198v.

[33] E.g. the gloss on Plato's *Timaeus* by William of Conches, Biblioteca Nazionale, Florence, Conventi soppr. E.8, 1398; item 7, catalogue of Ficino exhibition op. cit.

[34] E.g. Calcidius' commentary on Plato's *Timaeus*, Biblioteca Laurenziana, Florence, MS LXXXIV, 24; item 6 in catalogue cited.

[35] Biblioteca Laurenziana, Florence, MS LXXXV, 9; item 22 in catalogue cited.

[36] Plato's *Republic*, 532A.

[37] D. P. Walker, *Spiritual and Demonic Magic from Ficino to Campanella*, London 1958.

[38] Botticelli painted a fresco of St Augustine in his parish church at Ognissanti, Florence.

[39] See introduction to Marsilio Ficino, *The Book of Life*, tr. Charles Boer, 1980.

[40] Charles Boer, op. cit. introduction.

[41] An excellent translation of Ficino's study of Plato's *Symposium* is Marsilio Ficino, *Commentary on Plato's Symposium on Love*, tr. Jayne Sears, Dallas 1985.

[42] E. H. Gombrich has persuasively compared the Venus of 'La Primavera' with the Virgin of Alesso Baldovinetti's 'Annunciation'.

[43] Alison Brown, op. cit. p. 99.

[44] See E. H. Gombrich, 'Botticelli's Mythologies', *Journal of the Warburg and Courtauld Institutes* 8, 1945, pp. 16–17 for a translation of the letter quoted from Ficino's *Opera Omnia* (Basle 1576), p. 805.

[45] Cf. the overtly astrological imagery of the woman of the Apocalypse (Revelations chapter 12, verses 1–4) who is taken to represent the Virgin Mary. The Virgin standing on the crescent moon, derived from this passage, was specially related to the iconography of the Immaculate Conception. The Venus of 'La Primavera' wears a brooch in the shape of a crescent.

[46] A drawing of an antique Hermes, Mercury's Greek namesake, in Cyriacus of Ancona (Bodleian Library, Oxford MS Can. Misc. 280, f. 68r), shows that tongues of flame were already considered an attribute of the god in classical times. Cited by Edgar Wind, op. cit. p. 106 note 3.

[47] 'Portrait of a Young Man holding a medallion of Cosimo de'Medici', Uffizi Gallery, Florence. The portrait is usually dated to the middle of the 1470s, but purely on stylistic grounds. So a later date of, say, the early 1480s, which would make identification with Lorenzo di Pierfrancesco possible, need not be precluded.

[48] Lightbown, op. cit. vol. 2, p. 145, infers that the dalmatic worn by St Laurence in Botticelli's painting of the 'Virgin and Child with St Dominic, St Cosmas and Damian, St Francis, St Laurence and John the Baptist' in the Accademia, Florence, is a reference to his namesake, Lorenzo di Pierfrancesco. The dalmatic is red with gold flames, just like the costume of Mercury in 'La Primavera'. Furthermore, the 1499 inventory of the Casa Vecchia contains references to two similar red fabrics with gold flames. One formed the hangings of the priest's room next to the house's chapel. This would have been the room occupied by Ficino, after he had been ordained, when he stayed with his protegé.

[49] Ficino's translation of the *Pimander* and other Platonic texts, which belonged to the Medici (Biblioteca Laurenziana, Florence, MS XXI, 8; Catalogue 55 op. cit.) is ornamented with flames around the margins among other Medici emblems, such as bees.

[50] *The Letters of Marsilio Ficino*, tr. by the Language Department of the School of Economic Science, London 1975. See also D. P. Walker, op. cit.

[51] For detailed discussion of the relationship between musical harmony and the compositions of Renaissance paintings see

Charles Bouleau, *The Painter's Secret Geometry: a Study of Composition in Art* (London, 1963).

[52] Pico dell Mirandola, *Conclusiones*, no. 8, cited by Edgar Wind, op. cit. p. 39.

[53] See D. P. Walker, op. cit., for discussion of Ficino's concept of the ear as the most chaste of the organs of sense.

[54] Levi d'Ancona, *Botticelli's Primavera*, op. cit. p. 27. Lorenzo provided a dowry of 2000 florins, some twenty times the amount a rich bride might normally expect.

[55] Tr. Jayne Sears, op. cit. pp. 144–5.

[56] Tr. Jayne Sears, op. cit. p. 97.

[57] Alison Brown, op. cit. p. 99.

[58] Tr. Jayne Sears, op. cit. pp. 123–4.

Note: This chapter was written and the television film completed before we discovered the iconographic interpretation of Umberto Baldini, in 'Primavera' translated by Mary Fitton, London 1986. His work complements and confirms our own.

Notes to Chapter 5

[1] Oil on oak panel, measuring 73.5 x 59 cm, c.1509.

[2] Also known as Bois-le-Duc.

[3] Alternatively, the painter may have been one of Hieronymus' uncles. The other surviving frescoes are a late 14th-century Tree of Jesse, an early 15th-century St Nicholas, and a St James and St Peter of the same period.

[4] Bosch's name fails to appear in contemporary lists of citizens of S'Hertogenbosch, but they are known to be incomplete, (Charles de Tolnay, *Hieronymus Bosch*, 1965). The first written record of Bosch appears in the annals of the Fraternity of Our Lady at S'Hertogenbosch, which later described him as 'Jheronimus van Aken, painter, who signs himself Bosch'. This is the circumstantial evidence upon which Bosch's place of birth rests.

[5] The painting was seen there by Antonio de Beatis and may well have been the triptych in the Prado, Madrid, now known as 'The Garden of Delights'. See E. H. Gombrich, *Journal of the Warburg and Courtauld Institutes* 30, 1967, pp. 403–6.

[6] Mia Cinotti in *The Complete Paintings of Bosch* (London 1696), quotes a document from the archives of the Département du Nord at Lille (tr. P. Gerlach, *Brabantia*, 1967, p. 64, note 2) in which Bosch is paid the sum of thirty-six pounds for a large painting of the Last Judgement, commissioned by Philip the Fair. A picture of St Anthony is mentioned in an inventory of property owned by Margaret of Austria and attributed by its writer to Hieronymus Bosch: Cinotti, op. cit. p. 85.

[7] By 1574, Philip II is said to have acquired well over twenty of Bosch's paintings: Cinotti, op. cit. p. 85.

[8] This shift of emphasis is typified by the monk Paschasius Radbertus in his *Liber de corpore et sanguine Domini*, 831–3, and his commentary on the Gospel of St Matthew and the Crucifixion of Christ. See Gertrud Schiller, *Iconography of Christian Art* (London 1972), vol. 2, p. 9.

[9] Gertrud Schiller, op. cit. p. 9ff.

[10] Dr W. L. Hildburgh cites an interesting example of this interaction in a lecture to the Society of Antiquaries, 'English Alabaster Carvings as Records of the Medieval Religious Drama', read 23 March 1939 (Oxford 1949): a rare representation of the 'Crowning with Thorns' in alabaster shows the tormentors using two-pronged wooden forks to force the Crown on to Christ's head. This appears to reflect very closely a stage direction in the Coventry plays ('Ludus Coventriae', p. 294) in which the performers are instructed to put the Crown of Thorns on to Christ's head 'with forkys'. For an extensive catalogue of correspondences between medieval visual imagery and the textual evidence of the plays, see M. D. Anderson, *Drama and Imagery in English Medieval Churches* (Cambridge 1963).

[11] Matthew, chapter 27, verses 27–35; Mark, chapter 15, verses 16–19; John, chapter 19, verses 2–3.

[12] Stone relief, c.340, Roman triumphal cross sarcophagus showing 'Crux invicta' with scenes of the Passion, Gertrud Schiller, op. cit. plate 1.

[13] Generally agreed, since Tolnay (1937), to have been painted c.1510. The triptych is now in the Prado, Madrid. The Mass of St Gregory was a late medieval legend according to which Christ appeared on the altar, displaying His wounds and surrounded by the instruments of His Passion, to dispel the doubts of an assistant celebrating the Mass with Pope Gregory the Great (c.540–604).

[14] E.g. those in the Kunstmuseum, Berne; the Musée Royale des Beaux-Arts, Antwerp; and the Museum of Art, Philadelphia.

[15] Painted c.1510 and probably part of a polyptych.

[16] 'Christ Crowned with Thorns' has been ascribed to various periods of Bosch's life from his early career (Martin Davies in National Gallery Catalogues, 1955), through his maturity (Charles de Tolnay, *Hieronymus Bosch*, 1965 and Jacques Combe, *Hieronymus Bosch*, 1946) to the brink of his old age (Ludwig von Baldass, *Bosch*, 1943). We prefer to date the painting to his late maturity, say 1509–1510.

[17] *The Sonnets of Michelangelo Buonarroti*, tr. John Addington Symonds (1926), p. 5, sonnet 4.

[18] The lost bronze is known from a drawing by Baccio Bandinelli for a monument to Pope Clement VII, in the Louvre, Paris, see Charles de Tolnay, *Michelangelo* (Princeton 1963), vol. I, plate 247.

[19] A letter to Jêrome de Busleyden, 17 November 1506. *The Correspondence of Erasmus: Vol. II, 1501–1514*, tr. R. A. B. Mynors and D. F. S. Thomson, Toronto 1975, epist. 205, 42–3.

[20] *The Julius Exclusus of Erasmus*, tr. Paul Pascal with introduction and notes by J. Kelley Sowards (Indiana and London 1968), p. 48.

[21] Pascal, op. cit. p. 63.

[22] Although the emblem of Islam is technically an anachronism since the Islamic faith was not founded until after Christ's death, the dislike of Islam in the later Middle Ages led it to be taken to represent any enemy of Christianity. The characters of the Mystery Plays swear 'by Mohammed', and Bosch uses the same Islamic emblem on the flag of 'The Ship of Fools' (c.1490–1500, Louvre) and in his 'Ecce Homo' of c.1480–85 (Staedelsches Kunstinstitut, Frankfurt).

[23] The painting was commissioned from van der Goes by an agent of the Medici bank who lived in the Low Countries and sent straight to Florence upon its completion. The impressive altarpiece, now in the Uffizi Gallery, had a particular influence on Ghirlandaio.

[24] E.g. by Giovanni Bellini and Cima da Conegliano, see Peter Streider, *The Hidden Dürer* (Oxford 1978), p. 86.

[25] In the Biblioteca Ambrosiana, Milan,

[26] Peter Streider, op. cit. p. 127.

[27] Now in the Musée des Beaux-Arts, Ghent, this powerful picture may even have been Bosch's last work.

[28] British Library MS Egerton 2572. For the four temperaments see folio 51v.

[29] See also Gert von der Osten, *Painting and Sculpture in the Netherlands 1500–1600*.

[30] The painting was not commissioned but painted by Dürer as a gift to the city of Nuremberg, where it hung in the town hall for 100 years. It is now in the Alte Pinakothek, Munich. The accepted title of the picture is technically a misnomer since St Paul was not one of the twelve Apostles.

[31] Dürer's biography was among those in Neudörffer's *Nachrichten von Künstlern und Werkleuten*, see Erwin Panofsky, *Albrecht Dürer* (Princeton 1965), vol. I, pp. 234–5.

[32] See H. W. Janson, *Apes and Ape Lore in the Middle Ages and Renaissance* (London 1952), p. 239ff.

[33] Perhaps Dürer chose to make St Mark the choleric temperament since his evangelical emblem was the winged lion.

[34] *Le Compost et Kalendrier des Bergiers*, facsimile of Guy Marchant edition of 1493, Editions des Quatre Chemins, Paris 1926, f. 1.ii.v.

[35] H. W. Janson, op. cit.

[36] Genesis, chapter 9, verse 20.

[37] Christopher Butler, *Number Symbolism* (London 1970), p. 55.

[38] See René Taton, *Ancient and Medieval Science*, and *The Beginnings of Modern Science*, London, 1964 and 1964 respectively.

[39] Fire was given the number 8 and the regular geometric solid, the tetrahedron; air, 12 and the octahedron; water, 18 and the icosahedron; earth, 27 and the cube.

[40] Meester Dirc van Delf's 'Die Tafel van der Kersten Ghelove'. It came in two parts: the 'Somerstuc' and 'Winterstuc'. For an example of the former see Pierpont Morgan Library, New York, MS 691; for the latter, British Library MS Add. 22288.

[41] *Summa Theologica*, Question V.

[42] *Enchiridion Militis Christi* was first published in 1504. The introduction referred to was added to later editions.

[43] *Enchiridion Militis Christi*, ed. Anne O'Donnell (Early English Text Society), Oxford 1981, pp. 59, 60, 68, 89–90.

[44] Anne O'Donnell, op. cit. pp. 12, 14, 60.

[45] *The Imitation of Christ*, (ii, 12). For an authoritive account of the Brethren of the Common Life, see Albert Hyma, *The Brethren of the Common Life*, Michigan 1950.

[46] Christopher Butler, op. cit. p. 57.

[47] Christopher Butler, op. cit. p. 58.

[48] *L'harmonie du Monde*, 1579.

[49] *Alchimie de Flamel*, Bibliothèque Nationale, Paris, MS fr.14765 f. 135r.

[50] Laurinda S. Dixon, *Alchemical Imagery in Bosch's Garden of Delights*, Ann Arbor 1981, pp. 43–5.

[51] C. A. Burland, *The Arts of the Alchemist*, London 1967, pp. 141–2.

[52] Revelations, chapter 12, verses 1–4.

[53] Burland, op. cit. p. 157.

[54] Mia Cinotti, op. cit. p. 85.

[55] Jean Leymarie, *Dutch Painting* (Geneva 1976, London edn 1977), p. 26.

[56] *Encyclopaedia Britannica*, Literature, Western, p. 1117, Medieval Dutch Drama.

[57] For this and other information on medieval Dutch drama we are indebted to Prof W. M. H. Hummelen of the University of Nijmegen.

Notes to Chapter 6

[1] This was, of course, a very proper aspect of the revival of the values of classical antiquity, more specifically of Roman antiquity with its gallery of naturalistic portraiture. This was transmitted to the 15th century through cameos and coins.

[2] The first important portraits of undoubted verisimilitude are of Jean II of France and the tomb of Edward III of England.

[3] Holbein had been reduced to decorative painting like designing coats of arms. Most of his religious painting was destroyed by an outbreak of iconoclasm at Basel in 1529.

[4] To Petrus Aegidius; see Helen Langdon, *Holbein* (Oxford 1976), p. 8. The use of the word 'angel' is a pun, the angel being a contemporary English coin.

[5] Painted 1532/3, the paintings were lost at the end of the 17th century. An original sketch for 'The Triumph of Riches' is in the Louvre, Paris. A copy of 'The Triumph of Poverty' by Matthäus Merian, 1640, and copies of both pictures by Jan de Bisschop, c.1670, are in the British Museum. See Paul Ganz, *The Paintings of Hans Holbein the Younger* (London 1950), pp. 284–8.

[6] Dated 1532, Deutsches Museum, Berlin.

[7] Painted 1539/40 in oil and tempera on parchment mounted on wood. The rather unusual materials were perhaps chosen for ease of transport (Paul Ganz, op. cit. p. 251); now in the Louvre, Paris. For its relationship with the contemporary miniature in the Victoria and Albert Museum see Roy Strong and V. J. Murrell, *Artists of the Tudor Court*, catalogue of Victoria and Albert Museum exhibition, 1983, p. 48, entry 30.

[8] Painted on wood, 207 x 210 cm, signed and dated 1533, National Gallery, London, inv. 1314.

[9] E.g. by Alfred Woltman, *Holbein and his Time*, London 1872, who would prefer to call the painting 'The Scholars'.

[10] Dickes first expressed dissatisfaction with the identification of Holbein's sitters in *The Atheneum*, 25 Jan. 1896. He later claimed the picture commemorated the Treaty of Nuremberg of 1532 in *Holbein's Ambassadors Unriddled*, London 1903.

[11] The identification of Jean de Dinteville was first suggested in a letter to *The Times* by Sir Sidney Colvin, September 1890. In 1895, Mary F. S. Hervey confirmed the identification with documentary evidence: a 17th-century parchment describing a picture of 'Messire Jean de Dinteville chevalier Sieur de Polizy . . . qui fut Ambassadeur en Angleterre pour le Roy Francois premier ez années 1532 & 1533 . . . Est aussi represente audict

tableau Messire George de Selve Evesque de Lavaur personage de grandes lettres & fort vertueux . . . eux deux ayantz recontrez en Angleterre un excellent peinctre holandois l'employerent pour faire iceluy tableau . . .' In 1900, Hervey published the results of her extensive research, *Holbein's Ambassadors: the Picture and the Men*, London, which provided the basis for all later work on this picture.

[12] Hervey, op. cit. p. 209, note 3, and Dickes, op. cit. p. 36 for illustration.

[13] Cf. an ivory bauble in the Museum of London which shows the face of a smart young man on one side and a skull on the other.

[14] See Hervey, op. cit. pp. 31–2.

[15] On the death of the Marquis de Cessac the painting presumably passed to his heirs. It reappears in 1787 in the sale of the estate of a M. Nicolas Beaujon. It was bought by the art dealer, J. B. P. Le Brun. Le Brun sold the painting to an English dealer called Buchanan from whom it was acquired by the Earl of Radnor. See Hervey, op. cit. p. 5ff.

[16] 'Celui dont on voit l'estampe offre les portraits de MM. de Selve et d'Avaux; l'un qui fut Ambassadeur à Venise, l'autre le fut dans le nord . . .', Le Brun, *Galerie des Peintres Flamands, Hollandais et Allemands* (Paris 1792), vol. 1, p. 7, cited by Hervey, op. cit. p. 5.

[17] Georges de Selve's reputation as a peace-maker was lauded in the introduction to his collected works, *Oevres de Feu Révérend Père en Dieu, Georges de Selve, Evesque de la Vaur* (Paris 1559), not paginated.

[18] National Gallery 'Ambassadors' file, report by Dr Helen Wallis and Dr A. David Baynes-Cope.

[19] National Gallery 'Ambassadors' file.

[20] Hervey, op. cit. p. 210ff., accepts as genuine gores of a globe matching that of *The Ambassadors*, discovered by Henry Stevens of Vermont in 1885 and now in the New York Public Library, but in the light of an investigation of a group of 'Ambassadors' globes by Dr A. David Baynes-Cope (*Imago Mundi*, vol. 33, 1981, pp. 9–20) it seems likely that the existing globe gores were copied from the painting and not vice versa.

[21] We are grateful to John Glenn for examining the British Library copy of Apian's book (BL 391.a.7) and explaining its arithmetic significance. See also John Glenn, 'The Fine Art of Division' in *Mathematics Teaching*, Dec. 1984.

[22] For complete biography of Apian, see Siegmund Günther, *Peter und Philipp Apian* (Prague 1882).

[23] National Gallery 'Ambassadors' file, research notes on the instruments by A. Barclay of the Science Museum, London.

[24] Otto Pächt, 'Holbein and Kratzer as Collaborators' in *Burlington Magazine* 84, 1944, pp. 134–9. The 'Canones Horoptri' is Bodleian Library, Oxford, MS Bodley 504.

[25] 'Je vous prie m'envoyer le portraict du compas auvale duquel m'avez escript; car je suis bien empesché à comprendre la façon de laquelle il est fait.' From Jean de Dinteville to the Bishop of Auxerre, 23 May 1533, Bibliothèque Nationale, Paris, Coll. Dupuy, vol. 726, f. 46, cited by Hervey, op. cit. p. 80.

[26] Derek J. de Solla Price, 'The Book as a Scientific Instrument' in *Science* 158, Oct. 1967, no. 3797, pp. 102–4.

[27] E.g. Gospel book of St Emmeram at Regensburg, Bayerische Staatsbibliotek, Munich, Clm. 14000 f. 5v, see J. Hubart, J. Pescher & W. F. Welbeck, *Carolingian Art* (London 1970).

[28] Roy Strong, *Holbein and Henry VIII* (London 1967), p. 57

for inscription.

[29] The iconography of this painting makes better sense on the assumption that the centre space was not left for a doorway or window, as has been suggested, but for the throne itself. The figures beside it then stand, literally, for the Tudor dynasty, guarding and legitimising their representative upon that throne, be it Henry VIII in life or his son Edward VI who was actually shown standing before that throne.

[30] It has been suggested that this pose was derived from Donatello's statue of St George. Holbein is known to have used mirrors to obtain his semi-mechanical likenesses, so the reversing of a composition was no problem to him.

[31] The parallels between these two paintings is discussed in Roy Strong, op. cit. n. 28 above.

[32] First pointed out by Catherine Lewis Puccio in an unpublished article, *The Significance of the Silver Crucifix in Hans Holbein's The Ambassadors.*

[33] For the diplomatic state of play in 1533 see Owen Chadwick, *The Reformation*, Pelican History of the Church, vol. III (London 1964) especially maps pp. 138–40.

[34] Antoine Macault's translation of Diodorus Siculus, Musée Condé, Chantilly, MS 1672, f. 1r.

[35] *Hall's Chronicle*, London 1809, p. 792.

[36] 10 April 1533, Chapuys to Charles V. *Letters and Papers Foreign and Domestic* (London 1882), vol. 6, p. 150.

[37] 11 April 1533, Cranmer to Henry VIII, *Letters and Papers Foreign and Domestic*, op. cit. p. 152.

[38] 12 April 1533, Carlo Capello to the Signory, *Calendar of the State Papers and Manuscripts relating to English Affairs in the Archives and Collections of Venice* (London 1871), p. 393.

[39] *Letters and Papers Foreign and Domestic* (London 1883), vol. 6, p. 160, Dr Ortiz to Charles V.

[40] 23 May 1533, Bibliothèque Nationale, Paris, Coll. Dupuy, vol. 726, f. 46, cited by Hervey, op. cit. p. 80.

[41] R. J. Knecht, *Francis I*, Cambridge 1982, p. 141.

[42] See note 40, p. 81.

[43] *Mélanges Historiques*, part II, p. 211. Cited by Hervey, op. cit. pp. 83–8.

[44] Hervey, op. cit. pp. 84–5.

[45] *Hall's Chronicle*, p. 800.

[46] *Hall's Chronicle*, p. 801.

[47] Andrea Alciati (1492–1550) was primarily a jurist. He tempered the practice of traditional jurisprudence with the new critical attitude of the humanists. For a complete biography see Paul Emile Viard, *André Alciat*, Paris 1926.

[48] *The Complaint of Peace*, first published 1517, is pervaded by the metaphor of concord versus discord. See *Erasmus' The Complaint of Peace*, a modernised version of Thomas Paynell's English edition of 1559 (New York 1946).

[49] *Oevres . . .*, op. cit., the second of two orations or 'remonstrances' to the Germans. Mary Hervey, op. cit. p. 152, suggests this oration was composed for the Diet of Speyer.

[50] Andreas Osiander (1498–1552), who had played a leading part in reforming the city of Nuremberg on strictly Lutheran principles.

[51] Fritz Saxl, *A Heritage of Images* (London 1970), p. 120, plate 173.

[52] Standonck tried to use Montaigu as a base from which to reform the French church, but lack of official support hampered his efforts. After his death, in 1504, the college was no longer a centre of reform. Knecht, op. cit. p. 133.

[53] Dated 14 February 1519. A letter in May of the same year from a Swiss student in Paris says that Luther's writings were being received 'with open arms'. See Knecht, op. cit. p. 139.

[54] April 1521.

[55] *Oevres . . .*, op. cit.

[56] *Aristotle's Counsels to Alexander*, Basel University Library, MS O.II.26, f. 12v, (German, 1476).

[57] Biblioteca Ambrosiana, Milan, Codex Atlanticus (1483–1518) 35va–98.

[58] For this connection and other information on the history of anamorphic art we are indebted to Jurgis Baltrusaitis, *Anamorphic Art* (Paris 1969), tr. W. J. Strachan (Cambridge 1977), pp. 18–19.

[59] Quoted by Gérard Barrière in 'Des Objets Peints non Identifiables', *Connaisance des Arts*, no. 288, Feb. 1976, pp. 48–55.

[60] *Vitellionis Mathematici perspectiva, id est, de natura ratione et projectione radiorum risi*, Nuremburg 1535.

[61] Germanisches Nationalmuseum. See Alistair Smith, *The Ambassadors*, Painting in Focus No. 1, National Gallery, 1974, fig. 2.

[62] James M. Clark, *The Dance of Death in the Middle Ages and the Renaissance* (Glasgow 1950), p. 93.

[63] c.1330, Wensley Parish Church, Yorks. For an illuminated MS example of the subject see British Library MS Arundel 83.

[64] The cycle was destroyed when the wall was demolished to widen a road during the reign of Louis XIV. The paintings are known only through the woodcuts and verses recorded in Guyot Marchant, *Danse Macabre*, published 1485. See James M. Clark, op. cit. p. 24.

[65] This similarity of composition and iconography was first pointed out by Ralph N. Wornum in *Some account of the Life and Works of Hans Holbein, painter, of Augsburg*, London 1867, p. 181.

[66] This theory was first suggested by Mary Hervey, op. cit. pp. 225–7, in which she quite erroneously describes the floor of 'The Ambassadors' as an 'accurate copy' of the Westminster pavement. Although some details are similar, the scale is considerably reduced, the design partially reversed and the circles left blank. In the light of the meticulous attention to detail in the rest of the picture, it may be that Holbein worked from an inaccurate intermediary reference, but it is also worth considering other floors, such as the floor at Greenwich Palace recorded as being painted 'lyke stone coloure with orbys and antyke worke' in 1533. Although de Dinteville was resident at Bridewell Palace during his ambassadorship, he also stayed as Henry VIII's guest at Greenwich.

[67] John Flete, *History of Westminster*, c.1450, see British Library Cotton MS Claud. A. VIII for transcription of Flete by Sporley:
'Si lector posita prudenter cuncta revolvat, hic finem primi mobili inveniet.
Sepes trima; canes et equos hominesque subaddas, cervos et corvos, aquilas, immania cetae, mundum: quodque sequens preeuntis triplicat annos.
Sphericus architypum globus hic monstrat macrocosmum.
Christi milleno bis centeno duodeno cum sexageno, subductus quator, anno, tertius Henricus rex, urbs, Odoricus et abbas hos compegere porphyreos lapides.'

[68] Lines 3 to 5 of the inscription which may be translated:
'Three for the hedge; add dogs and horses and men, stags and ravens, eagles, giant sea serpents, the World; that which follows triples the years of the preceding.'
Sporley explains that this means that the hedge lives for 3 years, dogs for 3 x 3 years, horses for 3 x 3 x 3 years etc. This gives the life of the World as 3^9, i.e. 19,683 years.

[69] This anecdote appears in *Iconographie de L'Art* (Paris 1958), p. 234, and was kindly brought to our attention by Catherine Lewis Puccio.

[70] Alberto Veca, Vanitas: *il simbolismo de tempo* (Bergamo 1981).

[71] Fritz Saxl, op. cit. pp. 128–9, plates 188 & 189.

[72] For more on the fully developed *vanitas* theme see Peter C. Sutton et al, *Masters of the 17th century Dutch Genre Painting*, Philadelphia Museum of Art, 1984, catalogue of Royal Academy exhibition, London 1984.

[73] For complete biographies of Cornelius Agrippa see Charles G. Nauert, jnr., *Agrippa and the Crisis of Renaissance Thought* (Urbana 1965) and Lewis Spence, *Cornelius Agrippa: Occult Philosopher* (London 1921).

[74] Claude de Bellievre, *Souvenirs de voyages en Italie et en Orient; Notes historiques; Pièces de vers*, ed. Charles Perrat, Geneva 1956, p. 11, cited by Nauert, op. cit. p. 94.

[75] Nauert, op. cit. p. 108.

[76] As far as we know the correspondence between these extracts from *The Uncertainty and Vanity of the Sciences and Arts* and Holbein's 'Ambassadors' was first demonstrated by Baltrusaitis, op. cit. pp. 99–100.

[77] 24 September 1527. See Pierre Bayle, *Dictionaire Historique et Critique*, 1740, vol. I, pp. 110–11.

[78] C. A. Burland, *Arts of the Alchemists* (London 1967), p. 71.

[79] *Oevres . . .*, op. cit.

Index

Sources of Illustrations